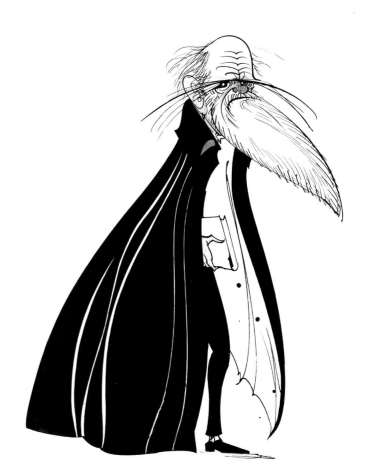

# HEROES & VILLAINS

## SCARFE AT THE NATIONAL PORTRAIT GALLERY

# HEROES
# & VILLAINS

*Scarfe* ● AT THE NATIONAL PORTRAIT GALLERY

Over fifty celebrities, writers and
experts debate famous Britons

Introductory essay by
**Matthew Parris**

NATIONAL
PORTRAIT
GALLERY

For my grandchildren Ella, Iggy and Abel
GERALD SCARFE

Published in Great Britain by
National Portrait Gallery Publications,
National Portrait Gallery,
St Martin's Place, London WC2H 0HE

For a complete catalogue
of current publications
please write to the address above,
or visit our website at
www.npg.org.uk

ISBN 1 85514 338 0

A catalogue record for this book
is available from the British Library.

Publishing managers: Denny Hemming
    and Celia Joicey
Project editor: Caroline Brooke Johnson
Design: Paul Welti
Copy editor: Marilyn Inglis
Picture research: Catherine Ford
    and Shirley Ellis
Production: Ruth Müller-Wirth
New photography: Peter White
Printed and bound by Conti in Italy

Gerald Scarfe wishes to thank Jane Scarfe
and Julie Davies for preparing, scanning
and retouching the artwork.

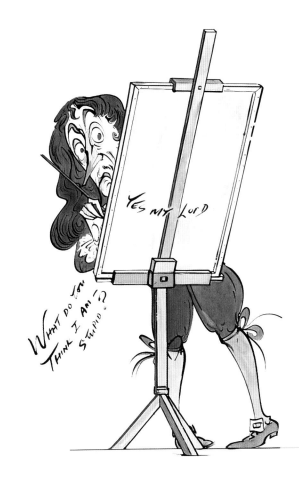

# Contents

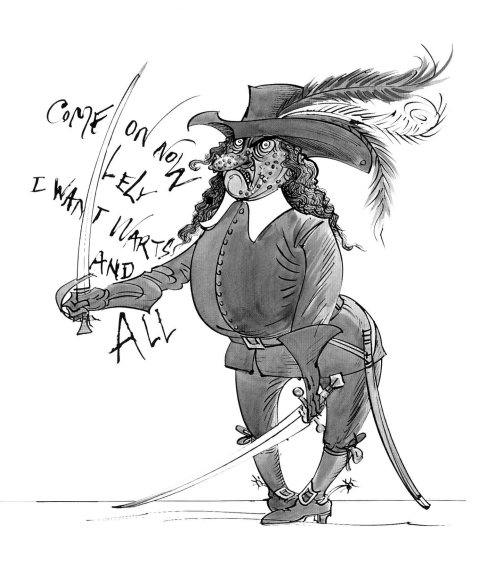

COME ON NOW I WANT WARTS AND ALL

# Foreword

**B**EING FAMOUS ISN'T EASY. For those in the public eye it's not just image or security questions but the continual open commentary, both positive and negative, offering praise or blame, worship or denigration. Fame polarises opinion, bringing out food for adulation or fodder for attack. Of course, achievement, rather than mere celebration or notoriety, is the key term for the National Portrait Gallery and is enshrined in the formation of its primary collection. But any discussion of achievement connects to how an achiever is perceived, and it is a rare achiever indeed who is thought by all to have produced exclusively good effects.

*Heroes & Villains* lets Gerald Scarfe loose in the National Portrait Gallery, and offering our leading caricaturist this many subjects (or targets) is a risky concept. But this is a project in which his wit wins through, and a detectable affection emerges for many of the subjects that he lampoons. These public figures are larger than life, whether alive or now dead, and they are made even larger by Scarfe's acerbic pen and its reshaping of their features, its refashioning of their bodies.

The project – a book and display, linked to a BBC film – explores portraiture and heroism, caricature and villainy. For each subject one commentary treats the person in positive terms, alongside their portrait, while a second article, alongside the Scarfe caricature, raises issues or complaints. A portrait is generally seen as flattering and a caricature as critical, but the divide between the two genres is arguably not so clear. On the one hand we expect character or personality to be visible in a good portrait, but a person's character may cloud the view of what they have achieved. On the other, the element of physical exaggeration in a good caricature creates instant recognition, latching the viewer onto the subject, but makes simplistic links between their looks and their ideas or principles.

While portrait painter and caricaturist may work within the same cultural climate, the collective view of their subjects will change over time. How we view a particular king or queen, an inventor or a poet will vary in relation to our own time and ideas. Yet a certain depiction will anchor memory, giving colour to a later historical view. In the 'Darnley Portrait' of Elizabeth I of 1575, we sense as spectators the determination in that cold stare: the Queen as determined despot and the Queen as icon with brilliant ability to consolidate a nation. Such a still and lasting image was created amidst the forces of political intrigue and divisive religious beliefs, and the impossibility for the artist of straying too far from the ascribed royal image. The portrait captures and describes her, good and bad, hero and villain.

My thanks go to all who have worked to bring this book to fruition: to Robert Carr-Archer, Denny Hemming and Celia Joicey, and especially Caroline Brooke Johnson, at the Gallery. They have worked hard to steer a proper and appropriate course between some fifty very differing points of view. I am extremely grateful to Matthew Parris and to all the

The 'Darnley Portrait' was painted when Elizabeth I was in her twenties. Supremely regal and aware of her duties as a queen, her haughty gaze fixes spectators in her path.

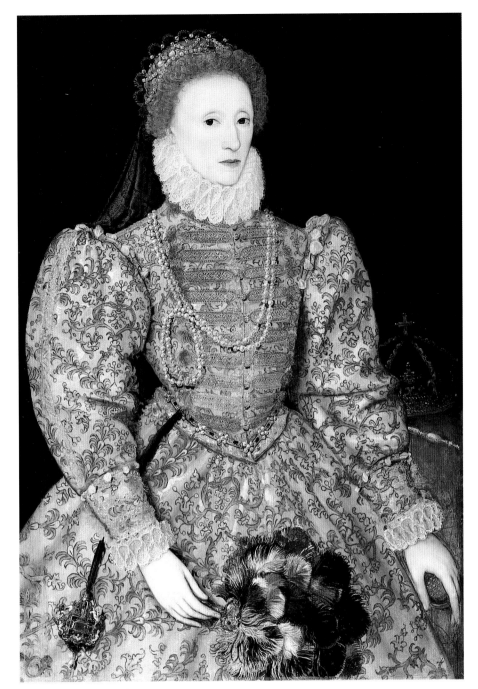

**ELIZABETH I (1533–1603)**
UNKNOWN ARTIST, c.1575

writers for their interest in the project and their wonderful contributions. Special thanks go to Paul Welti, the book designer, who has contributed greatly to the making of the project. But the greatest thanks are reserved for Gerald Scarfe, who has remained ebullient, sharp and brilliant by turns – a Cruikshank for our time.

SANDY NAIRNE
Director, National Portrait Gallery

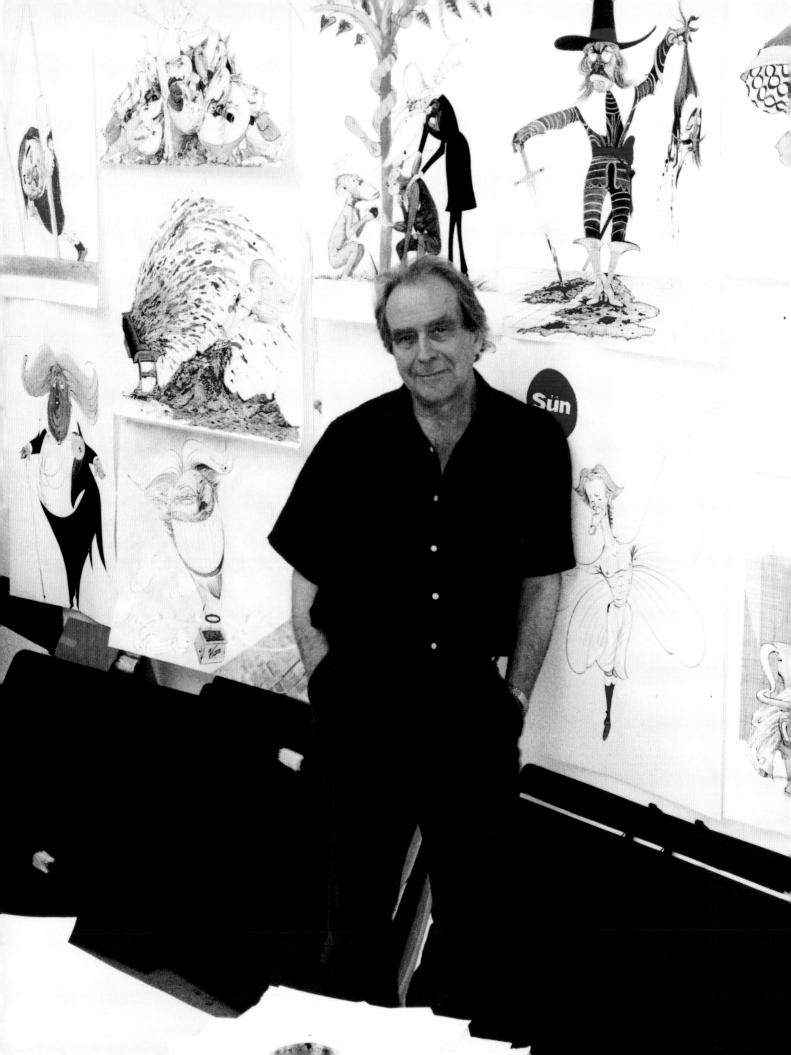

# Hung by Scarfe

Gerald Scarfe in his studio surrounded by this book's villainous caricatures.

F THE GREAT ARTIST HANS HOLBEIN the Younger had been a ruthlessly honest portrait painter the course of English history would have been very different. It was on the strength of his miniature of Anne of Cleves – portrayed by Holbein as a cracking bit of stuff – that Henry VIII sent for her to be his bride, only to be crushingly disappointed when the real goods turned up. Not an unusual state of affairs of course: for centuries the history of commissioned portrait painting by such artists as Sir Joshua Reynolds has been one of flattery and sycophancy – not surprising when you consider that the sitter is generally the one footing the bill. This means that, before the advent of photography at least, we can in general have very little real idea of what those immortalised truly looked like, and that, before caricaturists like James Gillray and William Hogarth, the representation of public figures tended to be unrealistically rosy.

When I was hanging an exhibition of my work at the National Portrait Gallery in 1999, I spent many hours walking around the Gallery, looking at the portraits in detail. I began to wonder what these people were really like, and whether I was getting a true picture of them. I tried to ignore the skill and flattery of the artist and find the person behind the image – and I wondered if, had I been painting Henry VIII himself, for instance, I would have been brave enough to portray him as he really was. Unlikely, I think – I'd probably have been as flattering as the rest of them, preferring to leave the palace with my head.

That's where the idea for this book came from: a light-hearted attempt to scrape away the oil, watercolour or pastel from the canvases and depict some of the National Portrait Gallery's most illustrious inhabitants with the unflattering pen of a caricaturist, rather than the flattering brush of the portrait painter. (Obviously I don't include painters such as Rembrandt van Rijn and Lucian Freud amongst the flatterers, who undoubtedly brilliantly convey the truth through their searing portraits.)

I've always been fascinated by portrait painters, especially those who tear the face apart and reassemble it, like Giuseppe Arcimboldo, Francis Bacon or Pablo Picasso. Caricature, I believe, is an extension of this way of exploring faces, and in many cases the line between art and caricature is blurred. Throughout history, artists – from Leonardo da Vinci to Toulouse-Lautrec – have used elements of caricature and, when struggling to capture the sitter, have exaggerated some aspects and underplayed others, in an attempt to give the 'feel' of that person. To measure a person's individual features and represent them on canvas is not enough, as a mechanically measured portrait can be boring, lacking the spirit of the sitter. Our faces are always moving, unless in sleep: changing expressions flit across them all day (except Iain Duncan Smith's). The artist must capture an amalgam of these fleeting images and pin them in position on the canvas before they fly away like butterflies.

So, in a way, this book represents a criticism of commissioned portraiture. Perhaps I have a biased view of this, tending to see caricature as being nearer to representing the truth of a person than an attractive oil painting does. I've been through the experience of being painted myself and, to my mind, was made to look better than I was – or at least

Wow!! A little cracker!

depicted in my 'best light'. On the few occasions I have had people to sit for me, I may have pulled my punches, knowing that the sitter would ask to see his likeness at the end – just as in any social situation, there's an instinct to be polite.

I prefer to watch my subjects unobserved, at a general gathering, perhaps: a drinks party or party political conference. Here I make quick sketches, sometimes only a few lines, and try to capture on paper his or her character. I then take these sketches back to my studio and amalgamate them into one drawing, capturing the essence, like reducing a sauce to its essential flavour. Even where politicians are concerned, I wouldn't dream of insulting them personally, but in the quietness of my studio I'm not concerned by what my subjects will think. I'm not purposefully setting out to be vicious to people – just attempting to say what I want about them without any interference. Caricature is my job: I've made my living being rude to people. I see it as truth.

The truth – even in art – can hurt. In 1964 *The Times* commissioned me to make a drawing of Winston Churchill during his last ever week in the House of Commons. Up until then he'd always been pictured as a heroic figure, the bulldog Englishman, standing on the white cliffs of Dover, cigar clenched between his teeth, defying the Hun, while Vera Lynn sang in the background. I was given special dispensation to draw in the Commons, and I settled down with my pad and pencils with a good view of his usual seat (at the bottom of the stairs at the end of an aisle), waiting for the great man.

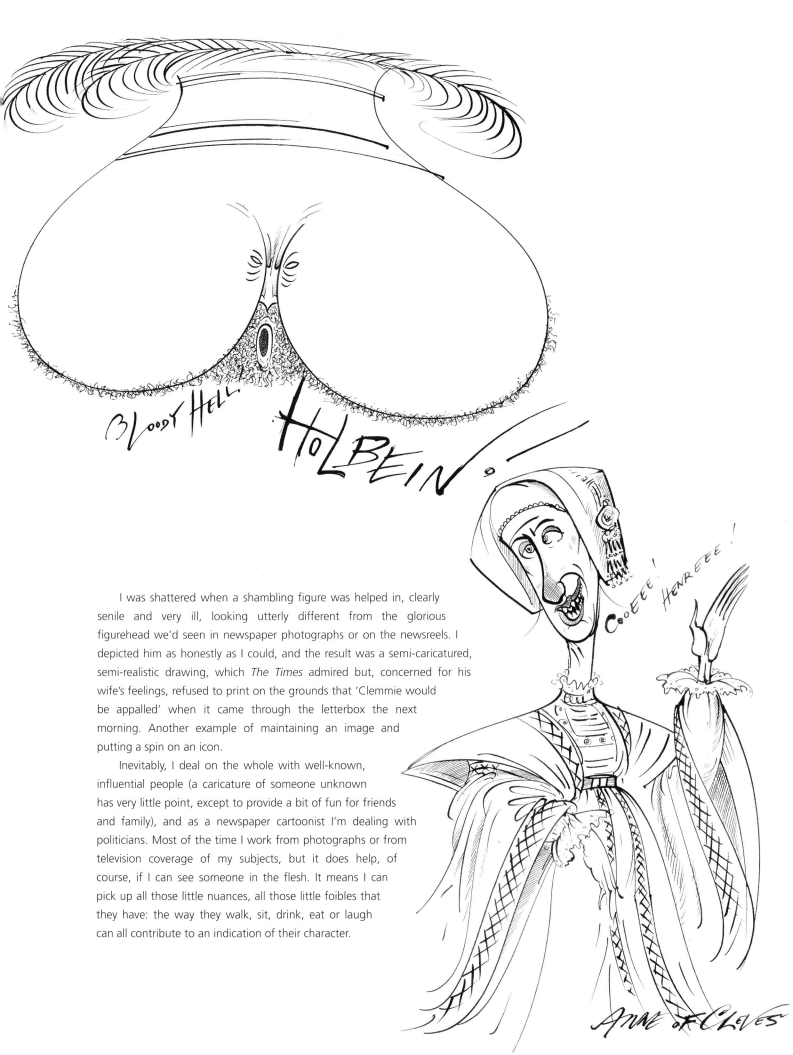

**BLOODY HELL. HOLBEIN!**

*CooEEE! HenreeEE!*

I was shattered when a shambling figure was helped in, clearly senile and very ill, looking utterly different from the glorious figurehead we'd seen in newspaper photographs or on the newsreels. I depicted him as honestly as I could, and the result was a semi-caricatured, semi-realistic drawing, which *The Times* admired but, concerned for his wife's feelings, refused to print on the grounds that 'Clemmie would be appalled' when it came through the letterbox the next morning. Another example of maintaining an image and putting a spin on an icon.

Inevitably, I deal on the whole with well-known, influential people (a caricature of someone unknown has very little point, except to provide a bit of fun for friends and family), and as a newspaper cartoonist I'm dealing with politicians. Most of the time I work from photographs or from television coverage of my subjects, but it does help, of course, if I can see someone in the flesh. It means I can pick up all those little nuances, all those little foibles that they have: the way they walk, sit, drink, eat or laugh can all contribute to an indication of their character.

*ANNE of CLEVES*

Distilling a person into a caricature involves a strange process. Something bleeds across from the sitter to my subconscious, and, at best, I find it's happened without my knowing it – it isn't until somebody says, 'Oh I love the way you've captured his slouch', or whatever, that I realise that I've done so. There's an invisible two-way communication going on between my subject and me. Like a computer, what feeds in through my eyes is processed automatically and should flow down my arm and, through the pen, onto the paper. A caricature isn't just a big nose or big ears: it's the whole persona or body. I'm a great fan of Max Beerbohm, who always caricatured the entire figure to convey the personality. I aim to do that, but I don't always achieve it: being a newspaper cartoonist, I'm continually up against a deadline and time can be against me. It can be an unsatisfactory way of life for an artist: I don't, like a Lucian Freud or Frank Auerbach, have months and months to revisit my work and perfect it: I may be personally unhappy with a drawing, but, once the deadline arrives, it has to fill that waiting space in the paper. When I do have time, I tend to go over and over something until I get it right.

I like to take people's features, throw them up in the air and let them fall down onto the paper in a way that still resembles them but is unique. I often get an image of someone the moment I see them, and have to hold it in my mind and whack it down quickly onto the page before it disappears. These immediate visions of people can disintegrate and fade away like dreams – and the translating of them into reality can be as difficult as the telling of those dreams to another person: just as you're coming to a bit you think you can remember, it's gone. A likeness is so fleeting that a millimetre of difference in a pen line can make or break the convincing image. This is where the oil painter has the advantage: the mistakes can be covered, whereas with the precision of line the options are much more limited. Sometimes, as I'm working, the likeness escapes me, and I have to repeat and repeat the drawing, throwing the discarded sketches, half-completed, onto the floor. The danger in redrawing the same image many times is that it can become meaningless, like a word repeated over and over again.

Caricature is an accepted English tradition, from William Hogarth through Thomas Rowlandson, James Gillray and George Cruikshank to *Spitting Image*. It's a cruel art form: the moment one adds a fraction of an inch to the victim's nose it becomes unkind, but it gives a lot of fun to the onlookers and, since most of the people one deals with are in power, they are fairly thick-skinned about it. The truth is that many people in public life, politicians in particular, are flattered to be lampooned in the daily press because it means they've arrived and are someone to be noted, preferring to be drawn as a slimy, fat slug than not drawn at all.

A caricature of a politician can represent far more than simply his own views and character. A party leader, for example, can be used as a symbol of the wrongdoings of the party in general, allowing the artist to transmogrify the subject into something completely different. Mrs Thatcher always gave me huge potential. She was great material, and I used an exaggeration of her aquiline nose to portray her policies – sharp, intrusive, razor-billed

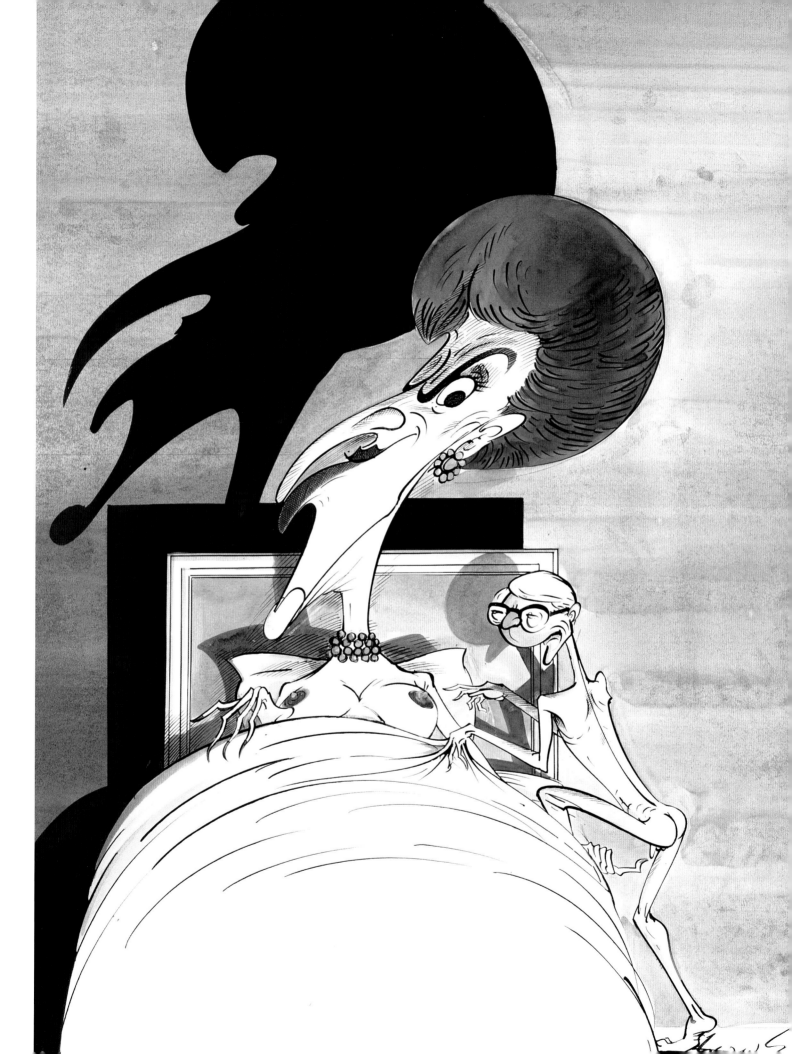

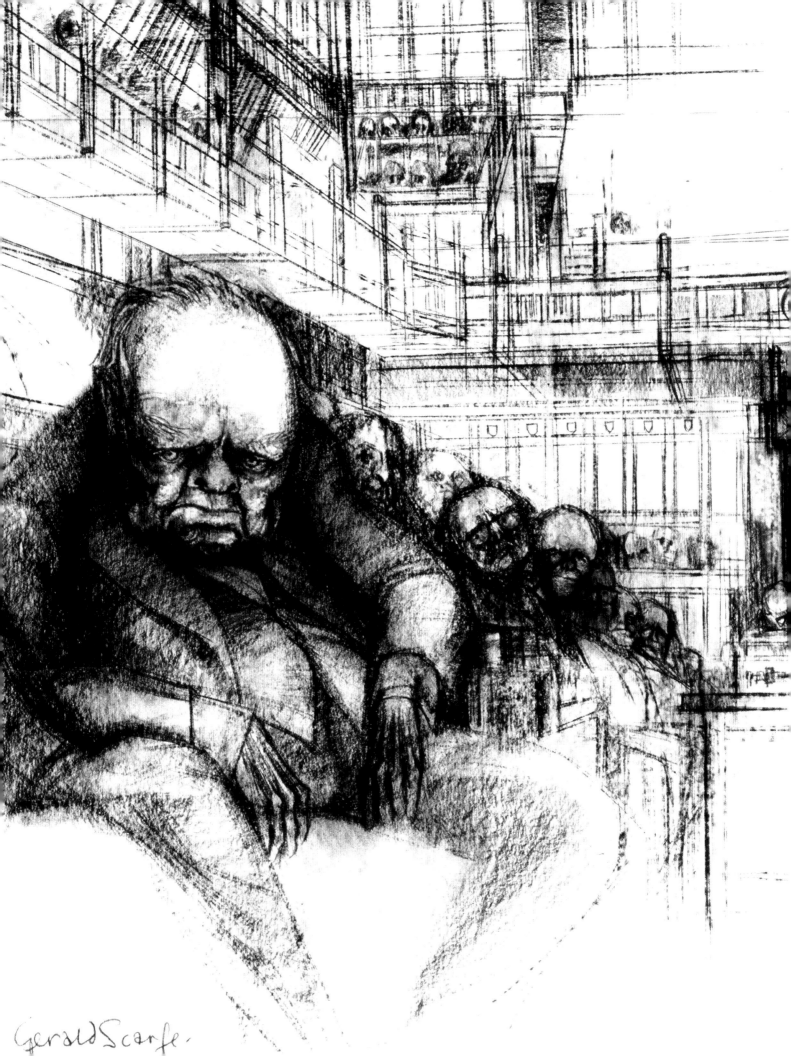

Gerald Scarfe.

and incisive. I was able to distil her sharpness more and more over the many drawings I made of her until she became an axe, cutting off the heads of the unemployed; a pair of scissors, dividing the United Kingdom; a knife, slicing into the Welfare State. Someone such as John Major could never be represented as a knife – no cutting edge: far too nice (although he did fool us all over his private life, of course – the dark horse). Sexual peccadilloes always provide good material, partly because they deal with the unspoken parts of our daily lives and we often see ourselves writ into the drawing: there but for the grace of God go I. Linked with politics, sexual intrigue gets even better: from the Profumo affair to Bill Clinton, there's nothing like a perjuring philanderer to create a stir and make a good drawing.

In other words the personality of the 'victim' dictates its depiction, just as the characters in a novel take on a life of their own and guide the writer on to the path they will take through the narrative. Sometimes I may not have an axe to grind about my subject, so I simply go for the individual personality. What interests me then is trying to filter down or distil the essence of that person – and to portray it in a very exaggerated way. I'm not quite sure why I want to elongate and distort: I just have a natural bent to do so and get tremendous satisfaction from achieving the ultimate distillation.

Ringo has a big nose, for instance, but I've given him a ridiculously enormous nose. If I'd have kept going, maybe in time I'd have gone on to draw him as just a nose and nothing else, but there comes a point in making a caricature when one loses reality and is no longer in touch with the viewer. It's like a piece of chewing gum: I can stretch and stretch it, but eventually the likeness will snap. It's tempting, when I'm working alone in my studio, to take a drawing as far as I can, further and further away, but, although I know the stepping stones that have taken it to that furthest symbolic point, the viewer won't, and might say, 'Who the hell's that?' because it's gone so far from the original. But it's very satisfying for me to take it down that line of stones and still retain the character.

It can be useful to use the tone of the drawing to reflect our view of a personality: Tracey Emin, a vulnerable artist who openly depicts her private life in her work to shock effect, required from me a caricature with vulnerability and shock content of its own. (Interestingly, someone who reeled back on first seeing my drawing, on second viewing some weeks later said, 'Is that the same drawing, or have you altered it? It doesn't seem as shocking as it was.' The shock effect of a picture doesn't survive much more than a viewing or two until we adjust.)

Working on this book has been fun. It's given me the chance to draw people, especially those from the past, that I would normally have no call to caricature. The present is easier to deal with, because they are my contemporaries and I can follow the antics of Ken Livingstone, Richard Branson and the Beckhams in newspapers and on television. Dealing with historical figures is inevitably difficult: particularly for this book, when I'm relying on portraits that I am claiming aren't like them – and it's amazing how widely some

of the paintings of a particular person will vary. Generally, it's what they are famous – or infamous – for, more than their personal character, that I have to go on. The 'villainy' is frequently in the deed, not the person – or, sometimes, in a reaction or chain of events far removed from the original instigator, who would have had no idea of the Pandora's box he had created. Thus Logie Baird, the man, becomes a relatively insignificant player, sitting comatose while the television vomits over him. The picture still includes a caricature of his physical likeness, but he's mainly used as a comment on the outcome of his own invention. The spawning of this kind of unfortunate, or 'villainous', by-product of an originally well-intentioned, even marvellous, invention happens frequently, from weapons of mass destruction to the complications of cloning, and, in Baird's case, gives me an opportunity to comment on the dumbed-down culture that we're sprayed with every day from our television sets.

Sometimes the villainous aspect has to be very tenuous, and becomes part of a joke, rather than a serious comment: Darwin, for example, initially caused me problems. How could I possibly portray him as a villain? I started with trying to achieve a likeness, then, once I had a caricature of him that I was happy with, decided to turn the concept on its head and start from a different angle. He may not be a villain to me, but, seen by the Church – even today by the fundamentalists – he undoubtedly is. From there it was easy: put him in the Garden of Eden and I could show the disastrous implications of his brilliant discovery from the points of view of Adam and Eve and a very annoyed bishop.

Shakespeare, too, was clearly not a villain in the true sense of the word, so I've commented on the way he interwove fact and fiction in his work, cutting out reality when it suited him, or adding little dramatic events to spice up the drama, leaving generations of us with a very distorted idea of what actually happened historically. It clearly doesn't make him a villain, but it's something to get hold of to caricature.

The writers arguing the pros and antis complete the two sides of the picture. I have, apart from a few cases, worked independently of them. My drawings are not necessarily illustrations of their texts, but are complementary or additional thoughts. I am, of course, immensely grateful to all those who so generously spent time and effort in putting forward their points of view, and in particular I would like to thank my friends Gyles Brandreth, Harold Evans, Adrian Gill, Peter Hall and Joanna Lumley.

For the last nine months my studio has been crammed with a band of fearful and colourful villains – and I have to admit that I've enjoyed their company. I hope you find the same as I hand them over to you.

GERALD SCARFE

While Margaret Thatcher's strength of personality may haunt her successors, it continues to inspire Gerald Scarfe.

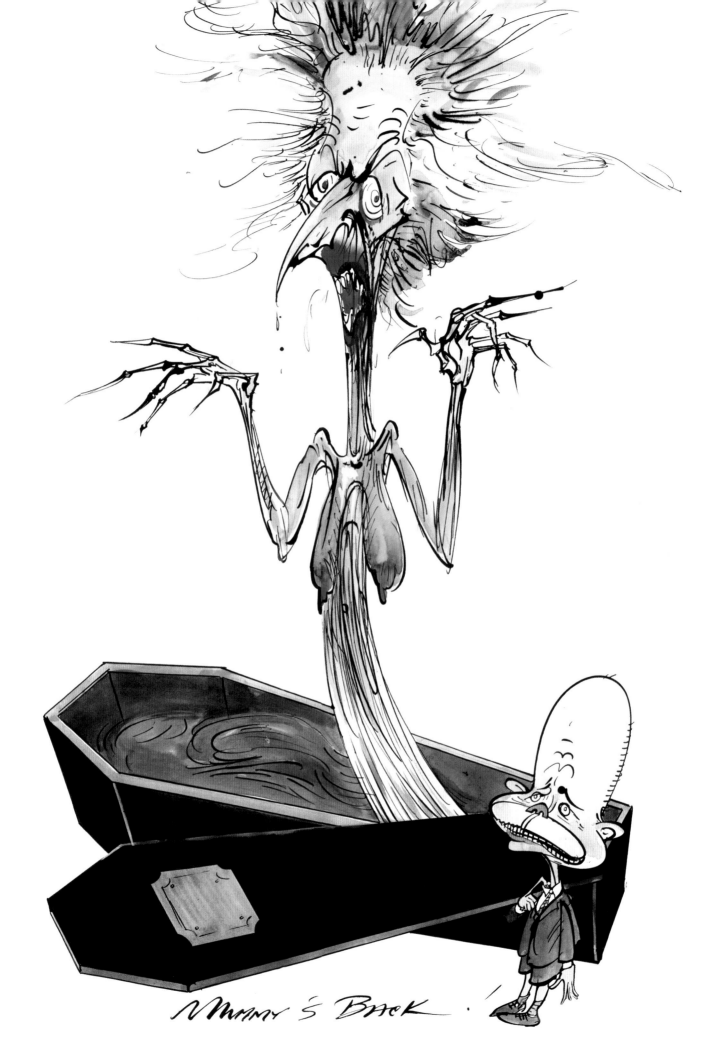

# Warts and All

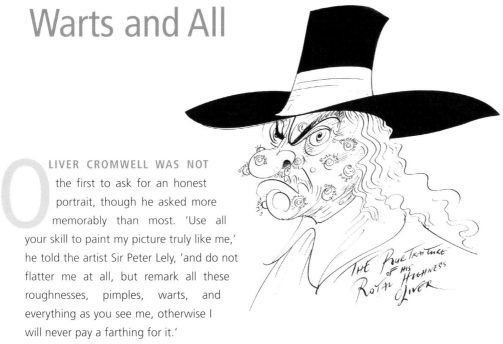

THE TRUE PICTURE OF HIS HIGHNESS ROYAL OLIVER

**O**LIVER CROMWELL WAS NOT the first to ask for an honest portrait, though he asked more memorably than most. 'Use all your skill to paint my picture truly like me,' he told the artist Sir Peter Lely, 'and do not flatter me at all, but remark all these roughnesses, pimples, warts, and everything as you see me, otherwise I will never pay a farthing for it.'

But Lely was a canny painter: he understood that though the Puritans may have despised ornamentation and prettiness, they hoped to be flattered in a different way. For the Lord Protector, Ugly was the new Beautiful: an austere and rugged command was the artistic mood the era craved, and 'warts and all' was part of that. Lely captured it, altering his style to suit the age, and was fashionable for his often-sombre work throughout the Commonwealth. He gave his subjects not everything, but at least something, of what they wanted. Most successful portrait artists do.

Commissioned portraiture can on occasion be subversive but it needs to watch its step. The convention is that the artist is more or less on his subject's side. We may not admit, even to ourselves, that we want to be portrayed as heroes, but few of us crave portraiture as villains. Graham Sutherland's study of Churchill was (though brilliant) too cruel for his client – or, at least, his wife. In her eyes it was tantamount to caricature. To the horror of the art world, she destroyed the portrait. By contrast Gerald Scarfe would, I imagine, take it as the most sublime compliment if Margaret Thatcher or Tony Blair were to roam the country seeking out his caricatures for committal to the flames. A caricaturist is on the whole not on his subject's side. He is proud to enrage. Even at his most affectionate he is there to tease, and mercy is not a quality we associate – or should – with Scarfe and his contemporaries.

My first encounter with Gerald Scarfe's work brought an involuntary gasp. It was the 1970s. I was a colonial youth not long arrived from Africa. There we had been taught to take politicians seriously. But I had opened a respectable British newspaper to be confronted by a cartoon of our Prime Minister Edward Heath, caricatured as an extruded dropping, Mr-Whippy-style, beneath a dog's bottom, the sharpness of Mr Heath's nose exaggerated to disgusting effect. Unable to believe that such a picture could be allowed, I took a second look in case I had misread it. I had not. Something more than a scatological interpretation of the Heath physiognomy imprinted itself on my young mind: the impudence of my countrymen's attitude to their masters. It was an impudence I never forgot. Later I was to anchor my career in making people laugh at politicians, which I did through sketches in words.

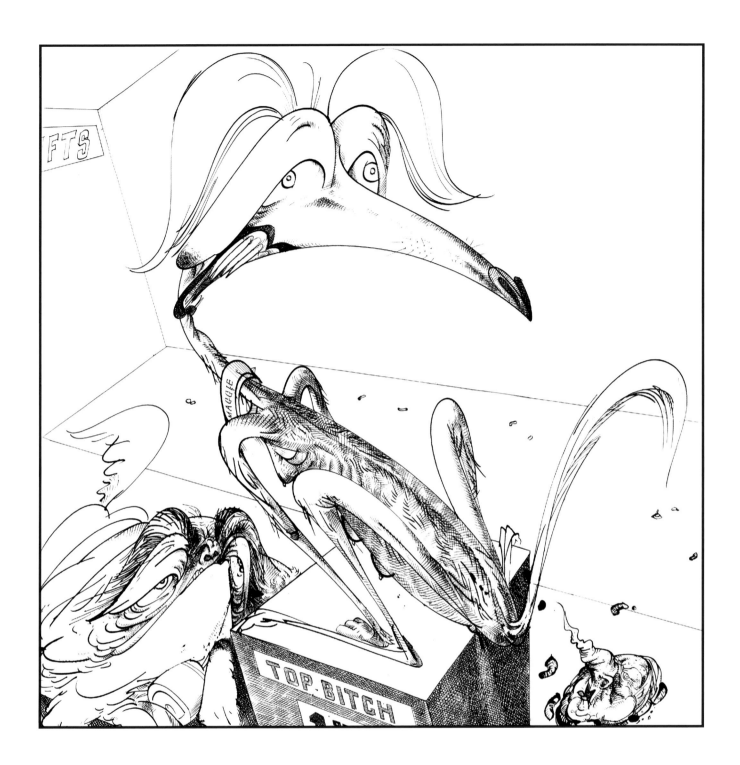

Edward Heath caricatured as a dog dropping beneath Margaret Thatcher's bottom left an indelible mark on Matthew Parris's memory.

Shortcutting language, caricature teases or derides in the most direct way possible: by pictures. Unless these are both impudent and sharp, it fails. Caricature must have a terrible suddenness. Scarfe's does. But because ridicule means making people laugh at someone, caricature must amuse. Granted, a caricaturist may incidentally be making an assertion: when *The Guardian's* Steve Bell represents John Prescott as the Prime Minister's dog, he implies subservience, stupidity and ferocity; John Major's underpants worn outside whisper of nerdishness; in *The Times*, Peter Brookes's 'Nature Notes' can even mount an argument; while the way the *Daily Telegraph's* Nicholas Garland drew Margaret

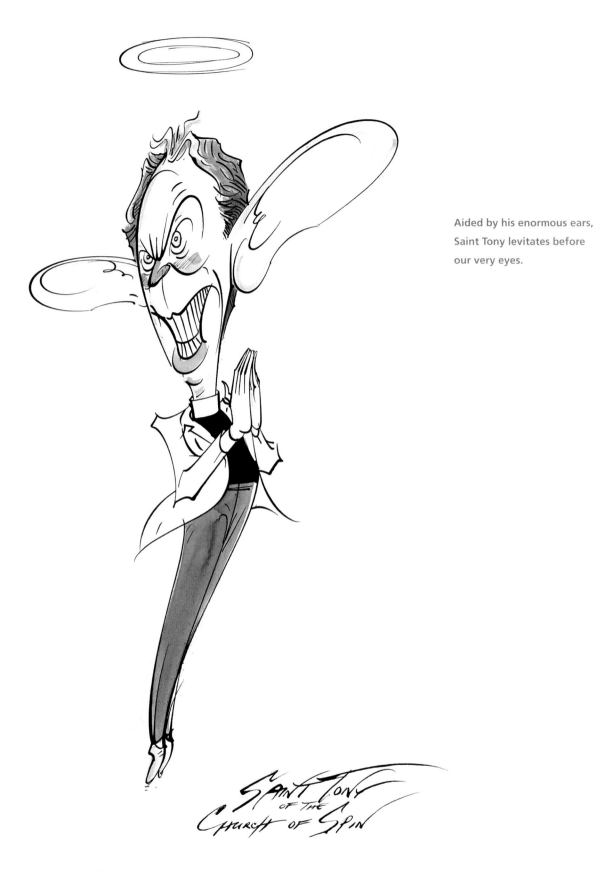

Aided by his enormous ears, Saint Tony levitates before our very eyes.

Thatcher with just a hint of panic colouring her cheek always struck me as a quite profound observation; but if all these ideas had not been very funnily drawn, they would just have been insults – a kind of graffiti – and they would never have lodged themselves in popular culture. As salt fixes a dye, so humour fixes a cartoonist's sketch.

The mockery may be affectionate or it may be unkind. The intention may be to shock, to criticise, to scorn or gently to poke fun; caricature may even express a sneaking admiration; but 'sneaking' is the word. Except obliquely (by making someone seem important) caricature never flatters. Essentially a distortion of reality through lighting upon something notable in a face or figure and exaggerating it for comic effect, caricature differs only in its sophistication, not in its method, from the way children pick on each other's oddities. And, as in the playground, the mockery strikes deepest when what is picked upon seems to reflect something of the character as well as the appearance of the victim. Teeth smile and teeth bite, and Tony Blair's teeth have served his caricaturists well in their hint at someone who can be by turns ingratiating or dangerous. A caricature of Margaret Thatcher smiling would seldom have worked because, though the Baroness can flash a grin when she must, charming her audience was never a familiar part of her technique. In this collection Scarfe puts blood on her teeth.

Some caricature – and some in this book – is simply a mischievous take on a famous (or not so famous) face, each cameo standing alone on its own as a *jeu d'ésprit*, a grotesque branch of portraiture. But famous faces come not in a void but with stories attached. First the caricaturist must establish his sketch as a kind of cipher – a shorthand for someone we know. Having done so, he can return repeatedly to the established image and have endless fun with it. The cipher can be dressed in clothes or situations that make a topical joke – and sometimes a topical point as well. The lively codpiece comes as naturally to Scarfe's Henry VIII as do the padded shoulders to his Princess Diana. To transform Oswald Mosley into a sort of living swastika is cipher made flesh, rather than the other way round. Sometimes the cipher elbows aside the reality: I cannot remember whether Tony Blair does have big ears: it no longer matters because his caricatures do.

What the caricaturist chooses to pick and make famous in his victim will reflect in part, but only in part, a personal flight of fancy and a personal opinion, and he becomes a propagandist for a point of view, or at least a reading of character. Sketches in the British press of George W. Bush as a monkey or Jacques Chirac as a worm are statements as well as pictures. By repeating a visual metaphor week after week the caricaturist may in time din into the nation's head a funny or unflattering association that had not at first occurred to it.

But this will never happen unless the picture goes with the grain of the public imagination. The caricaturist does not have a free rein and unlikely associations will seldom stick. You will not in these pages see Winston Churchill caricatured as the soul of merriment, Virginia Woolf as a social butterfly or Emmeline Pankhurst as a wilting violet. Nor (were we to caricature some of those who have written for us here) would we have much luck with a sketch of Richard Dawkins as an intellectual poodle or Ranulph Fiennes as a stay-at-home wimp. That is not because a case could not (for all I know) be advanced for Dawkins's servility, Fiennes's timidity, Churchill's jollity, Woolf's frivolity or Pankhurst's fragility, but because this is not how people see them, or are ever likely to.

A successful caricature is, you see, more than the artist's own reading of his subject: it is his reading of the public mind. That reading must be shrewd. 'Bambi' didn't work for Tony Blair for long after his election as Labour leader because, whatever Mr Blair did turn out to be, it was not sweet. But Scarfe was among the first to notice a related but different quality: Mr Blair is at the same time ferocious but almost fey. That sketch did and does work. Caricature involves a kind of imaginative leadership and like all leadership requires an instinctive sense of where the popular mind can and cannot be led. Caricature moves the way people see the famous, reinforces attitudes already half-formed, and may even suggest ideas and opinions which are at first unfamiliar; but to do so the artist needs a sheet-anchor down into the currents of the age, or his images will scud away.

So no caricaturist (I would assert), not even Scarfe, could make an unmitigated villain out of an undisputed hero. He cannot reverse polarities. What he can do is subtler: he can mitigate the heroism and chip away. He can remind us of little qualms we may already entertain about our heroes, or suggest to us plausible suspicions that may chime with us when we see them. He can work on these thoughts until we cannot get them out of our minds and he can insinuate the worm of doubt. Or he can simply make us giggle, after which we shall never quite be able to take our heroes so seriously again. When I was Private Parris in the Boys' Brigade I was witness to a camping accident in which the great hero of our squad, Lt Oliver, got his willy caught in his zip and needed to summon matron's help. Though the incident was logically meaningless, something of Ollie's predominance was on that day lost to the zip, never to be recovered. The zip unzipped his aura. Caricaturists do this too since their presiding god is the god of Impudence.

But a word, in closing, in the conventional portrait artist's favour. It is (on one level) easy for the caricaturist: he just has to attack. He needs please nobody but the crowd. The portrait artist does not have that luxury. I suggested at the outset that he is under pressure from his client to be merciful, and so he may be. But he is under pressure from his art to be honest and honesty is sometimes unkind. From the tension between mercy and cruelty can arise the most profound synthesis, for both contain a truth of their own. In the best portraiture that tension is sublime. Just as a portrait should dig beneath the trappings of fame, so a caricaturist must go beyond insult. Both, in the end, are looking for truth.

MATTHEW PARRIS

More steely than fey, this
portrait hints at the
darker side of politics.

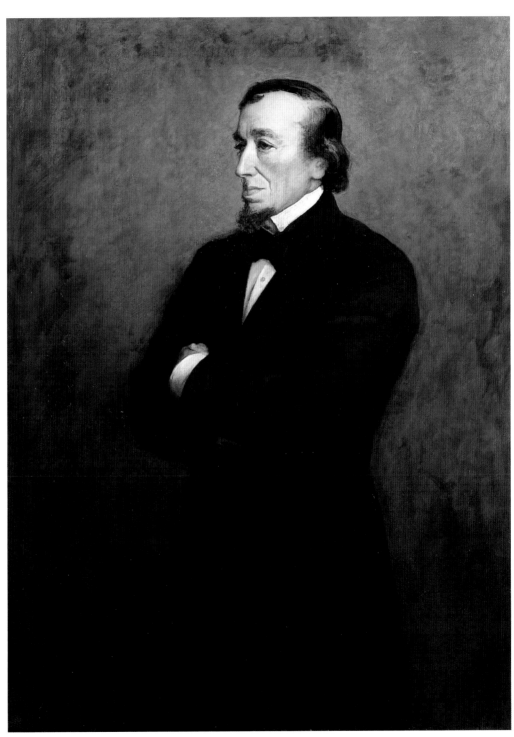

**BENJAMIN DISRAELI (1804–81)**
SIR JOHN EVERETT MILLAIS, 1881

# Heroes &

& Villains

# Richard Arkwright

**B**ORN IN PRESTON in 1732, Richard Arkwright was trained as a maker of perukes, or wigs, but in the late 1760s he latched on to the idea of making a machine to spin cotton. Traditionally, spinners or spinsters spun one thread at a time, or up to a dozen with a spinning jenny. However, this manual spinning required great skill, and the spinning jenny did not help much, because if one thread broke the spinster would have to stop the whole machine and mend it. Arkwright's machine used three sets of weighted rollers and a spindle to simulate the action of the spinster's fingers. Powered by a water-wheel, it came to be called the water-frame, and it allowed an unskilled teenager to spin up to ninety-six threads at the same time. If one thread broke, she could leave the machine running while she mended that one.

Thus Arkwright turned spinning into child's play, and he hired children to do it. He advertised for weavers with large families, built houses for them, and employed the children in the mills. He built a village around a factory in order to keep whole families of workers close at hand. In the mills not only did the kids keep warm and dry – unlike those who had to work down the mines – but they also went to school on Sundays. In other words he was a caring employer by the standards of the day, creating jobs not only to serve the needs of the mill but also the needs of the family, and others noted what he had done by setting up similar schemes.

He took out his patent in 1769, and had to borrow money to build his first full-size factory at Cromford in Derbyshire in 1771. However, the water-frame cotton-spinner turned out to be a money-spinner too, as he licensed the use of his machinery throughout England and Wales, and when he died in 1792 Arkwright left not only several mills, a castle in Cromford and a smart town house in London, but also a fortune of half a million pounds. The Victorians saw him as the pioneer production engineer, the pioneer man-manager and paternalistic employer, and of course, the pioneer inventor. His water-frame and his revolutionising of the factory owner's role earned him the accolade 'Father of the Factory System'. Arguably this was the visible beginning of the Industrial Revolution.

ADAM HART-DAVIS

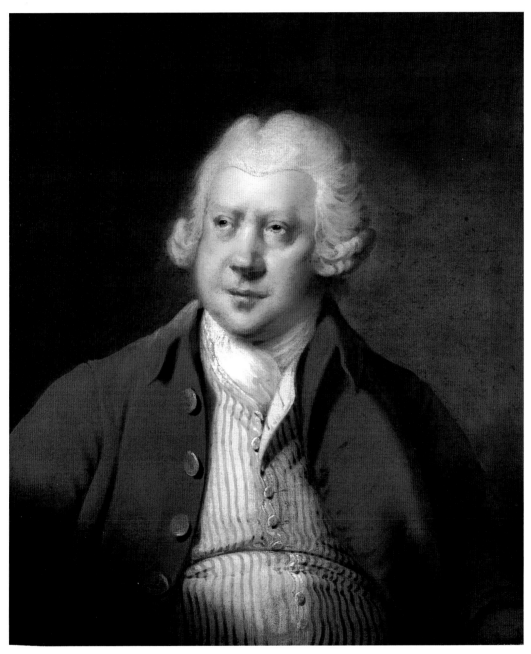

**SIR RICHARD ARKWRIGHT**
REPLICA BY JOSEPH WRIGHT OF DERBY, 1789

# Richard Arkwright

**S**OME HISTORIANS SEE ARKWRIGHT as the hero of the early Industrial Revolution, a bold man of vision. So why do I think him a villain? In the mid eighteenth-century Arkwright was emperor of the West Midlands. Born in Preston, he was a barber, a peruke-maker and innkeeper before experimenting with spinning machines. After establishing his patent in 1769, he built huge mills at Cromford and Matlock Dale in Derbyshire, growing enormously rich and licensing his power-driven water-frame and carding-machines to others. But Arkwright was a thief: he had pinched the key elements of the water-frame from the designs of others. He lost his patent in 1781, and although this decision was overturned four years later, in the meantime Lancashire cotton-spinners had spent vast sums on buildings and machines, employing around 30,000 men, women and children. They could not afford Arkwright's punitive rates and applied to have the decision annulled: when they won, a Manchester broadsheet crowed that 'the old Fox is at last caught by his over-grown beard in his own trap'.

We can see Arkwright's bullying power in Joseph Wright's brilliant portrait and in the description Thomas Carlyle drew from this: 'a plain, almost gross, bag-cheeked, pot-bellied man, with an air of painful reflection, yet almost copious free digestion'. He was ostentatious and boastful, jealous and secretive, and unlike other rags-to-riches tycoons like Josiah Wedgwood, he cared little for the conditions of his workers. At his death he was thought richer than a German prince – and in his lifetime one Birmingham manufacturer called him 'Tyrant & more absolute than a Bashaw'. His villainy lay not in his capitalism or entrepreneurship but in his arrogance, greed and inhumanity – he was the advance guard of the cruel side of industry, the people-grinding factories of the century to come.

JENNY UGLOW

# John Logie Baird

W E SCOTS HAVE ALWAYS SEEMED an inventive lot, whether in the arts or the sciences. But has any invention proved more durable and enthralling than television? The television screen is vaudeville theatre and lecture theatre combined. It's a place where we're entertained and educated. Television programmes can excite us, calm us, bewilder us, make us angry. There has never been a medium quite like it. It has helped shrink the world, so that we can explore from our sofa, and feel part of a global community of viewers. It can offer comfort to the lonely and laughter to the glum. Tyrants find their misdeeds broadcast to the world, while we all feel like participants in the televised moments of history. From moon landings to world cups, television has provided a host of memories which would have been unimaginable only a century ago.

I am a television junkie, and it pleases me more perhaps than it should that the man who has come to be known as the inventor of television was a fellow Scot. Of course, if John Logie Baird had known what heartbreak his invention would bring to the Scottish nation (all those woeful football internationals!) perhaps he would have thought twice about his experiments. I still remember the programmes of my childhood: *Andy Pandy*; *The Woodentops*; *Lost in Space* and *Dr Who*. Far from turning me into some passive vegetable, television stoked my imagination. I wanted to create 'strange new worlds' of my own. I would tear most of one side from a cardboard box, slip it over my head and become a performer, with my patient parents as viewers, turning an imaginary knob when they wanted a fresh channel. Later, I remember balancing an indoor aerial on top of a pelmet so we could pick up the first snowy transmissions of BBC2: *Call My Bluff* and *The High Chaparral*. I was a teenager when Channel 4 arrived and a parent at the inception of Channel 5. Television has framed my life thus far. Hopefully I won't be reaching for the 'off' button for a while yet.

IAN RANKIN

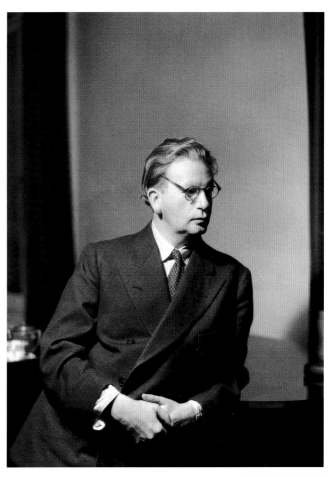

**JOHN LOGIE BAIRD**
HOWARD COSTER, 1935

# John Logie Baird

**AT FIRST, JOHN LOGIE BAIRD** might seem a hero. His early inventions – as a young man, he patented a new sock and made strides in the fields of soap and jam – never really took off, and his health was always poor. But he persisted, and in an attic room in Hastings, employing a washstand as his work-bench and a biscuit-tin as his projector with four-penny bicycle lamp glasses for lenses, the whole thing held together by string and blobs of sealing wax, he somehow managed to create the world's first television.

Just as Alexander Graham Bell cannot be held responsible for every wrong number, so poor Logie Baird, slogging away in his attic, cannot be expected to shoulder all the blame for *I'm a Celebrity – Get Me Out of Here!* When the first fuzzy picture of a Maltese cross appeared through the fog on his ramshackle set, he had every reason to believe that this was the start of something new and wonderful, an invention that would enrich future generations the world over. Little did he know we would end up with *Kilroy*, *EastEnders*, *Blind Date* and *Through the Keyhole*.

In the 1960s, it was thought television might save the world from wars by making their awfulness visible in every sitting-room. But wars have not stopped: they have simply grown more discreet. The same idealists thought that television might become the first genuinely democratic medium. How Mr Murdoch must be laughing! One of the least-mentioned properties of television is its eerie ability to bypass the human memory; how many quiz-shows I must have watched over the years, how many shoot-outs and cook-ins, how many heated late-night discussions, how many celebrities revealing their true selves – yet I find it hard to recall a single one of them. Watching television is a way of being asleep with your eyes open. If only John Logie Baird's string had snapped at just the right moment, sending his washstand and his biscuit-tin and his four-penny bicycle lamp crashing to the floor, how much more wide awake the human race would be!

CRAIG BROWN

# The Beatles

**CAN UNDERSTAND** sour pusses who say that John Lennon's bed-ins were silly, or that George's Indian mysticism was naive; that Ringo was a poor drummer and Paul could be schmaltzy; Apple was a nonsense and all that Sixties fascination with their long hair, cute clothes, Liverpool lingo and so-called jokes was pathetic. Go on. Say it. Won't upset me. It was all said at the time.

One of the new things they say now is that the Beatles brought about the collapse of the Soviet Union. That is pushing it a bit. This outlandish view is based on the theory that young Russians preferred Lennon to Lenin, realised that all Western culture was not decadent and so grew cynical about Communism. If you dismiss this as bollocks, I don't honestly mind. There have been many social, cultural and economic arguments in favour of the Beatles and against them, but I can't believe that anyone can truly, honestly dismiss the music.

At the time, even though I loved them dearly and waited with such excitement for each new album, knowing that it would not be the same as the last one, but pushing on in a different direction with new ideas, rhythms, instruments and influences, I did not expect them to last this long. I presumed and hoped that another group would come along, just as creative, just as original. In retrospect, some performers, such as Michael Jackson, have sold more records, for a time. Some artists made more money, for a while. But no singer or group has taken the place of the Beatles. Or even equalled them.

The strange thing about the Beatles is that the further we get from them, the bigger they become. In any survey of fans or musicians, all round the world, they are always way ahead as the most influential group of all time. Even the cover of *Sergeant Pepper's Lonely Hearts Club Band*, now thirty-six years old, gets voted the 'best ever'.

They gave us a hundred classic songs which will be hummed around the planet as long as humanity has breath left for humming. My heroes, for all time.

HUNTER DAVIES

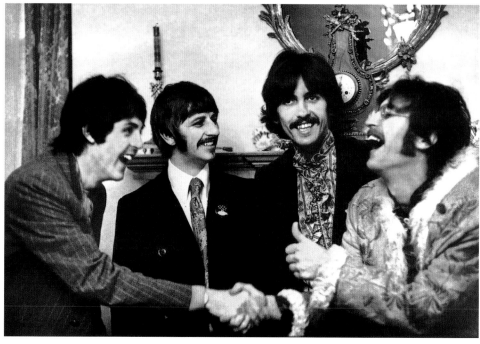

**THE BEATLES**
LINDA McCARTNEY, 1967

# The Beatles

'YELLOW SUBMARINE', 'Octopus's Garden', 'When I'm 64', 'Maxwell's Silver Hammer' – that lamentable litany of crimes against popular song would surely be enough to cast their perpetrators in a villainous light, but the charge sheet against the Beatles runs far deeper than a host of truly irritating ditties.

The real case against the most over-rated band of all time is not just that they had numerous appalling lapses in taste, but that they took something raw and pure and dirty and contrived to make it horribly clever. American Rock 'n' Roll and Rhythm and Blues were the inspiration for all the British beat bands of the early Sixties, but it was the Beatles who led this music away from its roots towards something altogether more composed and contrived. Teaming up with a nice middle-class producer of comedy records, they stripped away all the passion and the ache of this visceral black music, to replace it with the *faux* profundity of tricksy arrangements and studio effects, brass bands and sitars, nonsense lyrics and hidden messages. They made the blues whiter than white.

Their journey from bouncy Liverpudlian mop-tops to pseudo-spiritual masters of rampant pretension didn't take them deeper and further, except into their own inflated egos. The Beatles' masterwork is not *A Love Supreme*, *Beggar's Banquet* or *What's Going On*, but *Sergeant Pepper's Lonely Hearts Club Band*, a trite voyage of soulless musical tourism, buoyed up only by the hot air of its own vainglorious silliness. This is music that you can't dance to or make love to, instead you're supposed to sit back, grow a beard and marvel at its cleverness, think about it instead of feeling it. Because of the Beatles we ended up with a whole generation listening to triple concept albums of muso-doodlings while smoking dope, wearing kaftans and believing that they could change the world by sitting in a bed.

ROBERT ELMS

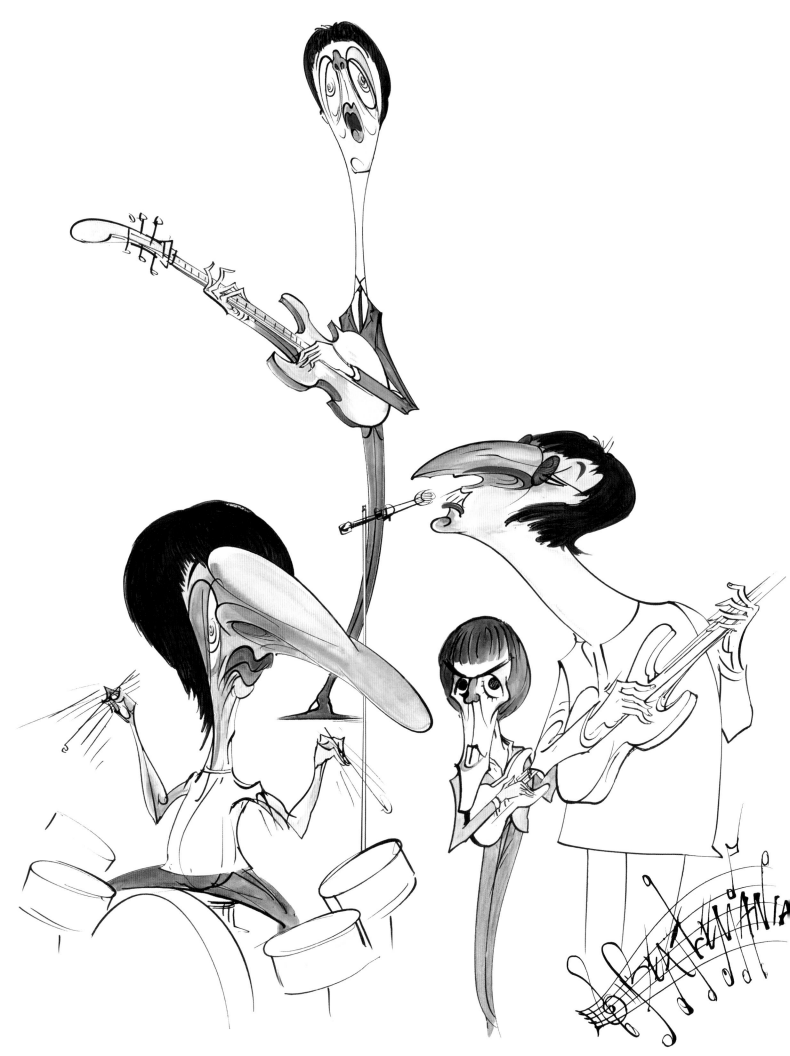

# David and Victoria Beckham

THE FACT THAT SOMEONE LIKE ME has to actually sit down to explain to someone like you why the Beckhams are possibly the most exciting couple in the world, is I'm afraid a sad, but unsurprising, indictment of how much intellectual, shabby snobbery still clings like verdigris to the vestiges of the outside lavatory that is the Establishment. Look, I'm assuming you think they are ghastly, as common as plastic corks, as embarrassing as a follow-through in a Jacuzzi, so let's get this in perspective: Posh and Becks are the most fabulous couple because (with the exception of you and couple of dozen tedious, cynically embalmed, whinging sad gits) everyone says they are. Now, it is perfectly fair to point out that majorities aren't necessarily always right but, then again, they are wrong far less often than you'd like to suppose with your tiptoe taste and allergy to bad grammar. It's not just our masses that say so: it's the world's masses that see something aspirational and enchanting in the Beckhams.

We've spent a hundred years trying to democratise, egalitise, enfranchise, outreach, encompass and engage the culture – to give it a critical mass. The Beckhams are what the mass chooses to pin up. Look, let me put it another way, you know all those late-Victorian and Edwardian schoolboy heroes, all those beautifully softly spoken Adonises who played up and played the game, don't you see that they're Beckham, shorn of the embarrassing purple prose and the patronage of Empire? And Victoria has simply stepped ready formed and complete from the pages of Jane Austen, again without all that tedious inner dialogue. Posh and Becks are the corporeal evocation of the golden age of English literature. I'm sorry it's embarrassing to have to explain them to you in these dead terms, but as I said, frankly everyone else in the world just got it immediately.

A.A. GILL

# David and Victoria Beckham

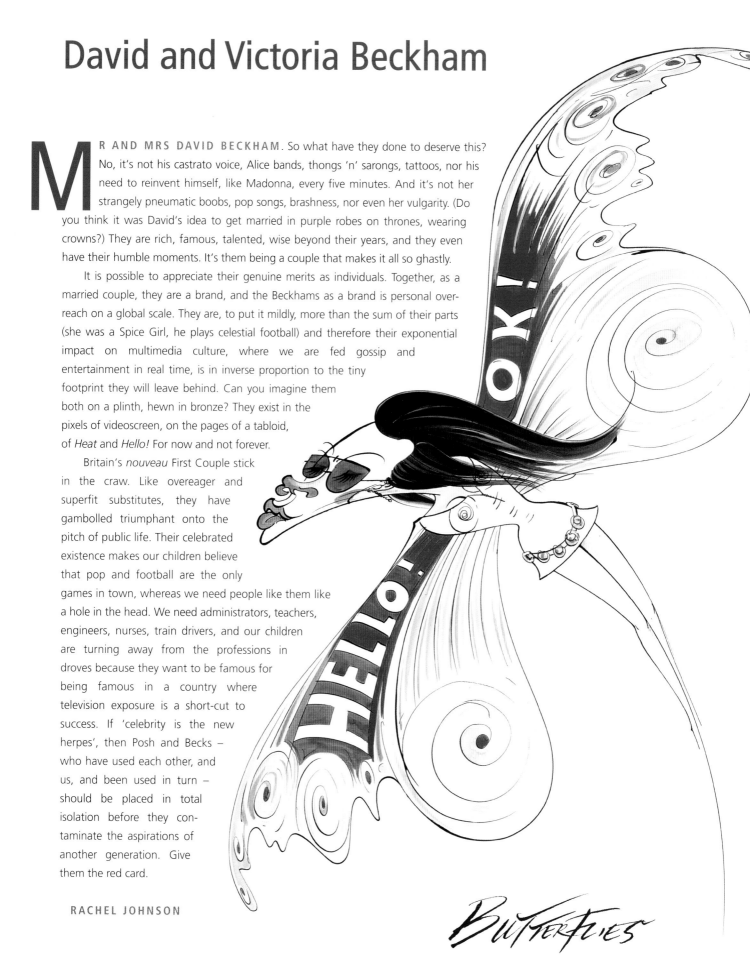

**M**R AND MRS DAVID BECKHAM. So what have they done to deserve this? No, it's not his castrato voice, Alice bands, thongs 'n' sarongs, tattoos, nor his need to reinvent himself, like Madonna, every five minutes. And it's not her strangely pneumatic boobs, pop songs, brashness, nor even her vulgarity. (Do you think it was David's idea to get married in purple robes on thrones, wearing crowns?) They are rich, famous, talented, wise beyond their years, and they even have their humble moments. It's them being a couple that makes it all so ghastly.

It is possible to appreciate their genuine merits as individuals. Together, as a married couple, they are a brand, and the Beckhams as a brand is personal over-reach on a global scale. They are, to put it mildly, more than the sum of their parts (she was a Spice Girl, he plays celestial football) and therefore their exponential impact on multimedia culture, where we are fed gossip and entertainment in real time, is in inverse proportion to the tiny footprint they will leave behind. Can you imagine them both on a plinth, hewn in bronze? They exist in the pixels of videoscreen, on the pages of a tabloid, of *Heat* and *Hello!* For now and not forever.

Britain's *nouveau* First Couple stick in the craw. Like overeager and superfit substitutes, they have gambolled triumphant onto the pitch of public life. Their celebrated existence makes our children believe that pop and football are the only games in town, whereas we need people like them like a hole in the head. We need administrators, teachers, engineers, nurses, train drivers, and our children are turning away from the professions in droves because they want to be famous for being famous in a country where television exposure is a short-cut to success. If 'celebrity is the new herpes', then Posh and Becks – who have used each other, and us, and been used in turn – should be placed in total isolation before they con- taminate the aspirations of another generation. Give them the red card.

RACHEL JOHNSON

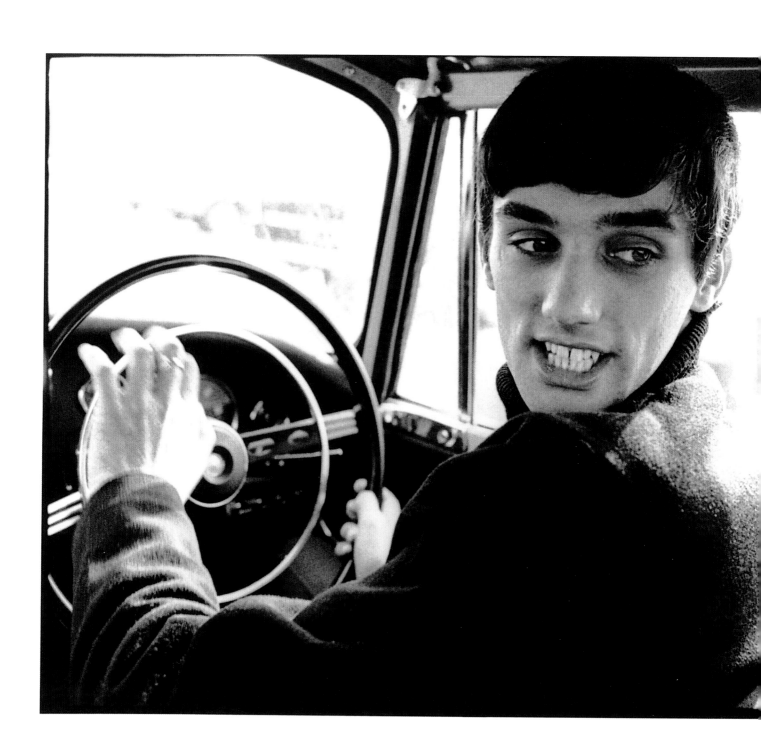

# George Best

**GEORGE BEST**
NEIL LIBBERT, 1965

**Y**OU DIDN'T HAVE TO KNOW anything about football to fall for George Best. One moment footballers were cheerful comb-overs in long shorts, the next second blam!, there was Georgie with everything possible going for him – masses of black hair, Irishness, gappy front teeth, dimple in his chin and the speed of Spiderman on illegal substances.

Georgie, we loved you!, and although we didn't have a television in our shared girls' flat in Earl's Court, we had newspapers and magazines where, lo and behold, you had morphed into the Fifth Beatle, along with El Cordobes, George Martin and anyone else who had hair and talent at the same time. Carnaby Street called you, George, and extravagantly styled coats and shirts with collars big enough to clean your shoes were worn by you, and you looked fab in them even if others didn't. You always looked shy, George, and always seemed polite and charming to interviewers (like Elvis, who called reporters 'Sir').

I went to a night club and you were there, grooving along in an extremely funky way with a beautiful actress who, alas, was not me. But I have met you, George, when the rhinoceros of life had stampeded comprehensively across those dreamy days, leaving hope and promise squashed in the mud like a fag packet behind the goalposts. I met you in Manchester, when we were both attending a charity gig, and there, in a crowded lift, I stood near to you, Georgie, and we greeted each other by name, and I noticed afterwards that it was like being near Muhammed Ali (whom once I kissed, and he kissed me back): for a moment, time was bent out of true and the colossal stillness of a living legend stopped the clocks and your green-eyed grin went on and on until you got out on the fourth floor. We've always loved you, Georgie Best, and always will, you and your prophetic name.

JOANNA LUMLEY

# George Best

**T**HE VILLAIN IS THE DRUNK, bankrupt, brawling, delinquent disgrace, the evil genie who inhabited a dark corner of the psyche of the golden boy from Belfast; the villain effectively forced him, at the age of twenty-six, out of the game he graced so memorably. In 290 games for Manchester United he scored 115 goals, six in one game, and then he was gone in scandal and jail, betraying his team and his fans, but most of all betraying himself.

I grew up in Manchester United territory, but I was brought up on the legend of Stoke's Stanley Matthews, the gentlemanly 'wizard of dribble' who played his final professional game at the age of fifty, with never a single booking in thirty-three years on the field. Best had everything that Matthews had in ball control. He could shoot and pass, long and short, and do it with both left and right foot, thereby escaping my father's contempt for the modern one-footed footballers. He had the sinews of a showman. There was a beguiling Irish wit in the way he would show the ball to the burly defender, and then vanish, swerving round him for a curling shot at goal. George Best in acceleration froze time for everyone except himself. What joy we would have had if a fraction of this legerdemain in ball control could have been applied to self-control. But no doubt that is a selfish regret. His friend Michael Parkinson made the point well: 'The only tragedy George Best has to confront is that he will never know how good he could have been.'

HAROLD EVANS

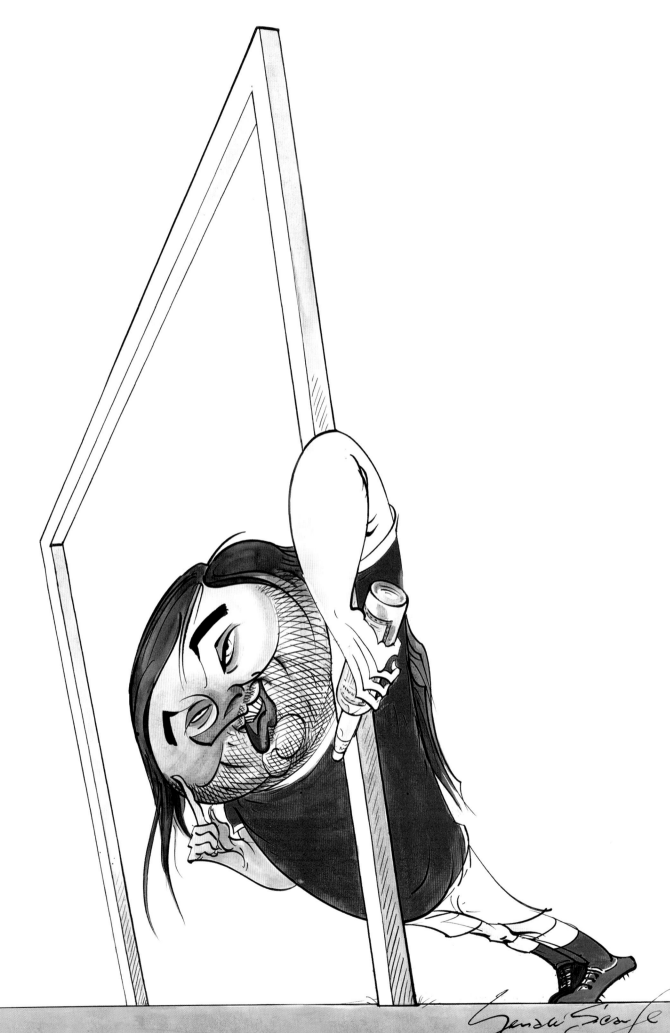

# William Blake

**F**ROM THE EARLIEST CHILDHOOD visions – of God, an old man with long white hair poking his head through the bedroom window, of a tree filled with sparkling angels on Peckham Rye – William Blake's life was a clash of spirituality and druidic allegory with the filthy, violent streets of his contemporary London.

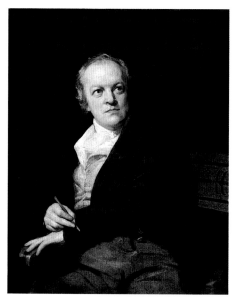

**WILLIAM BLAKE**
THOMAS PHILLIPS, 1807

Seeing himself as poet, prophet and revolutionary artist, Blake assimilated Old Testament imagery and ancient mythology to reinvent himself as an unfashionable, latter-day Ezekiel or Isaiah: 'What is the price of Experience do men buy it for a song / Or Wisdom for a dance in the street,' he asked. His rages against 'mind forg'd manacles' and the 'Net of Religion' fell largely on deaf ears; his profound belief in sexual energy, its misuse leading to darkness and savagery, drew indifference but impressively predated Freud.

Always in his time, a canny eye for commerce drew him to engraving as a trade, and he invented new techniques to realise the magnificent illuminated books. However, his self-education seemed to reject current artistic movements and looked to the past, to Spenser and Shakespeare, ancient folklore, Dürer and Raphael. His landscape is vast, apocalyptic, frightening, coded, peopled with demented, tragic figures. There is also a tender, pure side to Blake with his beloved wife Catherine. His visions of Michelangelo and the Angel Gabriel never ceased. I envy his ability to see through the everyday into another world; his courage to be passionately direct and angry; his calm welcoming of death which he described as simply the movement from one room to another.

JOANNA MACGREGOR

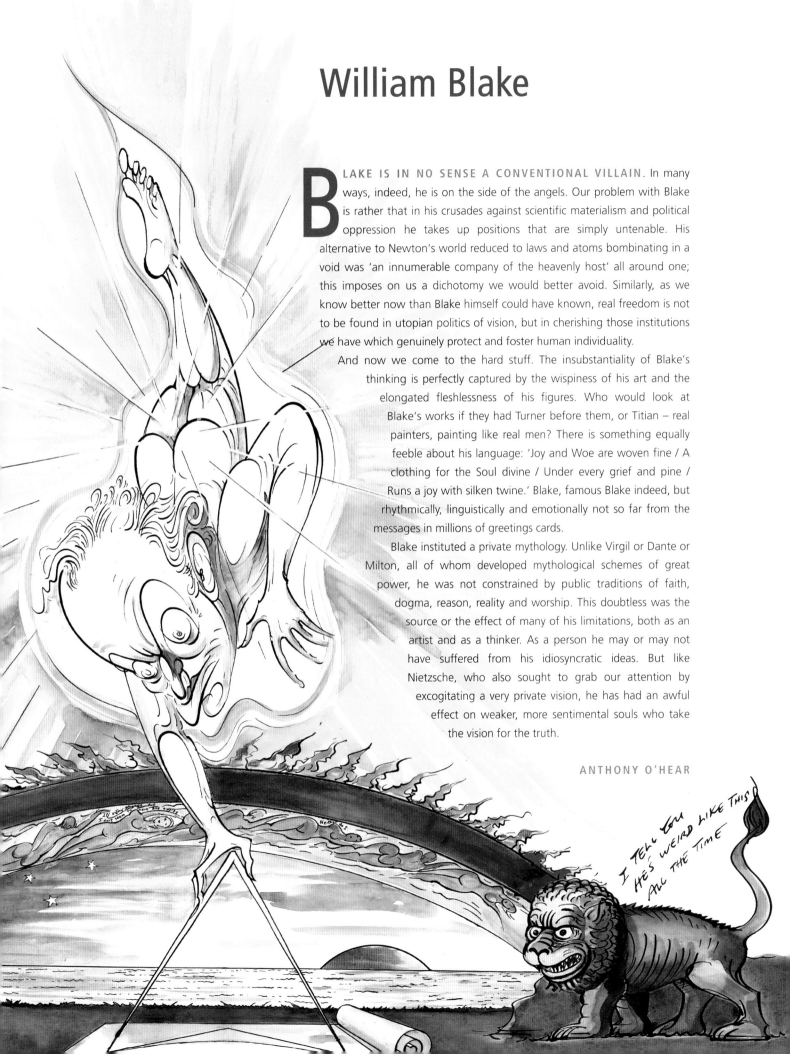

# William Blake

**B**LAKE IS IN NO SENSE A CONVENTIONAL VILLAIN. In many ways, indeed, he is on the side of the angels. Our problem with Blake is rather that in his crusades against scientific materialism and political oppression he takes up positions that are simply untenable. His alternative to Newton's world reduced to laws and atoms bombinating in a void was 'an innumerable company of the heavenly host' all around one; this imposes on us a dichotomy we would better avoid. Similarly, as we know better now than Blake himself could have known, real freedom is not to be found in utopian politics of vision, but in cherishing those institutions we have which genuinely protect and foster human individuality.

And now we come to the hard stuff. The insubstantiality of Blake's thinking is perfectly captured by the wispiness of his art and the elongated fleshlessness of his figures. Who would look at Blake's works if they had Turner before them, or Titian – real painters, painting like real men? There is something equally feeble about his language: 'Joy and Woe are woven fine / A clothing for the Soul divine / Under every grief and pine / Runs a joy with silken twine.' Blake, famous Blake indeed, but rhythmically, linguistically and emotionally not so far from the messages in millions of greetings cards.

Blake instituted a private mythology. Unlike Virgil or Dante or Milton, all of whom developed mythological schemes of great power, he was not constrained by public traditions of faith, dogma, reason, reality and worship. This doubtless was the source or the effect of many of his limitations, both as an artist and as a thinker. As a person he may or may not have suffered from his idiosyncratic ideas. But like Nietzsche, who also sought to grab our attention by excogitating a very private vision, he has had an awful effect on weaker, more sentimental souls who take the vision for the truth.

ANTHONY O'HEAR

I TELL YOU HE'S WEIRD LIKE THIS ALL THE TIME

**SIR RICHARD BRANSON**
DAVID MACH, 1999

# Richard Branson

**V**IRGIN IS NOW AN OXYMORON. This boy Branson would have had trouble with such a tricky word when he was at Stowe. He was dyslexic, must still be. I use it to remind us how he licked a handicap; my second daughter is dyslexic so I know how hard it must have been in the Fifties and Sixties when the word had barely reached the dictionary. Typically, Branson took his enemy head on: words were the basis of his first enterprise, a student newspaper, before the famous chrysalis of the telephone booth that metamorphosed into a major mail-order record business.

Oxymoron is not just a tease. It perfectly expresses the fact that most of his Virgin enterprises are no longer making their debuts yet they have the effervescence of youth. They seem fixed features in our permanent landscape in air travel, music, phones, trains, drinks, bikes, cosmetics, hire-cars, weddings, safari parks, and heaven knows what else in hundreds of Virgin companies, but somehow they have a first-time freshness. They seem infused with Branson's instinct for enjoyment. Of course, his adventures in ballooning and in the buff, zipping across the Atlantic and blacking-up as a Zulu, are also publicity stunts, but they do all capture his trademark impudence. It is amazing that he has managed to imprint the impudent brand name on such a diversity of products and services. Nothing quite matches it in the legends of American innovation.

Of course, there are hiccups in the Virgin story – whoever thought we would yearn for British Rail? – but somehow you know that this irrepressible fellow takes any failure personally, that he is caring as well as carefree. The world would be a lot less fun without him – as he would be the first to agree.

HAROLD EVANS

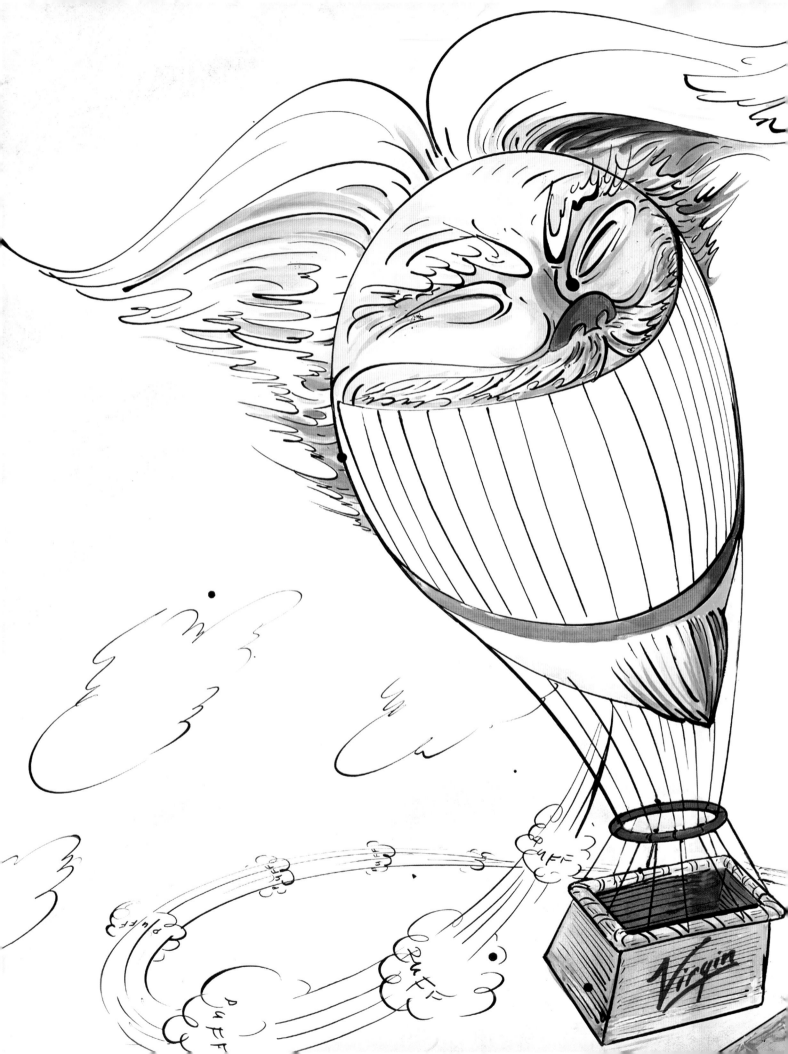

# Richard Branson

**S**IR RICHARD BRANSON IS BRITAIN'S best-known businessman. But Branson comes from an old tradition. Sheridan's Mr Puff defined the techniques of personal salesmanship that are still effective today – the puff preliminary, the puff collateral, the puff collusive and the puff oblique. In the nineteenth century, the Scottish grocer Thomas Lipton used this method to sell products – pigs bearing his name ran through the streets, a cheese elephant was solemnly shipped from the United States and Lipton even used balloons to advertise his wares. But Branson has taken self-publicity as all, famous for being famous.

Still, behind Branson's stunts are real business achievements. His career was founded on a successful music business, for which he realised a substantial sum, and his airline added some idiosyncratic fun to a stuffy industry. But other ventures have not made a similar impact, and the obscure financial structure of the Virgin group has always made it difficult to tell what is making money and what isn't. The myth of a magic Virgin brand that can add value to anything from cola to financial services is indeed a myth, and the best thing about Virgin Bride is the name. And those trains!

Still, we should not confuse this showmanship with the serious business of building and managing large organisations. The great businessmen of the twentieth century were not high-profile public figures. Men like Sloan and McGowan, who created General Motors, or Harry McGowan, who built ICI. They were people like Alfred Sloan, who invented the systems of modern professional management and others stood on their shoulders to build still more powerful companies. Some business leaders, like Simon Marks, were individually inspiring people; their dedication to customer service and employee welfare defined values which were sustained for decades after their death. Greatness in business is attained by those who found organisations that transcend not only their personality, but any personality.

*JOHN KAY*

*Hot Air Balloon*

# Agatha Christie

IT HAS BECOME FASHIONABLE to decry Agatha Christie as a novelist, and certainly one wouldn't include her writing in the canon of English literature. She is read for other satisfactions. For fifty-six years she produced detective stories of astonishing ingenuity, creating in Hercule Poirot and Miss Marple two fictional amateur sleuths who have become part of the mythology of mystery writing. In a turbulent century she has provided entertainment and relief to millions of readers and is outsold only by the Bible and Shakespeare. This is no mean achievement.

Born in Torquay in 1890, she was inevitably a woman of her time and her stories, despite the obligatory corpse, eschew violence and horror and provide a reassuring and nostalgic escape into a more peaceful and ordered world, insulated from the disagreeable complications of modern life. She was a shy and private woman with a great dislike of publicity. This intensified after her dramatic and much-publicised disappearance in 1926 following the failure of her marriage to Archibald Christie. Recovering her confidence both as a woman and as a writer, she subsequently married the archaeologist Max Mallowan and took an active interest in his work. But she remains elusive, a woman who is almost as mysterious as her plots.

These largely depended on her meticulous eye for detail and the element of surprise. She is a literary conjurer who places her cards face downwards, shuffles them with cunning fingers and invites us time and again to turn up the wrong image. It is highly doubtful whether any of her methods of murder could succeed in real life. But although the plots may be incredible, readers happily suspend disbelief since this is Christieland and millions throughout the world still enter it in happy anticipation of being diverted, baffled and entertained.

P.D. JAMES

DAME AGATHA CHRISTIE
ANGUS MCBEAN, 1949

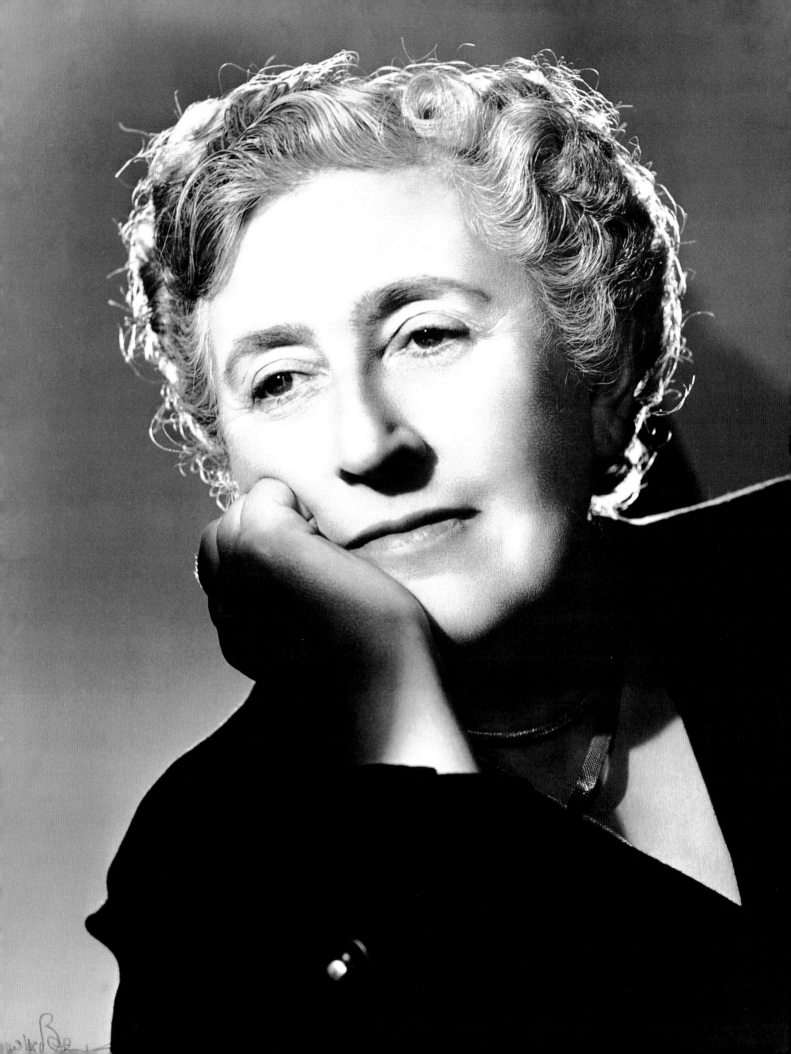

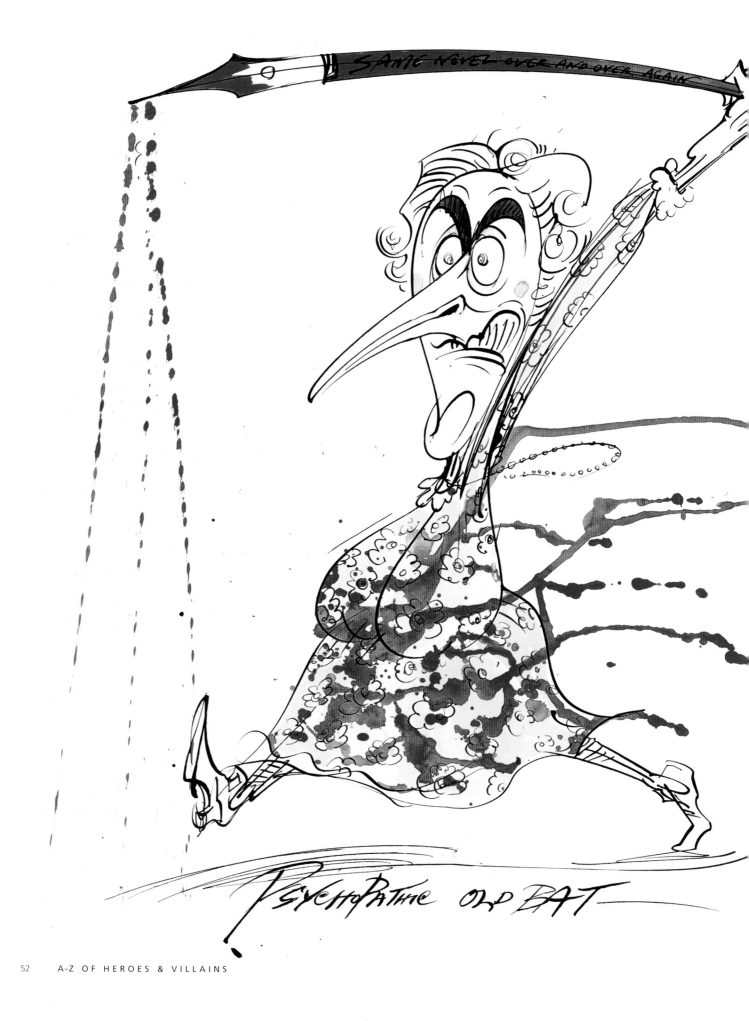

SAME NOVEL OVER AND OVER AGAIN

PSYCHOPATHIC OLD BAT

# Agatha Christie

**W**HEN I WAS ELEVEN or twelve, I was a voracious reader and my sister was going through a mania for Agatha Christie. I tried a few of the books but couldn't get on with them. Smug Belgians and harum-scarum old ladies solving crimes in genteel locations – it was a world I couldn't relate to, sitting in my council house in a 1970s Scottish mining town. Christie put me off reading crime fiction altogether for far too long. What's more, I think she had a pernicious effect on the British crime novel, as many practitioners felt they had to write about stately homes, amateur detectives, and obscure poisons and potions. The police detective, meantime, was portrayed as a bumbling oik, unable to comprehend that he was in the presence of a more intelligent and refined sleuth. Christie and her followers wrote about a pastoral, mythical England where cricket was played on the village green, the crimes were relatively bloodless (those potions again) and justice prevailed. It took the advent of television to portray the working copper as an 'ordinary hero' – think of *Gideon* and *Z Cars*. Suddenly crime was urban (as had been the case in real life for over a century), and justice sometimes could be seen to fail.

I'm jealous of Christie, too, of course. She had the playing field pretty much to herself for a long time and could utilise every trick in the book: they all did it, the narrator did it, nobody did it. By the 1940s, some critics were tolling the death of the whodunnit, so efficiently had Dame Agatha covered that field. Yet the crime novel has proved its resilience, changing with the times, challenging its readers with themes and story-lines that speak of the here and now, a Britain far removed from Christie's.

She still sells in her thousands and there are still plenty of readers around the world for whom she *is* the British Crime Novel, many of them loath to part with the certitudes with which she presented them. It has taken some considerable time for British crime writers to crawl out from beneath Christie's shadow.

IAN RANKIN

# Winston Churchill

**M**Y HERO IS WINSTON CHURCHILL because without him I would not be alive to have a hero.

Churchill was far from flawless: to my mind he was wrong about India and wrong about the abdication of Edward VIII, and was a truly terrible Home Secretary. His flaws, however, are almost totally insignificant beside one huge undeniable virtue; he saved democracy. When Hitler took power the Americans were isolationists, the French were collaborationists, the Italians were fascists, and most ministers in the then-Tory government – and most especially, Prime Minister Neville Chamberlain – were appeasers. Excluded from that government, Churchill spent the latter part of the 1930s warning against the Nazis (whose party name he pronounced with disgusted contempt). He was a voice in the wilderness, but at that time the wilderness was the best place to be.

When Chamberlain's government failed in 1940, he was there ready to take over. His failure even to admit the possibility of defeat – which other Tory politicians would have liked to ward off by making a deal with Hitler even after war broke out in 1939 – rallied the nation. The Soviets and Americans, when they reluctantly and belatedly came into the war, built their resistance around their own huge forces, but without Churchill's England holding out after the Battle of Britain, would never have got together. He was one of the three greatest men of the twentieth century, the other two being Mikhail Gorbachev (for ending the Cold War) and Nelson Mandela (for being himself).

Why would I not be here without Churchill? Because I was a Jewish child when he became Prime Minister and, if he had not held out against the Nazis, I would have ended up in an oven.

GERALD KAUFMAN

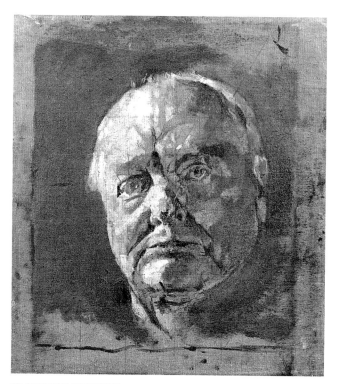

**SIR WINSTON CHURCHILL**
GRAHAM SUTHERLAND, 1954

# Winston Churchill

**P**ART OF ME ADMIRES Winston Churchill this side of idolatry. I was a boy in the Second World War when it seemed he saved our lives. He inspired us (when defeat seemed inevitable) to incredible heroism. Yet it was a courage that always had the requisite English touch of deprecation. Our leader was a wily politician, ever able to believe the worst of his fellow politicians, so he always watched his back. We should be grateful that he never believed a word Stalin said; otherwise the Cold War could well have been much frostier.

No, I admire him. But I don't admire his prose style. In his interminable books he disturbs me as profoundly as that other great maker of purple artificial prose, T.E. Lawrence. Both men have an assumed voice, a magisterial sounding-off. In Churchill's case it owes everything to Gibbon and his *Decline and Fall*. I was educated by F.R. Leavis to believe that not only is the style the man, but if the style is suspect, then so too is the man. Churchill's style is just bearable when heard – as oratory it works histrionically. But it is unendurable when read. It almost makes me doubt the man. But then I remember my dismay when my grandfather, my father and three uncles refused to be impressed even at the end of one of his great radio orations. 'He's never done anything for the working man,' they said. 'Nor will he.'

**PETER HALL**

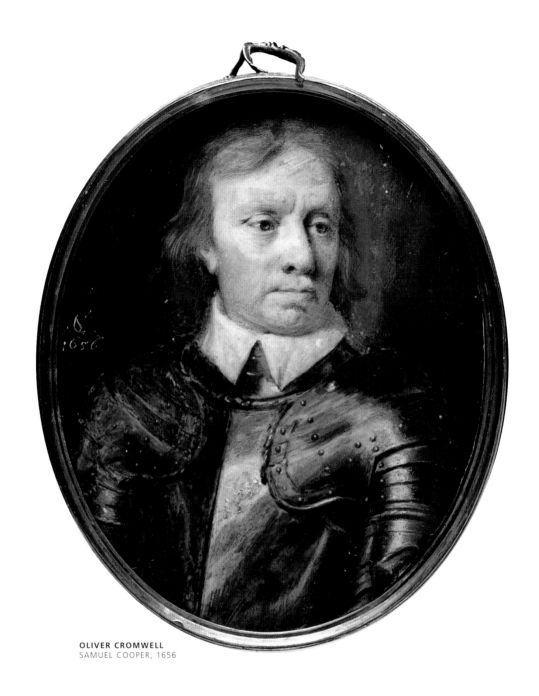

**OLIVER CROMWELL**
SAMUEL COOPER, 1656

# Oliver Cromwell

W E BEGIN WITH THE WARTS. The famous instruction to Sir Peter Lely that he be painted 'warts and all' is a heroic gesture signalling how Cromwell wanted to be treated, and how the whole business of portraiture in paint, pen or pencil should be approached.

The warts are ugly, but the insistence that they not be left out is above admiration. It does not mean Cromwell intended his less visible characteristics to be painted. He was

honest, within a politician's limits, and in an unknown world where he had to make his politics with very little precedent, he was a shrewd politician.

He was courageous, but not suicidal, as the wart-call says. Sometimes he had to give warts the wrong labels, as when his failure to control his army in Wexford caused a massacre of the garrison for which he then took responsibility; he called himself ruthless so that he would not be labelled ineffectual.

He killed Charles I, probably the best and certainly the noblest man to sit on the English throne since Edward the Confessor. It was probably unwise; it was not vindictive; it was to kill kingship rather than the King. They were very like each other – good husbands, loving fathers, warm-hearted friends and aesthetic leaders. Both had cheery manners, kindly dignity, genuine piety and personal courage. Both were devious, partly in response to the intransigence of their most vehement supporters. They were bigoted about each other's religious beliefs.

When Charles died in the best performance a king ever staged, he had the comfort of knowing his role. Cromwell, on the other hand, had to live, unprecedented, encircled, isolated. The lonely bravery of his letters, the hunger of their affection for God – not simply reverence – makes the wart-man a creature of beauty.

OWEN DUDLEY EDWARDS

# Oliver Cromwell

ROMWELL IS AN OBJECT LESSON for those who doubt the ability of power, even more the love of power, to corrupt. The causes of moderation, tolerance, probity and justice, which he had upheld in his early conflicts with Charles I, became poisoned by his military success. Cromwell's New Model Army was generations ahead of its time and he contributed much to that peculiarly Anglo-Saxon concept that the State – even the monarch – is subject to the law, before arrogance and dogmatism consumed him. Having led parliament in its struggle with the monarch, Cromwell went on to declare himself king in all but name, even nominating his son to succeed him. Perhaps the show trial of Charles I was almost inevitable, but it was a mockery of the rule of law – no more than a kangaroo court.

Cromwell purged parliament of his critics, then ruled by decree, ignoring parliament altogether. While proclaiming religious tolerance, even of Mohammedanism, he forbade Catholics and Anglicans the right to worship, persecuting their priests to the point of execution. Before long Magna Carta was ignored, crony judges appointed, critics deprived of their votes and the country carved into twelve districts controlled by major generals. At the height of Cromwell's dictatorship, British subjects were transported as slaves to Barbados.

All that has been washed away by time – but 350 years later this kingdom still pays a terrible price for Cromwell's worst excess – his bloody massacres in Ireland, which left a legacy of bitterness and division.

NORMAN TEBBIT

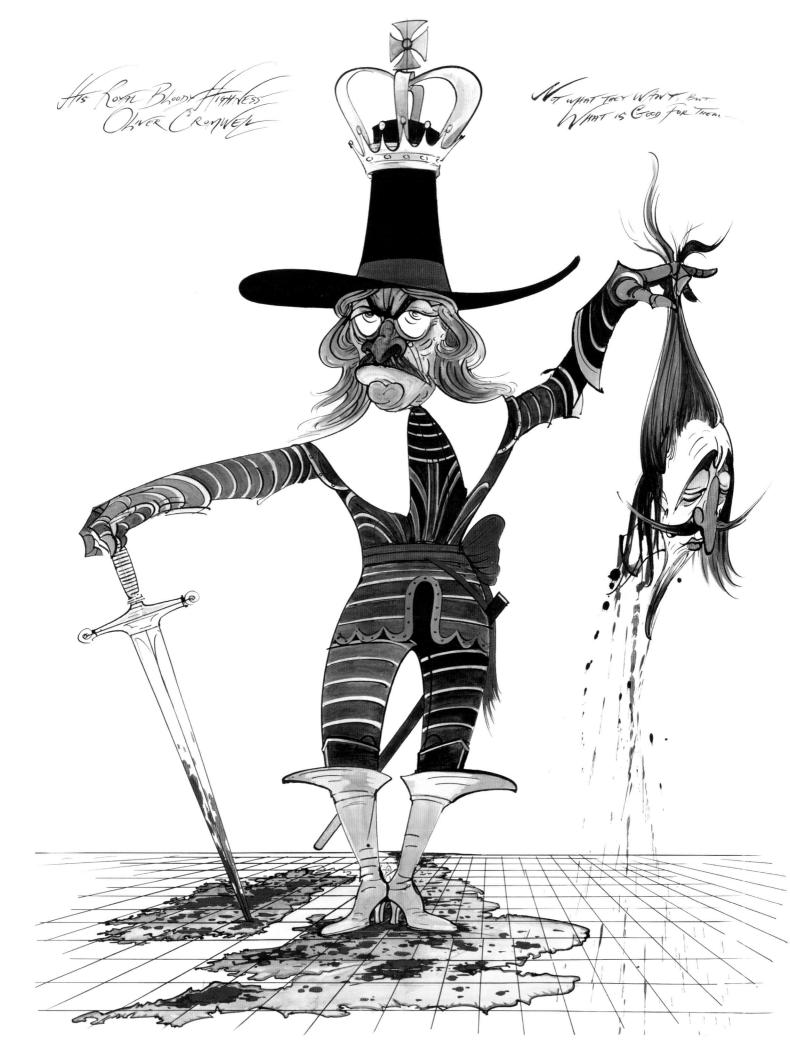

His Royal Bloody Highness Oliver Cromwell

Not what they want, but what is good for them.

# Charles Darwin

ONCE SUGGESTED THAT IF creatures from outer space ever visit us and want to assess our level of civilisation, the first question they will ask is whether we have discovered evolution yet. However alien and outlandish the visitors may seem to us, they will revere their own Charles Darwin as we should revere ours. The distinguished American philosopher Daniel Dennett is in no doubt: 'Let me lay my cards on the table. If I were to give an award for the single best idea anyone has ever had, I'd give it to Darwin, ahead of Newton and Einstein and everyone else.'

Incidentally, Darwin was also a nice man (unlike Newton), and a good husband and father (unlike Einstein). But was Dennett being too bold in ranking him ahead of those intellectual titans for his single best idea?

Suppose we measure the power of an idea as a ratio: the amount that it explains divided by the amount that it needs to assume in order to do the explaining. Darwin's idea, natural selection, explains at a stroke the entire existence of life; its complexity, beauty and overwhelming illusion of design. But the mechanism Darwin needed to postulate is almost ludicrously simple – the non-random survival of randomly varying hereditary elements. Indeed, the idea is so simple (the denominator of our ratio so small) that one is tempted to exclaim, as Huxley almost said: 'But any fool could have thought of that.' Except that nobody did until Darwin. Alfred Wallace independently tumbled to the denominator, natural selection. But only Darwin linked it clearly to the numerator – all the dazzling complexity, elegance and diversity of life – and consummated the ratio. Darwin is a hero, not just for his own time and ours, but for geological time and very probably astronomical space as well.

RICHARD DAWKINS

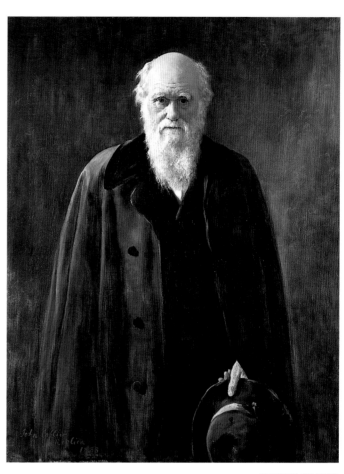

**CHARLES DARWIN**
COPY BY JOHN COLLIER, 1883

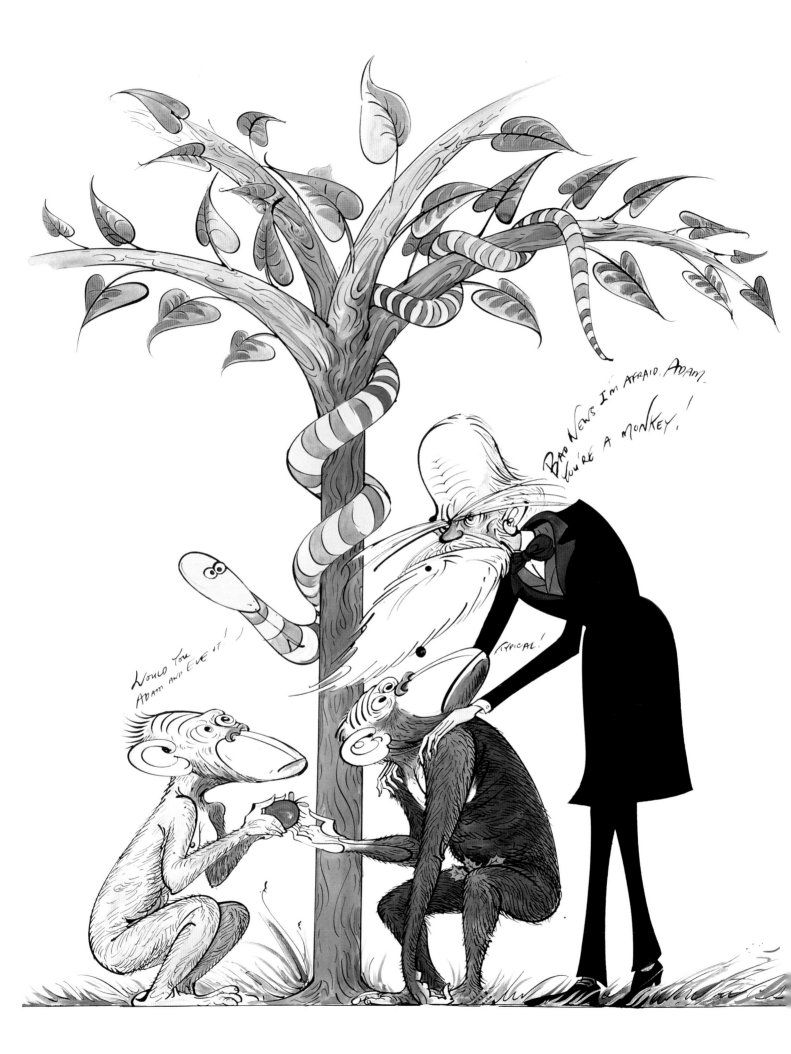

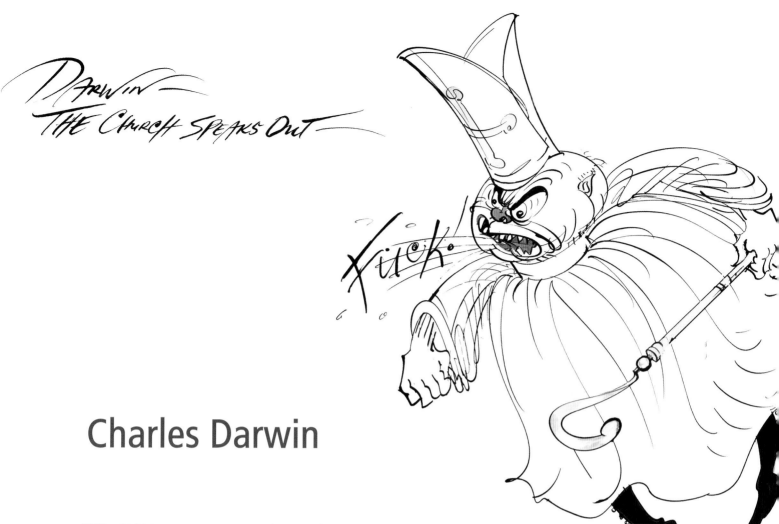

# Charles Darwin

**P**EOPLE HATE DARWIN because he taught us that the world is a meaningless slaughterhouse and that we are trapped within it. For centuries, clergymen had told us that the natural world displays the power, wisdom and benevolence of God. They saw a harmonious plan of creation in which species form neatly defined units, with each species designed as a masterpiece of engineering efficiency. Darwin realised that the pressure of population generates a relentless struggle for existence, reducing nature (in Samuel Butler's words) to 'a nightmare of waste and death'. He then proposed that this orgy of selfishness and suffering drives the motor of creation through the survival of the fittest. The plan of creation evaporates and living things become the cobbled-together products of trial and error.

To make it worse, Darwin then forced us to confront the possibility that we ourselves are products of this haphazard interaction of chance and death. We are reduced to the level of superior apes, fumbling with sticks and stones, grunting to each other in a vain attempt to communicate. By undermining belief in a soul that can be damned to eternity, Darwin encouraged us to behave like the animals he had portrayed in so dismal a fashion. Life was reduced to a game of genetic Russian roulette, with the selfish gene creating the illusion that we have a conscience. As Bernard Shaw said, if natural selection is true only fools and rascals could bear to live. Darwin was no fool because he made a fortune on the stock market, but he must have been a rascal because he invented social Darwinism to justify the exploitation on which society is based.

Darwin frightens us because we haven't been able to make his ideas go away, and we are beginning to suspect that he might have been right after all.

PETER BOWLER

# Diana, Princess of Wales

**D**IANA, PRINCESS OF WALES will be remembered as a controversial figure; and as time passes critics of such characters tend to gain ground. So those of us who can testify to the good in her should take the witness stand. One shining virtue in Diana was her gift for consoling the sick, the injured, the bereaved or merely the unfortunate.

I saw this in 1997 when, under the auspices of the British Red Cross, she went to see the ravages landmines had wrought in Angola, a country wracked by war. I saw it again later that year when, in the last month of her life, we spent three days together in Bosnia meeting victims of landmines.

Few of the people we saw in Bosnia knew who she was. They simply rejoiced to encounter someone who would hear their tale of woe. Anticipating this, Diana arranged with our hosts, Norwegian People's Aid and Landmine Survivors Network of Washington, that at least half an hour be allotted to each interview.

There was the widow whose young husband had just been killed by a mine while fishing. There was a woman in the Sarajevo cemetery who had lost her only son. There were those who had survived gruesome injuries, which they were eager to display and discuss. There were legless men playing volleyball.

To all of them Diana seemed able to convey through the language barrier total understanding of their plight. Some were emotionally overcome by this reception. Where there has been such suffering, those who suffer go short of sympathy. No one had listened to them so attentively before.

The experience also taught Diana something about herself. The gift of being able to console people in despair is granted to so few. It might well have offered a new beginning in her own rather confused life.

BILL DEEDES

**DIANA, PRINCESS OF WALES**
BRYAN ORGAN, 1981

# Diana, Princess of Wales

**T**HE ESTABLISHMENT WAS RIGHT – Diana, Princess of Wales, was their enemy. In the beginning she stole royal sovereignty by doing what royals do, only better – being seen and showing off. She lent her celebrity to untouchables: people with AIDS, and – to the Government's fury – the campaign against landmines. In the end she defied the royal demand for submission by standing up to them and speaking out in public against the future king for his bad behaviour as a man.

But her campaign was sly and stealthy – this ingenue was a strategist. It was risky – dissenters from her class had, after all, lost their heads. But she triumphed – she told her story and she ruined their reputation. The parliamentary parties missed the point with the soppy endorsement of New Labour's new royalist: the notion of the 'People's Princess' was a contradiction in terms. The sentimentalists among them were wrong, she was not a saint; and the sceptics who saw her story as merely soap opera were wrong too.

She aimed her stiletto straight between the eyes of the most powerful and protected cult in the country. By bearing witness to the cold conspiracy and careless cruelty behind royal patriarchy she became the first woman since the magnificently unhygienic and unruly Caroline to take on a pointless Prince of Wales. And by translating her private pain into a public protest she offended the etiquette of duty that masks royal dominion. Diana bequeathed confusion to a primitive family that has 'love and hate' tattooed on its tiaras, requires grown men and women to bow and walk backwards and for whom the protocol of power is its only purpose. Her poignant villainy sponsored an unprecedented republican feeling that found no champions in parliamentary politics but surprised society itself and shocked the royals.

The Establishment was right – she was their enemy.

BEATRIX CAMPBELL

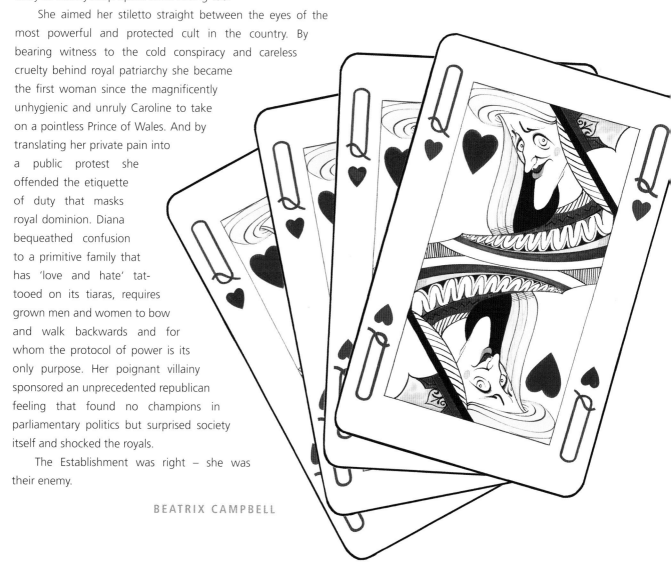

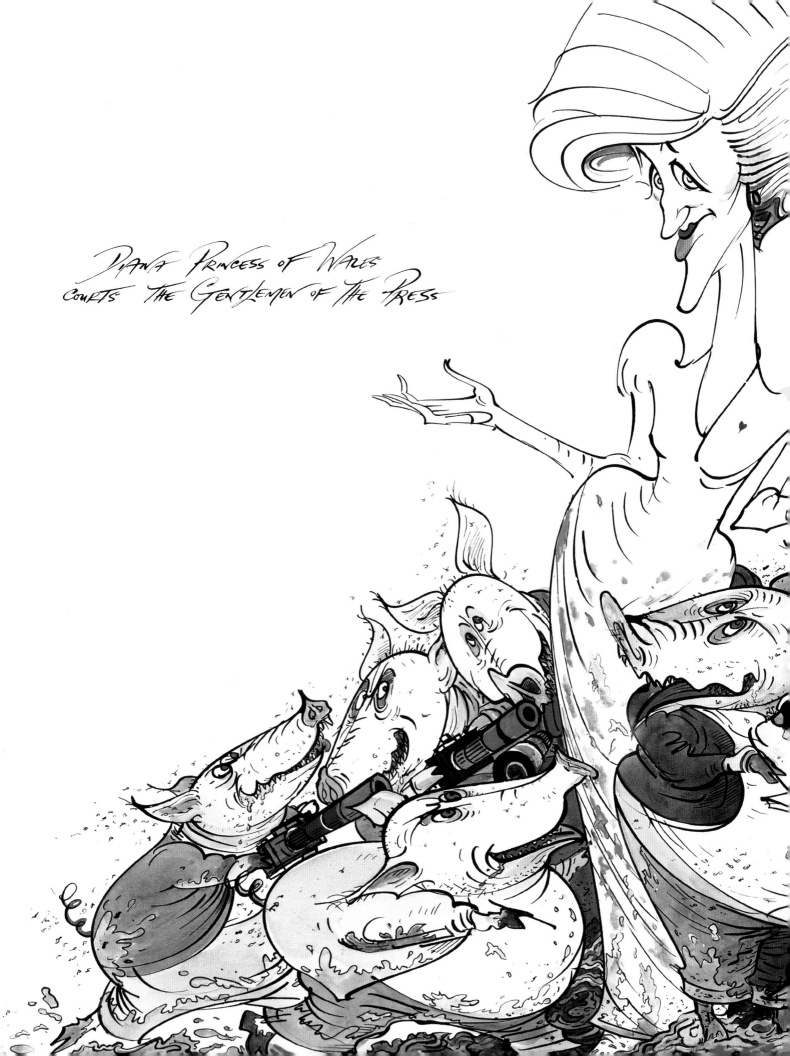

DIANA PRINCESS OF WALES
COURTS THE GENTLEMEN OF THE PRESS

LIVE BY THE SWORD
DI. BY THE SWORD

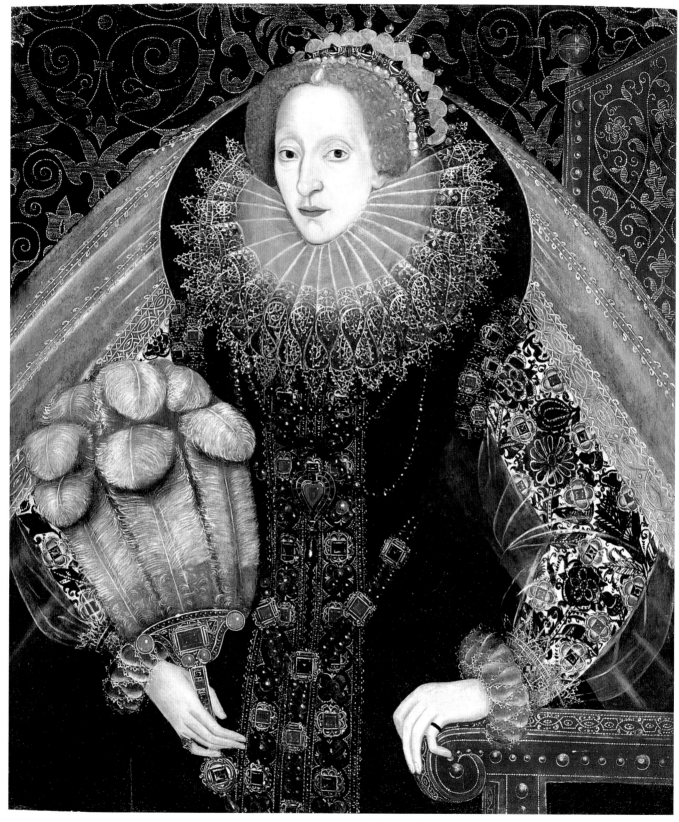

ELIZABETH I
UNKNOWN ARTIST, c.1585–90

# Elizabeth I

**T**HE VIRGIN QUEEN was a brave and ultimately benevolent woman. Despite her reputation as ruthless, vain and scheming, Elizabeth I was also witty, caring and highly intelligent.

A consummate politician, she possessed the ability to inspire and intimidate in equal measure. Her ruthless sense of destiny was an absolute necessity, which allowed her to walk a tightrope above the pitfalls and intrigues of seething national and international politics. Charismatic Elizabeth inspired the nation and generated enormous loyalty in her subjects. Many were led to the edge of bankruptcy as she and her court travelled the country enjoying the enforced hospitality of the aristocracy. As a result of the febrile atmosphere she created – the dynamism, the new wealth and the desire to impress – the nation was left with a legacy of great houses that had been built to capture her imagination and lure her patronage.

The isolation that Elizabeth experienced in her younger years inevitably helped to mould her character within a carapace of steely determination. Treated as a political pawn while still a child and imprisoned on the orders of her own father, it is not surprising that she felt that she could trust no one but herself. Sumptuously adorned and fêted by her court, yet aware at all times of possible plots and intrigues that could end her life in an instant, it is understandable that her image nowadays is a composite, a contradictory mixture of international flirt, Ice Queen and peripatetic houseguest from hell.

FIONA REYNOLDS

# Elizabeth I

**E**LIZABETH I WAS THE FIGUREHEAD of a particularly savage regime – she and her entourage created a piece of monstrous self-idolisation that has lasted to this day. The Virgin Queen was clearly no virgin, but her chaste marriage to the State served a political purpose. The idea that she brought glory as 'Gloriana' was little more than a crude way to see England and Wales through the famine of the 1590s; to inspire soldiers and sailors into battle; and to fire up adventurers into plundering foreign lands.

To sustain this kind of aggression, it was necessary to create a society that was riven through with spies, a society sustained on the principle that if you're not with us, you're against us. To deviate from the state religion – either towards Roman Catholicism or towards Anabaptism and Calvinism – was to invite imprisonment, torture or death – all of which went on a-plenty. It's also clear that this state religion wasn't brought about on theological grounds. It was, in essence, a political religion, serving the purpose of creating the nation state. That's why it had to be defended with such brutality.

All the evidence suggests that Elizabeth was an extremely intelligent and an accomplished woman. This makes her quite different from some other European monarchs who became genetically enfeebled through inter-marriage. This, and the fact that she was a woman, makes her, in some people's eyes, some kind of feminist hero, or at least a hero for womanhood. Another way of looking at this though, is to see her as someone whose intelligence and femininity were used both by her and her Machiavellian Privy Council in order to create and sustain a brutal regime. For most women, the Elizabethan period was a disaster: the struggle for European and world domination left many widowed, or at best trying to survive with a partner maimed or mutilated by war. The rapid increase of enclosures of common land pushed thousands more into destitution too.

There wasn't much compensation in knowing that your ruler was some kind of demi-god.

MICHAEL ROSEN

The Facade that hid the Horror

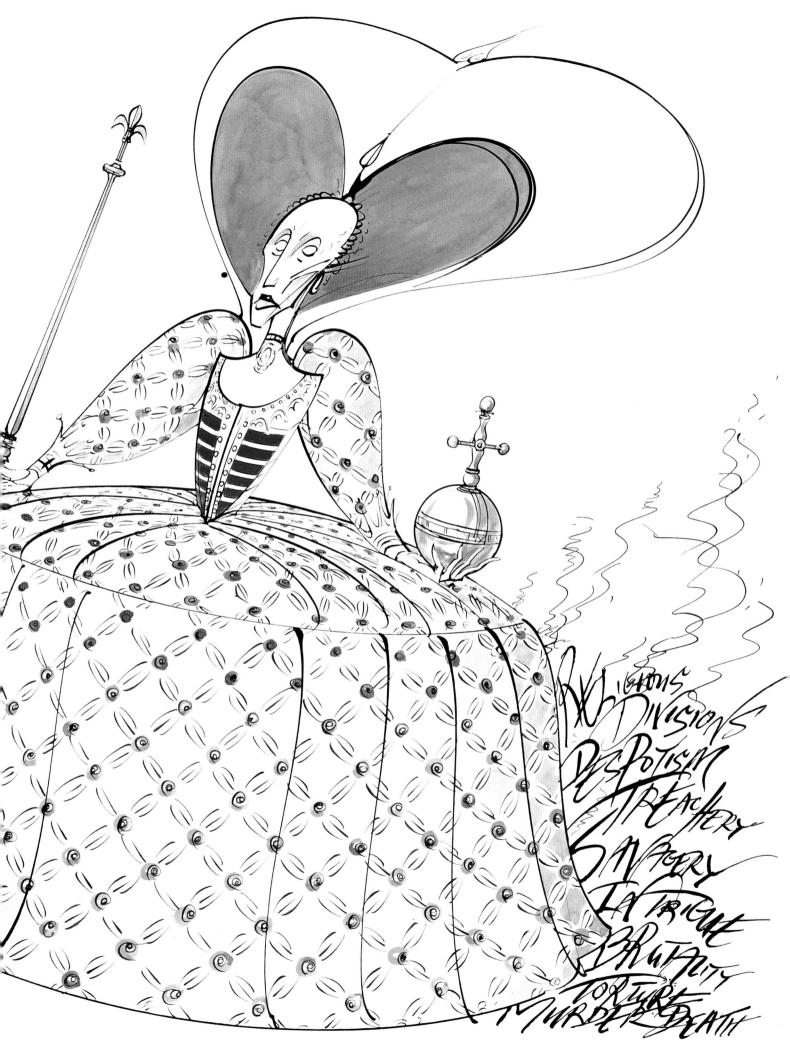

# Tracey Emin

SELF-PUBLICISING? YES. Histrionic? Yes. Self-obsessed? Yes. If you want a shrinking violet who knows her place and is grateful for whatever few crumbs the art establishment throws at her, then mad Tracey from Margate is not your girl. She clamours, shrieks, howls for attention: 'Look at me, look at my body, look at my shitty lovers who betrayed me, look at my rape, my suicide attempt, my two abortions, my drinking, look at my bed (the state of it!), look at my LIFE.' But there is no hint of self-pity in this exposure – rather, a burning, invigorating rage. In life, she may have been the victim; through art, she has her revenge.

Her art beckons you with its sheer feminine prettiness – its delicate drawing, its quaint embroidery, its chocolate box colours. 'How charming' you think, seeing a Tracey Emin blanket across a room. And then you draw near and read the mis-spelt words, the furious message, the cry of pain: 'Fuck off back to your weak world that you came from.' The message is always: 'Don't underestimate me, I might look weak and womanly but I am harder than you think. And more courageous than you will ever be.'

LYNN BARBER

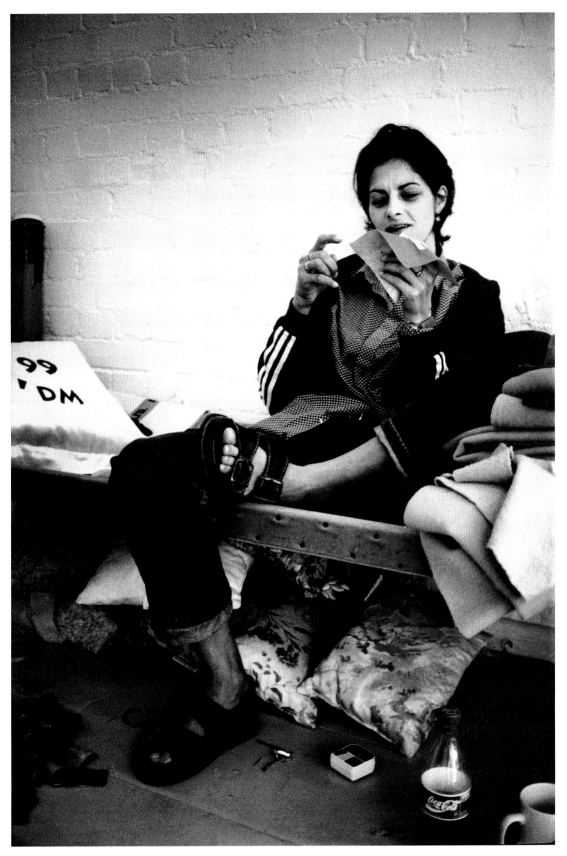

**TRACEY EMIN**
JOHNNIE SHAND KYDD, 1997

# Tracey Emin

**M**ISS EMIN'S VILLAINY is that she is a prime example of a present that has scant regard for the past, glorious and inglorious. Tabloid enthusiasm praises the ignorant for their ignorance. As a result, the skill of the artist has been usurped by celebrity, a disease not limited to art but currently rearing its ugly head far too often in the theatre. This celebrity is in turn nourished by outrage and offence. To my mind outrage and offence are the self-obsessed Miss Emin's stock in trade. Her art has no intended meaning – meaning is thrust upon it by critics.

For Miss Emin to be famous it is enough for her to curse and swear in public, to appear seemingly drunk and abusive on our televisions, to draw crude outlines of herself urinating and to exhibit the stained and rumpled bed from which she has apparently just risen.

Is what she does enough to merit the critical language inspired by Michelangelo and Rembrandt? Apparently it is. And here's the rub, for Miss Emin is far from responsible for the praise heaped upon her by critics – she is their instrument, not they hers. Miss Emin is nothing more than a poor deluded soul denied all talent whose strident protests against that denial have attracted the attention of those who control our galleries. These men (mostly), by publicly exposing a young woman's profound distress that would have been better taken to an analyst, have nurtured in her a tiresome arrogance.

THELMA HOLT

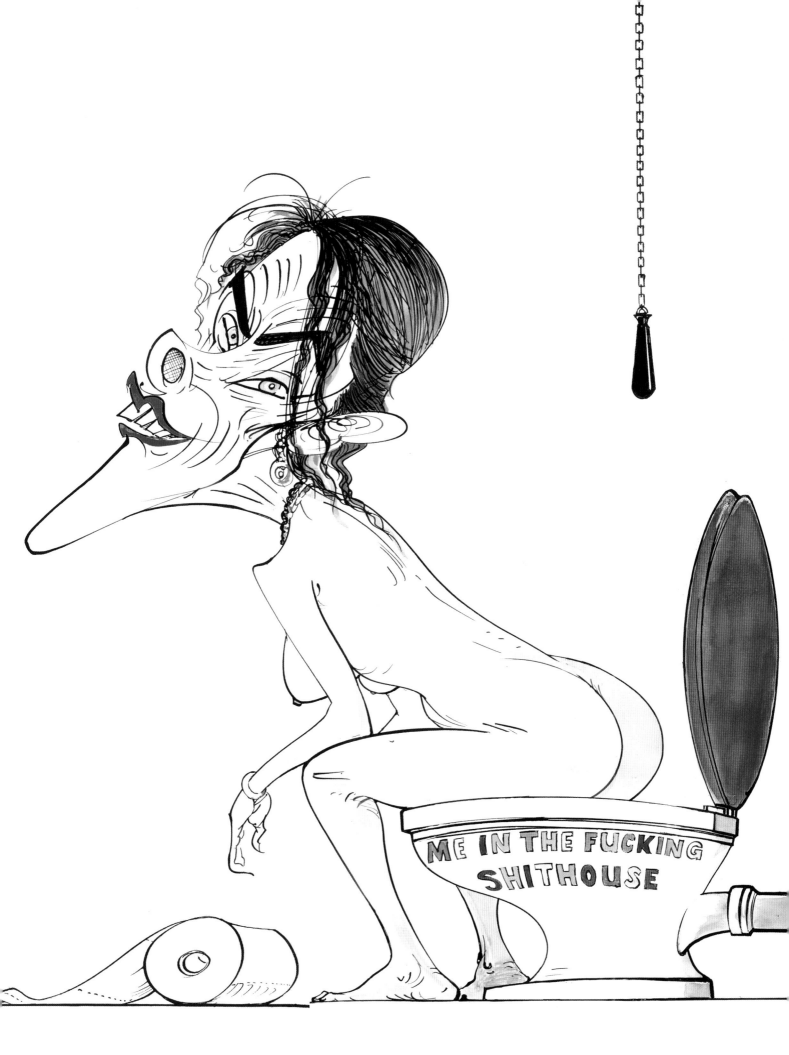

# Rosalind Franklin

**M**Y HEROINE IS THE SCIENTIST Rosalind Franklin, who died tragically young at thirty-seven. For others – especially Nobel laureate James Watson of DNA fame – she was almost a figure of fun, a caricature. But her X-ray photographs, shown to Crick and Watson without her knowledge or consent, helped lead them to cracking the mysteries of DNA. She never won the Nobel prize. It is never awarded posthumously, but she was not credited with her contribution at the time, either.

Rosalind Franklin was not always an easy person; her professor at King's College London, Maurice Wilkins, did not acknowledge her contribution until much later. Yet she was a woman of great talent and insight, a woman of warmth and verve, a person of passion from a large, warm Jewish family, to whom she was devoted. She achieves heroine status in my eyes because she stuck to her guns despite many difficulties, and she moved to a different laboratory (J.D. Bernal's at Birkbeck) to carry on with what mattered to her. She was a true scientist and a great woman.

Other people's villain in her day, she is now acknowledged, fifty years after the discovery of the double helix structure, as one of the four key researchers – James Watson and Francis Crick in Cambridge, and in London, Maurice Wilkins and Rosalind Franklin. All four of them are now celebrated as the world of science marks the fiftieth anniversary of the research.

JULIA NEUBERGER

**ROSALIND FRANKLIN**
VITTORIO LUZZATI, 1950

# Rosalind Franklin

**H**OW COULD SUCH A HIGHLY GIFTED woman so let down her sex – unforgivable. Franklin has come to represent how badly scientists treat women but it was largely her own fault, her own doing.

She was born into a grand Jewish family, the brightest and most determined of the children, but even when young had a stormy personality. She never hesitated to have a showdown and had many rows. She was also determined to be the best at whatever she did. Men found her attractive but she never had a long-term relationship. She studied science with a passion and after her PhD, went to Paris where she did excellent

work on the structure of carbons in coal using X-rays to analyse their structure. She then returned to King's College London where she was employed to study the structure of the genetic material DNA.

She did not choose the problem nor ever really understood the importance of DNA and its structure. For her, it was just another problem to be done well and she did produce excellent X-ray pictures. She was much too frightened of being wrong to speculate on the structure that these pictures suggested. On one occasion she went up to Cambridge to see an early model of DNA constructed by Watson and Crick and was contemptuous of the errors they had made – she could never have made them. She also ignored some advice on the problem that Crick gave her. But it was just this caution, a lack of appreciation of what DNA was, and the insistence on never being wrong that resulted in Watson and Crick partly using her data to solve the structure in 1953. So instead of being the heroine who solved a major problem about the nature of life, and providing young women scientists with a wonderful role model, she helped give both male and female scientists a bad reputation. Yes, women of her generation had a hard time in science – she could have helped change it, but instead made things worse.

LEWIS WOLPERT

*THE CREATION OF CLONES*

# Kenneth Grahame

**K**ENNETH GRAHAME'S PLACE in the pantheon of children's literature rests almost solely on his masterpiece *The Wind in the Willows*. On the face of it, it is an unlikely story to appeal to children. There is no child hero – no children at all, in fact – and all the main characters are male. They are a collection of anthropomorphic animals who inhabit a pre-First World War arcadia: the thoroughly decent, gentlemanly Ratty, the reclusive, donnish Badger, the ebullient, boastful Toad. Good fellows all, though it is with the nervous, less socially secure Mole that we most strongly identify.

The inexplicable, irresistible appeal of the story to me, as a suburban nine-year-old girl, had little to do with the *Boy's Own* adventure element, although I liked that kind of thing well enough, or the Class Struggle – River Bankers (gents) versus stoats and weasels (plebs) – a familiar contemporary accusation. It is far more that it achieves a perfect balance between the two poles of children's literature: the desire to escape, to run off and become a wayfarer or a river gypsy, which all children need to do in their imagination, and the equally strong pull towards the warmth and security of home, the hot dinner waiting at the end of the day's adventuring.

Children will always create their own arcadias. My generation did it in back gardens, bits of wasteland, bombsites and on seaside holidays. In today's more protective times, when children sorely lack privacy from adults (and vice versa), it is not surprising that they are drawn to parent-free fantasies in the head.

Grahame's own arcady, the river bank around Cookham, was already being eroded by suburbia when he created his unique rural idyll. The appeal of Pan Pipes was enormously fashionable then. Today 'The Piper at the Gates of Dawn' chapter is often skipped by readers-aloud anxious to get on with the outrageous adventures of Toad. But it's through the sheer power of his evocation of the dreamy riverbank and the terrors of the Wild Wood as well as the strength of his characterisation that Grahame remains a giant among story-tellers.

SHIRLEY HUGHES

**KENNETH GRAHAME**
JOHN SINGER SARGENT, 1912

# Kenneth Grahame

THE RIVER BANK IDYLL where Toad, Ratty and Mole enjoy friendship, good food and wine has inspired generations. Love of the countryside, the importance of companionship, the delight in the eccentricities of Toad and 'messing about in boats' are Kenneth Grahame's lasting legacy. But this idyll is less perfect than it seems and Grahame is not the benign creator such an innocent landscape might suggest.

Despite writing a classic of childhood, his own childhood was scarred by his mother's death when he was only four, and by his father's subsequent desertion and alcoholism. And the child for whom they were originally written, Grahame's son Alastair, was not enjoying the carefree childhood one might suppose since he was almost blind from birth and suffered from recurrent nightmares. It was to allay these nightmares that Grahame first told the stories about Toad, Ratty, Mole and Badger.

When persuaded that they should be published, Grahame adapted them, maintaining the childlike framework while really creating a band of bachelor men, the kind of company he would have enjoyed himself were he not trapped in a hopeless marriage. With a marked absence of females in his writing, he boasted that the book was 'clean of the clash of sex', which seems fitting for a man who never grew up, remaining 'shattered and repelled' by adult sexuality. Instead, these childlike characters stand to preserve the established order of society, resisting progress. Toad's forays into the new-fangled world of the motor car meet with disaster, ensuring that he puts such folly to one side, showing it to be disagreeably speedy, noisy and dangerous. But Grahame goes further in restricting the lives of his characters. Despite the good sense of Badger who lives in it, the River Bankers are terrified of the Wild Wood, and even more of the Wide World that lies beyond. As Ratty says: 'I've never been there, and I'm never going, nor you either, if you've got any sense at all. Don't ever refer to it again, please. Now then! Here's our backwater at last, where we're going to lunch.'

JULIA ECCLESHARE

# Graham Greene

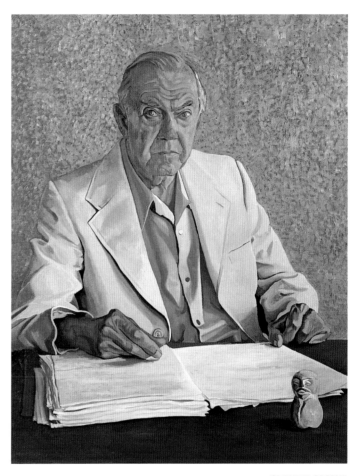

**GRAHAM GREENE**
ANTHONY PALLISER, 1981–3

**G**RAHAM GREENE HAD HIS DETRACTORS, including his contemporary Anthony Powell, who patronisingly described him as 'good at reportage, a lively journalist, able businessman', but snittily dismissed his novels as 'vulgarised Conrad, to which tedious Roman Catholic propaganda is added'. Other antagonists have included rafts of damaged and dismissed mistresses, and exposed tyrants and demagogues everywhere from Mexico City to Nice. But while the women and the dictators might be justified, Powell's judgement is ridiculous: Graham Greene is one of the all-time great voices of English literature.

What fascinates about Greene is not simply that he was a man of action and a man of letters, nor that he maintained a perilously balanced equilibrium between public moralising and a fabulously rackety private life, but that in his novels he created a distinctive world. Greeneland – whether it happens to be Clapham, Vienna or Liberia – is melancholy, enigmatic, romantic and perfectly drawn. Greeneland is populated by believable characters: flawed, tormented, funny (often flyblown) and honest. *Brighton Rock*, *The Heart of the Matter*, *The Power and the Glory*, *The End of the Affair*, *The Quiet American* and *The Honorary Consul* are unforgettable. Even the titles themselves have become part of the language. He was a prodigious writer; his letters to the press alone would take up two fat volumes.

Graham Greene led an extraordinarily full and various life with myth and reality in ambiguous, ironic interplay. The man in a white suit descending from an old prop 'plane on a hot and dusty African dirt strip, a spy in shadowy rainswept Vienna, a distinguished old literary émigré plotting a campaign against the corrupt Mayor of Nice from his regular table at the gloomy Felix au Port restaurant in Antibes. He was a romantic with a fascination for women, drink, travel and every species of human frailty. All these cravings he legitimised in literature.

Maybe he was struggling against boredom and depression, but we are all beneficiaries of that struggle. Graham Greene showed that a writer could – indeed, must – occupy a prominent place in public life. There's no one whose achievement I admire more.

STEPHEN BAYLEY

# Graham Greene

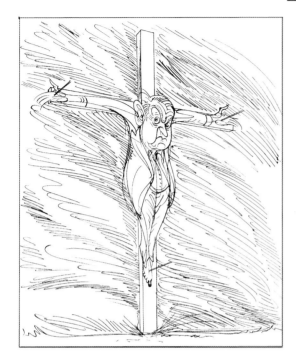

**T**HOSE PIERCING EYES, as Graham's old friend and quaffing partner Lord Clark once pointed out, seem literally to follow one around the room, elbowing their way willy-nilly into the innermost recesses of one's very soul.

With those novelist's eyes, G.G. never missed a trick. 'A leopard,' he once told me, 'is a large animal with spots – and the seal is strikingly well-adapted to cold water.' I thought nothing of it at the time, but on a subsequent visit to Whipsnade Zoo, I found that Graham had both the leopard and the seal down to the proverbial T.

On another occasion, after he had returned from three weeks as the personal guest of Idi Amin, the then-Ugandan president,

'What, perchance, was he like, Graham?' I asked.

'Very black. Very African,' replied Graham.

Sure enough, when I checked out these insights with a friend in the Secret Service I found them to be absolutely spot-on. Shrewdness was after all Graham's middle name.

He was famous for being a recluse, of course, shunning all but the most necessary publicity and never permitting more than three or four journalists to interview him at any one time. It helped that he was a master of disguise, always wrapping himself up well in his grubby gabardine mackintosh and parading up and down the foyer of the Ritz bearing a sandwich board with the slogan, 'I am NOT Graham Greene'.

The other clue to this veritable magician with words was, I rather suspect, his Roman Catholicism. Whenever a book seemed in danger of running low on plot, he knew just when to pop in an addled priest. Before long, a battered missal, a crumpled Panama, a crisis of faith and a bottle of cheap Scotch would be following hot on his heels. This is Greeneland, as real today as it was yesterday; and rather more real than it will be tomorrow.

WALLACE ARNOLD

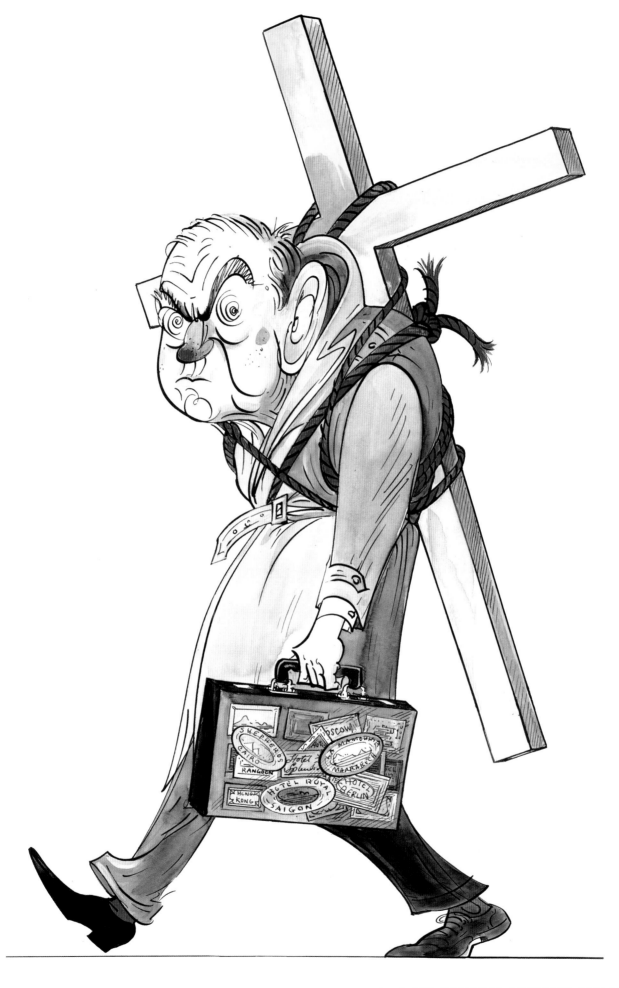

# Henry VIII

**M**OST PEOPLE HAVE THE WRONG IMAGE of Henry VIII. They see him as a Bluebeard who changed wives and chopped off heads with gleeful alacrity, or as a puppet ruler manipulated by others. Often, they think he was like the caricature played by Charles Laughton, who threw chicken bones over his shoulder and lived in a Hollywood-style version of Merrie England. Furthermore, the propagandist images of the mature king, which derive from Holbein, and of which this portrait is an example, have become so famous that they have overlaid all other conceptions of the younger, less embittered and tyrannical monarch.

The real Henry was a complex man, and his fascination lies in his sheer power, his all-round versatility, his intelligence, his idealism, his courtliness, his courage and his undoubted sex-appeal. He was as much a victim of circumstance as his unhappy wives. Fate dealt him several unkind hands, not the least of which was his first wife's failure to produce a male heir. Had she done so, Anne Boleyn would have had to be content to remain the King's mistress, and there would have been no break with Rome. It was frustration that made Henry the so-called monster he later became: frustration at the Pope's long drawn-out and politically led prevarication over what was undoubtedly a reasonable request for an annulment, and frustration at Anne Boleyn's refusing to sleep with him for six long years. Soon afterwards came Anne's perceived betrayal and Jane Seymour's death in childbirth, followed by a decade of worsening ill-health and increasing pain. It is quite possible to feel sorry for Henry in his several predicaments, and had Providence been kinder to him, his finer qualities would have survived into later life.

ALISON WEIR

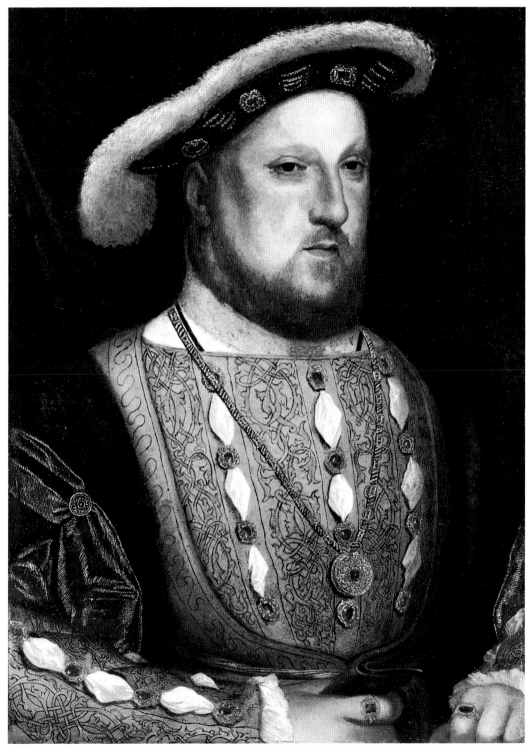

**HENRY VIII**
AFTER HANS HOLBEIN THE YOUNGER, c.1536

# Henry VIII

**THE SPOILT BRAT OF THE TUDORS,** Henry VIII immortalised way beyond his due by Holbein and worth consideration only because he fathered Elizabeth I, could have saved the life of one of the greatest Englishmen in our history, William Tyndale. However, his hypocrisy and vindictiveness or perhaps just his usual indulgent blind selfishness meant that he did not lift a finger and Tyndale was strangled, then burnt at the stake. For what? For translating, single-handedly, from the Greek and Hebrew original, a Bible into English which was to influence eighty per cent of the King James Bible three generations later and which gave us some of the most beautiful phrases and prose rhythms in the language. 'Blessed are the poor in spirit for theirs is the Kingdom of Heaven'; 'Blessed are the peacemakers for they shall be called the children of God'; 'Let there be light', he wrote, and 'eat, drink and be merry', 'the powers that be' and 'a man after my own heart'. Shakespeare may have heard his words in his Stratford-upon-Avon church. The English-speaking world has coasted on them ever since.

Henry VIII, who ingratiated himself with the Pope by attacking Luther, banned Tyndale, sent out ships to seize his English Bible on the high seas, hired spies to track him down and assassins to capture and murder him. This was done after Henry VIII, once the Pope's favourite, had split from Rome; after he had already decided that it was politic to accept that the Bible could be translated into English; when Tyndale had become, in effect, the mind and word of the English Protestantism now so convenient to the opportunely converted King. There was a great deal else he did (destroying the great monasteries, for instance) that blacken his reputation, but nothing worse than allowing the man who wrote God's English to be strangled totally unnecessarily.

MELVYN BRAGG

*Henry and his Chopper*

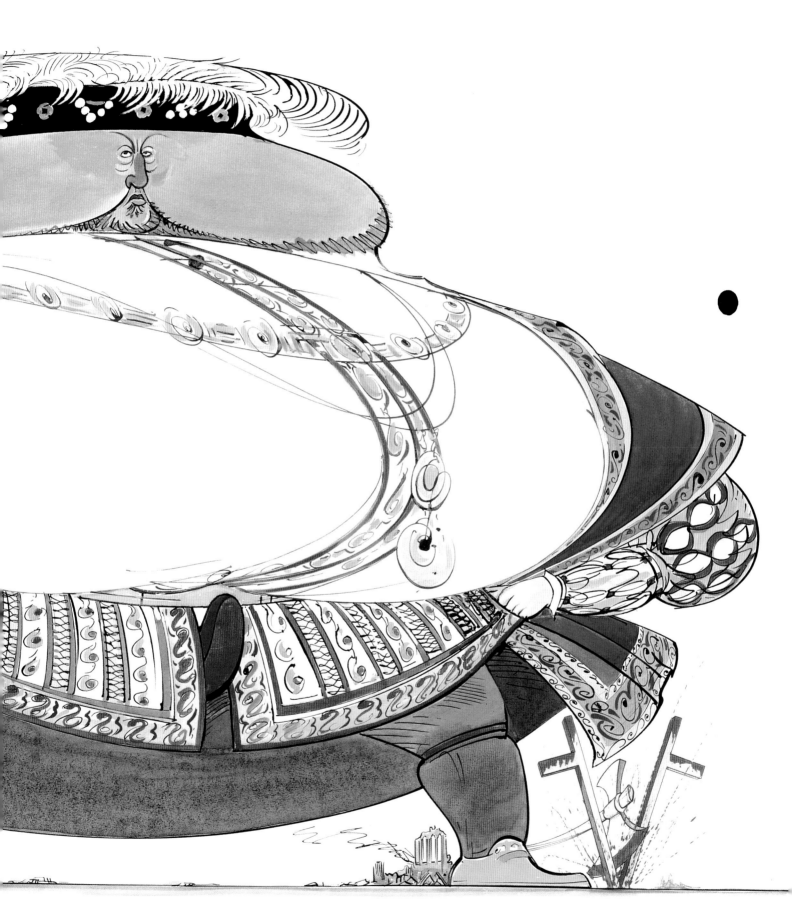

# William Hogarth

**H**OGARTH WAS COCKY, QUARRELSOME, STUBBORN and sometimes appallingly chauvinistic. Not heroic qualities. But in his prints he caught the life of the poor and the rich – doctors and apprentices, eager musicians and cruel sleepy judges, young soldiers and old fishwives – so vividly that you can still see a Hogarth crowd today. He opens our eyes.

Hogarth was the first great social and political satirist: today's cartoonists revere him and still draw on his jokes. But he was also the first to weave graphic satire into stirring stories like the *Harlot's Progress* and *Rake's Progress*, 'moral tales' where it is hard to tell if the main character is victim or predator or both. Ambiguity haunts him: the smug *Industrious Apprentice* becomes Lord Mayor, but our hearts are with his Idle opposite hanged on Tyburn tree. Hogarth loathed corruption, and his concern for the common people burns in his stark campaigning works like *Gin Lane*.

Self-interested no doubt, he also worked doggedly for fellow artists: campaigning for the Engraver's Act of 1735, setting up the St Martin's Lane Academy, organising London's first exhibition spaces. He led the young, rebellious British artists fighting the dominance of Old Masters, fashionable foreign portraitists and canting critics. He was far from modest – in his tongue-in-cheek *Self-portrait with Pug* he sets his image atop Milton, Shakespeare and Swift – yet he was always vulnerable because he cherished a dream. He wanted to be remembered not for his satire but for his painting – and perhaps his true humanity is seen best in his conversation pieces, his luminous portraits and his moving studies of children and servants. He is my hero, in the end, because he can give an ordinary girl glimpsed in the street the dazzling immortality that we find in the artistry of his *Shrimp Girl*.

JENNY UGLOW

**WILLIAM HOGARTH**
JEAN ANDRÉ ROUQUET,
c.1740–5

# William Hogarth

**A**LTHOUGH WILLIAM HOGARTH PLAYED THE HERO'S ROLE in his own mythology – as the great defender of native British culture, sworn enemy of the pernicious tribe of picture dealers and champion of a living, modern nature threatened by the dead hand of false old art – in the eyes of many contemporary painters and engravers this was all self-serving tosh. During the mid-1750s, years of pent-up anger at Hogarth's bullying efforts to dominate the London art world, found expression in a vicious campaign of graphic satire aimed at 'the author Pugg' – so-called after his favourite breed of dog. He was lampooned for his pretensions as an aesthetic theorist, his dictatorial behaviour at the St Martin's Lane Academy and the various stratagems he'd devised to promote his financial interests at the expense of rival practitioners.

The satirists had good reasons to complain, to which we might add several more. Prominent among these is that complacent attitude of moral superiority which oozes from Hogarth's serial narratives; while he was quick to criticise the harlot, the rake and others for their delusions of grandeur, he conveniently forgot his inflated assessment of his own abilities and importance. He lobbied parliament to pass a law securing copyright for engravers – but in fact the act was phrased in such a way as to make him its main beneficiary. Hogarth profited, too, from his campaign against foreign artists, and against those among his compatriots who sought to improve themselves by studying on the Continent. Although he never tired of spouting his brand of virulent xenophobia, when it suited him – as in the case of *Marriage à-la-mode* – he didn't hesitate to employ French engravers to enhance the commercial appeal of his work. But perhaps it is hardest to forgive Hogarth for leading painting in Britain down the path of literature, to the delight of professors of English but arguably to the great and lasting detriment of the English School of art.

DAVID SOLKIN

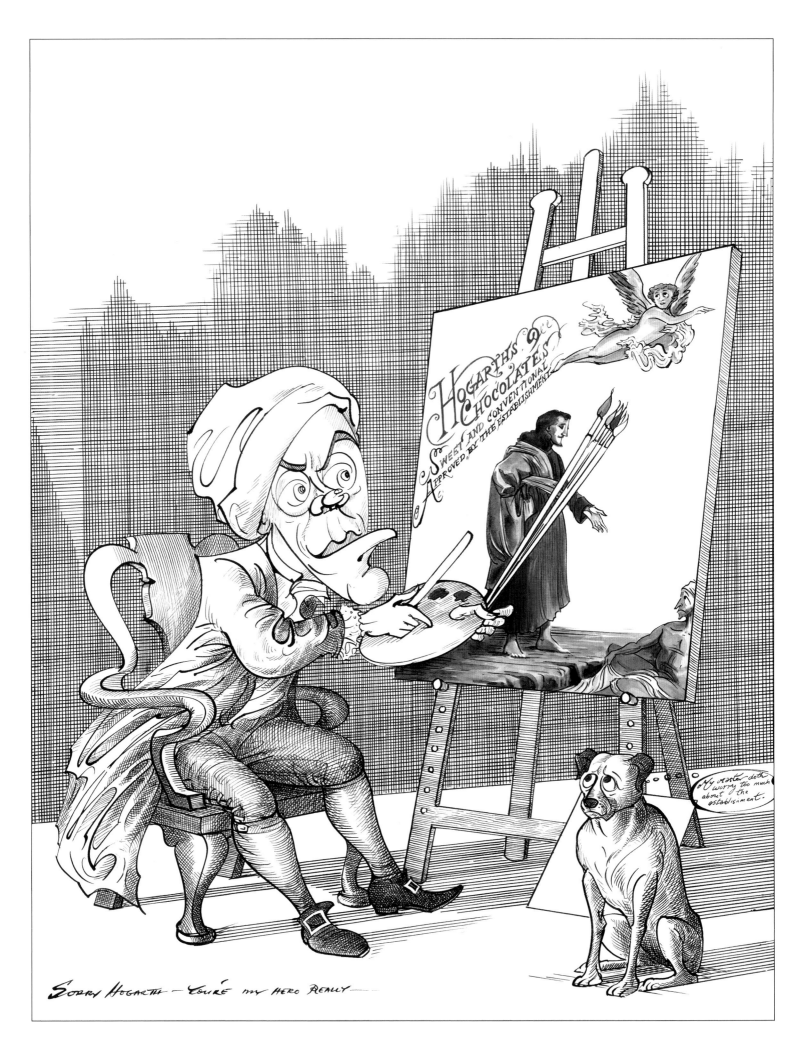

# Ken Livingstone

**KEN LIVINGSTONE**
TOM MILLER, 2001

SINCE WE HAVE HEROES and anti-heroes, surely it's time to recognise the difference between villains and anti-villains. As Ken Livingstone's biographer, I've spent too much time looking into his weaknesses to have him as my hero. But I certainly can't see in him the villain of imagination, summed up in that *Sun* headline in his early days as leader of the Greater London Council (GLC) dubbing him 'the most odious man in Britain'. If an anti-hero is a central character lacking in the traditional noble qualities, an anti-villain must be someone who is always vilified, but incapable of any great crime or wickedness. That's him, spot on: the eternal bad boy who doesn't actually do any bad.

My evidence? Well he has this habit, surprising in a politician, of keeping his promises. In 1981 he told the voters he would cut fares on the tubes and buses to encourage more people to use public transport. There was spare capacity in those days and the policy worked. So the judges made him stop and Mrs Thatcher intervened to abolish the GLC. In the mayoral campaign in 2000, he said he would introduce a congestion charge to deter motorists from driving into central London. Many warned that the technology for detecting and charging for car use would fail if it wasn't tested in a smaller city first. He went ahead and everything worked from day one.

Of course he has a nasal south London accent, keeps amphibian pets and favoured dialogue with Sinn Fein long before it became fashionable under John Major and Tony Blair. That ruled him out of polite society for years. But it didn't alienate Londoners. Faced with a choice between this cheeky chappie and the party political machines, they picked the anti-villain, the bad boy they could trust.

JOHN CARVEL

# Ken Livingstone

THE TOTAL FAILURE of opportunity best summarises Ken Livingstone's villainy. At a time when Londoners could well do with a charismatic character in a central role, someone who could rally and enthuse, who could look after us now we have become one of the world's prime terrorist targets, we have, instead, Ken Livingstone.

His opportunity to lead one of the world's greatest cities as we moved into the new century has already been lost, his legacy destined to be nothing more inspirational than the congestion charge. This tax – his meisterwork that impacts financially on those least able to bear it and adds a bureaucratic nightmare to daily life – appears to have failed to improve traffic flow to any noticeable degree.

When he became Mayor of London, Livingstone arrived on the crest of a well-wishing wave. He was the small guy who triumphed against the massed bands of politicos. He was the people's hero, or at any rate, we were willing to think that he might be. Now three years down the line what have we got? The opposite of a hero. A man who will do anything for a useful photo opportunity but who rarely stays for the follow-through. A man who seems to think that every initiative taken needs to be stamped with his self-congratulatory logo, on billboards, on buses, on hoardings. A man now notorious for claiming to have slept through an eventful party. What kind of a mayor is that? Certainly not the one I'd had in mind when I voted for him.

ALEXANDRA SHULMAN

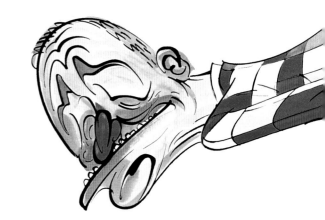

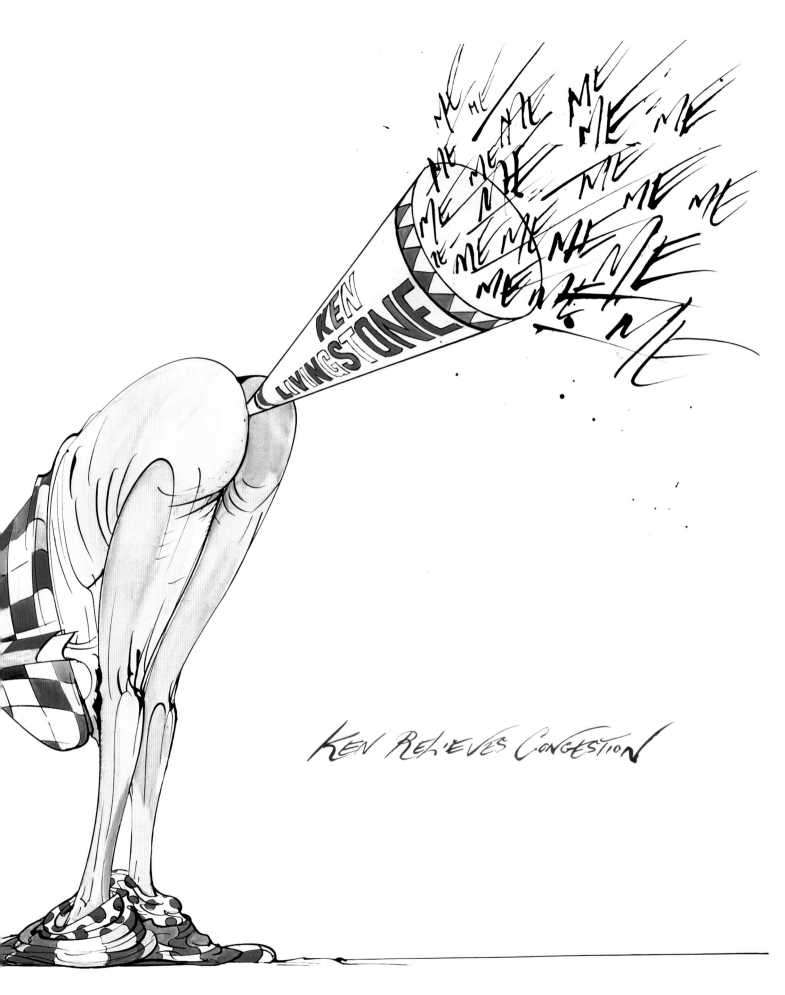

KEN RELIEVES CONGESTION

# David Lloyd George

'**H**OW CAN I CONVEY TO THE READER** who does not know him, any just impression of this extraordinary figure of our time, this siren, this goat-footed bard, this half-human visitor to our age from the hag-ridden magic and enchanted woods of Celtic antiquity?' John Maynard Keynes asked the question of David Lloyd George in 1919. Lloyd George was a giant in everything except stature.

Prime Minister from 1916 to 1922, A.J.P. Taylor called him 'the greatest ruler of England since Oliver Cromwell' – and Lloyd George was a lot more fun than Oliver Cromwell. Statesman, social reformer (father of the Old Age Pensions Act and the National Insurance Act), inspiring war leader, nimble diplomat, matchless orator, philanderer, conspirator, flawed human being. When he was in his prime, in Wales they sang this song about him:

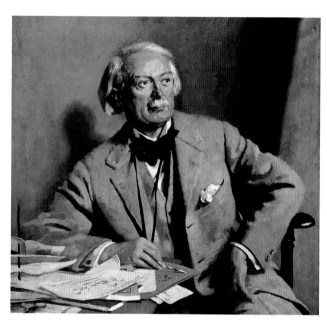

**DAVID LLOYD GEORGE**
SIR WILLIAM ORPEN, 1927

Lloyd George, no doubt,
When his life ebbs out,
Will ride on a flaming chariot
Seated in state on red-hot plate
'Twixt Satan and Judas Iscariot.
Ananias that day to the Devil will say,
'My claim for precedence fails.
So move me up higher away from the fire,
And make way for the liar – from Wales!'

Emotional, amazing, arrogant, engaging, passionate, persuasive, principled and unprincipled by turn, he was indeed 'the Welsh wizard'. He was a true hero: the stuff of fable. When Lloyd George was about, there was magic in the air.

GYLES BRANDRETH

# David Lloyd George

**D**AVID LLOYD GEORGE WAS FORTUNATE to go through his political career, particularly the latter part of it, when the press showed more deference to public figures than they do today. For all his great qualities, which saw us through the perils of the First World War, he was a devious character, who did more to lower the tone of public life than any modern offender in the Labour or Conservative party.

We can pass over his private life, with its parallel establishments, his wife in one and Frances Stevenson, his mistress, in another because others lived in the

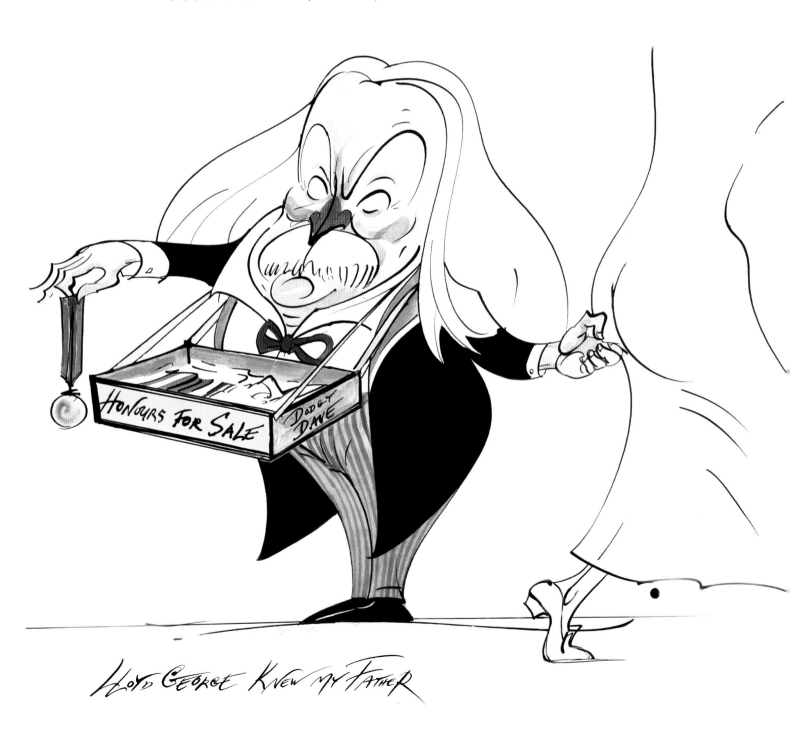

*Lloyd George Knew My Father*

style; and dwell only on why Lloyd George came to be widely politically mistrusted. It was because he so often showed himself to be a tricky customer.

There was the letter Major-General Sir Frederick Maurice sent to the press, which accused Lloyd George of giving parliament a false account of our military strength on the Western Front. Lloyd George ultimately defeated the General, who played a strong hand badly; but nobody who studied the episode can doubt where the truth lay.

The most damaging charge against Lloyd George was that he sold Honours in the post-war years, not for his own gain but for what was euphemistically called 'the Party fund', kept in readiness for elections. He certainly bestowed Honours on some very strange business characters, leading to accusations, which, in his inimitable way, Lloyd George answered robustly but not convincingly.

These characteristics led to the break-up of the wartime Coalition of which he was Prime Minister, after Stanley Baldwin had explained to a gathering of his party at the Carlton Club why he so mistrusted Lloyd George. This was a Prime Minister of courage, ability and drive who defaced public life.

BILL DEEDES

----- AND MY MOTHER TOO —

# Oswald Mosley

OSWALD MOSLEY WAS SEVENTEEN when the Great War began. A Sandhurst cadet, he joined his regiment, the 16th Lancers, at the Curragh. Wishing to get to France he transferred to the Air Force, and flew behind the German lines as an observer before he was eighteen, subsequently fighting with his regiment in the trenches. He became passionately anti-war, a result of his experiences.

Aged twenty-two, in 1918, he was elected Tory MP for Harrow. He was in parliament for thirteen years. He felt very strongly that soldiers returned from war were let down by politicians. Nothing was done about miserable living conditions in England, then the richest country in the world. He joined Labour, but found the same apathy in its leaders, faced with mounting unemployment, hunger and misery.

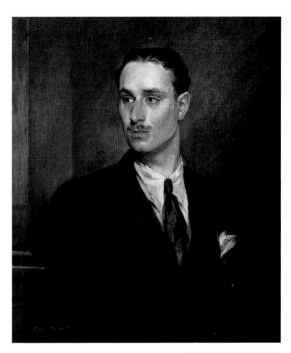

**SIR OSWALD MOSLEY**
GLYN WARREN PHILPOT, 1925

He founded the New Party and lost his seat. In order to make a reality of his ideas he founded the British Union of Fascists (BUF) in 1932. Meetings were attacked by Communist-led opponents.

The historian A.J.P. Taylor said of Mosley 'a superb political thinker, the best of our age' and R.H.S. Crossman, a Labour minister, said of his Thirties ideas: 'Mosley was spurned by Whitehall, Fleet Street and Westminster, simply and solely because he was right.'

Mosley thought a European war would be a disaster for our country, win or lose. His slogan was 'Mind Britain's Business'. The Polish Corridor was not Britain's business. He campaigned for negotiated peace, with Britain and the Empire intact. When Germany invaded France, and there was talk of invasion, he wrote 'in such an event all of us in the BUF would resist the foreign invader with all that is in us'. There was no invasion, but a fortnight after these words were printed he was arrested. There was never a charge, or a trial. *Habeas corpus* was swept aside.

The day war ended he said, 'Fascism is dead. Now we must make Europe.' He strove for United Europe for the rest of his life. He was a great patriot, and was saddened by the steep decline in Britain's power and influence. But he was optimistic for our future in Europe.

DIANA MOSLEY

# Oswald Mosley

**F**OR ME, NO VILLAINY OUTCLASSES THAT OF THE NAZI ERA and Britain's Nazi figurehead, Oswald Mosley. Of course there are many ways of assessing a true villain and one yardstick is the lengths of cruelty and the depths of cunning attained by any candidate for the devil's laurels. Mosley does not score highly on this basis as he was facile and blundering, not Machiavellian. Nor could his motives be described as villainous in the widely accepted sense of the word. But he was as culpable as Hitler and Mussolini in that he favoured the cult of anti-Semitic Nazism that led to what must vie for the title of mankind's all-time act of inhumanity, the Holocaust.

Had Mosley had his way, had his British blackshirts come out on top as did their counterparts in Germany and Italy, this country may well have seen the same appalling cruelties and suffering as did all those sorry countries piloted by the policies of the Third Reich.

Nowadays the horrors of the Holocaust seem far away and difficult to imagine. It is hard to accept that such evil could have issued from Europe's most civilised country, the home of Einstein, Beethoven, Freud and Bach. Or that a coldly calculated policy of mass genocide could have been efficiently implemented by a democratically elected Government.

I saw in the media not so long ago photographs and films of cattle and sheep slaughtered and burnt in pits. Some five million were disposed of in this manner, a total that fell far short of the eight million people of all ages who were murdered and incinerated by those same Nazis whose actions Oswald Mosley favoured and exhorted.

I also watched the American reaction to the sudden death of some three thousand New Yorkers in the World Trade Centre. Those victims of modern terrorism died quickly without suffering months of deadly fear beforehand. I remember that, in just one of dozens of similar murder camps, the Nazis would daily gas and burn two separate sittings of six thousand humans. And they did so daily for eighteen months. I know of no greater evil and, in Britain, the monsters responsible are represented by Oswald Mosley.

RANULPH FIENNES

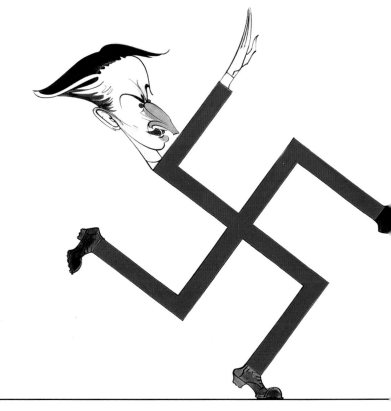

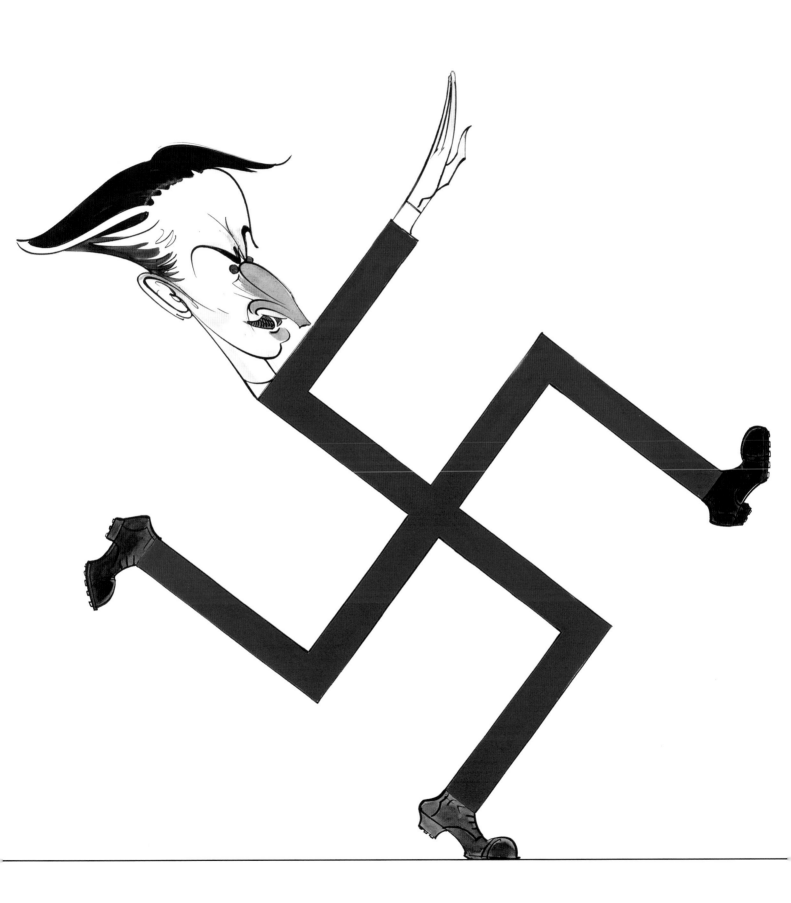

# Isaac Newton

**P**ERHAPS IT IS INCONGRUOUS to think of a scholar as a hero and certainly Isaac Newton suffered none of the danger and persecution that marked the life of William Tyndale. And I still think of heroism in terms of Sir Philip Sidney dying on the battlefield, Nelson at Trafalgar and those who faced the mud and murderous guns on the Somme. Yet the mind can scale heights, be bold, be dauntless, and we have Einstein's recommendation of Newton: 'He stands before us,' Einstein wrote, 'single and alone.' He was not at all a nice man, but true heroes can be excused that.

Newton knew other scholars – no one works in a vacuum – so he had bricks with which to build. But I have never met a scientist who did not believe that Newton's feat, as a young man, in describing and defining gravity and the Three Laws of Motion, was not something of quite a different order of things. Very few scientists will ever admit that one mind was key and unique. The general opinion is that if A had not discovered this matter then B or C would have done and sooner rather than later. Science is portrayed as a study of interdependent minds, compelled to be federal and collaborative, with no place for the single stars like Shakespeare or Michelangelo, Turner or Bergman. Yet even some of that stern society will sometimes admit that had not this desperately lonely, unhappy, even dysfunctional man devoted all his tremendous intellectual energies to the matter and gone where no mind had been before, then we may have waited a long, even a very long time, for discoveries and laws that utterly changed the modern scientific and technological world.

MELVYN BRAGG

# Isaac Newton

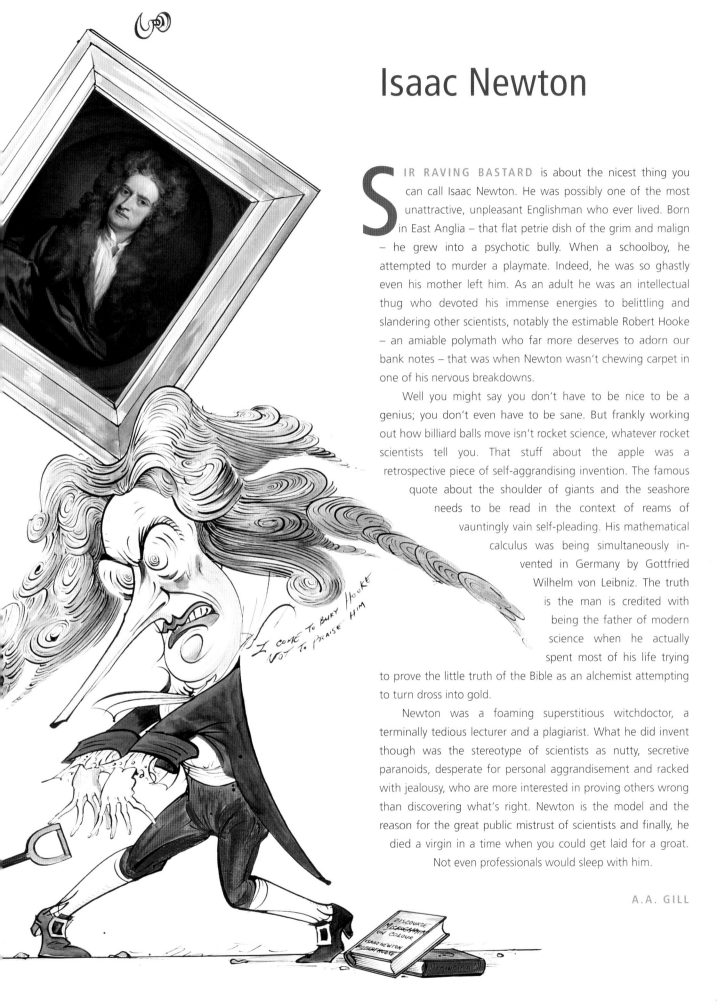

**S**IR RAVING BASTARD is about the nicest thing you can call Isaac Newton. He was possibly one of the most unattractive, unpleasant Englishman who ever lived. Born in East Anglia – that flat petrie dish of the grim and malign – he grew into a psychotic bully. When a schoolboy, he attempted to murder a playmate. Indeed, he was so ghastly even his mother left him. As an adult he was an intellectual thug who devoted his immense energies to belittling and slandering other scientists, notably the estimable Robert Hooke – an amiable polymath who far more deserves to adorn our bank notes – that was when Newton wasn't chewing carpet in one of his nervous breakdowns.

Well you might say you don't have to be nice to be a genius; you don't even have to be sane. But frankly working out how billiard balls move isn't rocket science, whatever rocket scientists tell you. That stuff about the apple was a retrospective piece of self-aggrandising invention. The famous quote about the shoulder of giants and the seashore needs to be read in the context of reams of vauntingly vain self-pleading. His mathematical calculus was being simultaneously in-vented in Germany by Gottfried Wilhelm von Leibniz. The truth is the man is credited with being the father of modern science when he actually spent most of his life trying to prove the little truth of the Bible as an alchemist attempting to turn dross into gold.

Newton was a foaming superstitious witchdoctor, a terminally tedious lecturer and a plagiarist. What he did invent though was the stereotype of scientists as nutty, secretive paranoids, desperate for personal aggrandisement and racked with jealousy, who are more interested in proving others wrong than discovering what's right. Newton is the model and the reason for the great public mistrust of scientists and finally, he died a virgin in a time when you could get laid for a groat. Not even professionals would sleep with him.

A.A. GILL

**GEORGE ORWELL**
FELIX H. MAN, c.1947

# George Orwell

T TOOK A LONG TIME for me to warm to George Orwell. Imposed on us in school in the 1950s as the supreme exemplar of limpid, unaffected English style, he became my literary Big Brother. I hated his self-consciously polished ironies, his attack-dog aggression. Brought up at home on Dickens and Balzac (whom I later learnt he admired), Orwell's parade of snappy bleakness seemed always on the edge of sneering or fighting.

One novel, however, overthrew many of the platitudes with which I had lumbered Orwell. *Coming Up for Air*, read in the late 1950s when the drabness of London life – at least MY London life – still evoked the Thirties he was writing about rather than the Swinging Sixties to come. Its aggressively banal anti-hero George Bowling, a fat, middle-aged balding insurance agent, was created to be set off against descriptive passages of phenomenal power. And in Bowling's epiphany with fishing, his ecstatic-elegiac vision of a pastoral England on the point of disappearing, the romantic in the socialist made his shocking appearance.

Many years later I had a similar rediscovery with *Burmese Days*. Often misrepresented as an extended hymn of hate against the British Empire, it is actually a much subtler book than its author subsequently allowed. Beyond Orwell's flinty courage in facing up squarely to totalitarianism while remaining a democratic socialist, beyond the indivisibility of his passions for both justice and freedom, there are moments when he allows himself to make precisely visual, aural, even tactile, the countless ways we experience being English that I most treasure. The sooty fingerprint of his Wigan tripe-shop landlord as he cut Orwell his slices of off-white bread; the sighting of a kestrel over the gasworks in the Euston Road; the sound of an old forbidden song crooned by a prole woman at the washing line, carrying with it the perilous music of lost freedom. It's not only that reading Orwell is an indispensable tool for modern citizenship – which it is, ensuring that we are a step ahead of the Managers of Power – but by immersing ourselves in the sharp, brilliant play of his writing we can, as a bonus, feel that, even for him, the beautiful was not necessarily the enemy of the good.

SIMON SCHAMA

# George Orwell

THE REASONS OTHER PEOPLE GIVE for loving George Orwell are my reasons for detesting Eric Blair. It starts with the pseudonym, with the way he never dealt with where he came from and who he was, manufacturing instead this plain-speaking, decent, utterly English persona. That's the problem: all those qualities are manufactured, not real.

It's not that he was a bad man, rather that he was wrong, and in ways that matter and go on mattering. It's not that he wrote bad novels, though what has endured of his writing is a few essays, some journalism and two political novels. It's not even that in his reportage he told lies about where I come from, about 'the North' and about working people. It doesn't even really matter now that he turned on his comrades, derided them, misrepresented them and wrote noxious propaganda during the war.

No, what matters to me is the way Blair used language. He is famous for exposing the deceit and error in other people's writing. He is praised for his common sense, no-nonsense prose. But he wrote about politics, about life, in ways that killed serious discussion of politics for a generation. He gave us, in Raymond Williams's phrase, 'a mood – not an analysis'. Class and power are to do with property, capital and economic relationships, but Orwell goes on about our society being like a family with the wrong members in control, about the position of our ruling class having 'long since ceased to be justifiable'. No. Those images make power and class seem natural and ordinary, as if our aristocracy used to be worth its salt but is a bit tired now. Blair saw the consequences of capitalism right enough, but Orwell ignored the system that drives it all. I think Perry Anderson got it about right: 'If he had few or no original ideas, a limited creative imagination, and an unreliable capacity to recount information, what remains of his achievement?'

SEAN MATTHEWS

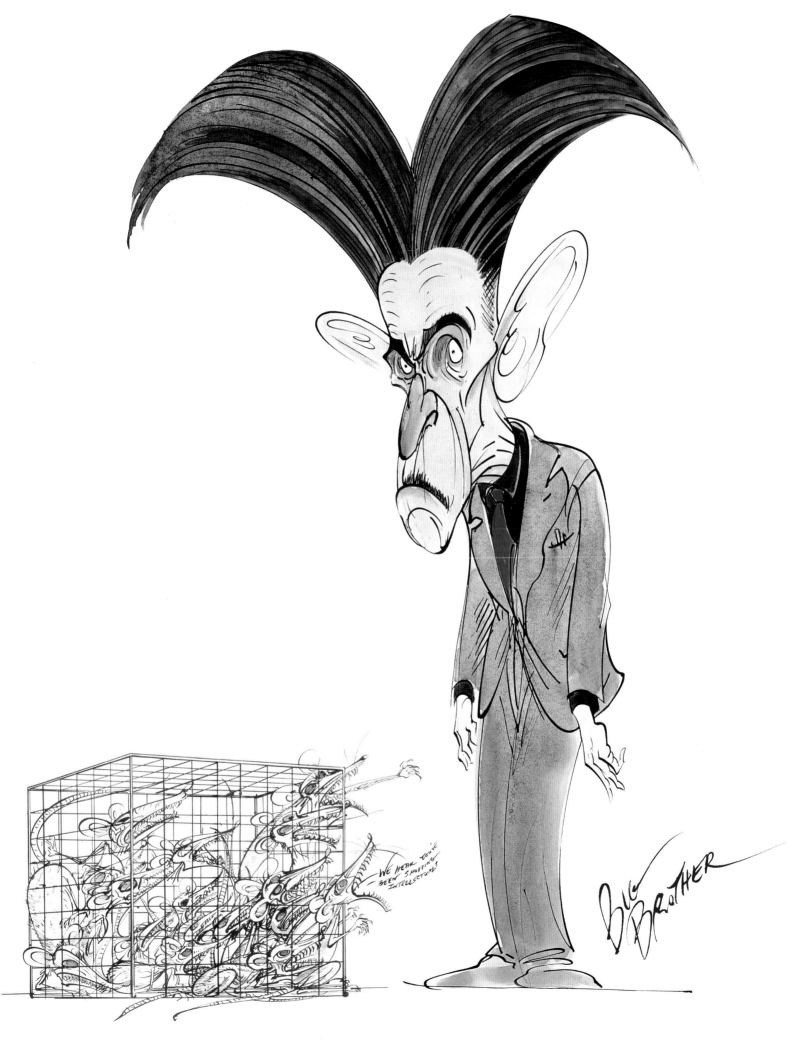

WE HEAR YOU'VE
BEEN SHOPPING
INTELLECTUALS

**EMMELINE PANKHURST**
GEORGINA AGNES BRACKENBURY, 1927

# Emmeline Pankhurst

**O**UTRAGEOUS, COMBATIVE, ELOQUENT and dignified, Emmeline Pankhurst was the movement for women's suffrage's 'wonderful dictator'. She embodied contradictions: in public she was a rebel-warrior, undaunted and defiant, like her heroine, Boadicea; in private, a reserved, pleasant, middle-class Victorian matron. The qualities that united the two sides of her character were integrity and determined devotion to the greater good.

She lived as she preached; no champagne socialism here. 'Deeds not Words' was her motto. Widowed young, Mrs Pankhurst bitterly resented what she saw as charity when money was raised to help her family. Later, she resigned from her job in order to dedicate herself to campaigning, forfeiting her home, her salary and her pension. She shattered conceptions of what women would and wouldn't do for a cause, striking policemen in the face and throwing stones through the windows of 10 Downing Street to provoke arrest and bring attention to her cause, at a time when it seemed incredible that women could hope to be treated as men's equals.

Arrested and re-arrested frequently in her mid-fifties, Emmeline Pankhurst embarked on a series of hunger and thirst strikes, sometimes smashing up her utensils and refusing to sleep, move or be examined. Released because she was too ill to be cared for in prison, she would muster up the strength to address thousands at public demonstrations in Britain, Europe and the United States before being re-arrested once again. In 1912 alone she was arrested twelve times.

Emmeline Pankhurst was a revolutionary idealist who believed the world really could be made a better place. 'We are here,' she declared, 'not because we are lawbreakers; we are here in our efforts to become lawmakers.' It is thanks in large part to her that women are no longer systematically overlooked and dismissed; it is thanks to her that women can now raise their voices – without having to resort to her methods – and make them heard.

LUCY MOORE

# Emmeline Pankhurst

**W**HY DO SO MANY MODERN FEMINISTS recoil with horror from Emmeline Pankhurst?

The reasons are both personal and political. Beneath her exquisitely feminine exterior, Mrs Pankhurst was extraordinarily ruthless in personal relationships. Her children complained of her lack of affection and inability to sympathise with any signs of weakness; for years she refused to allow her son Harry to wear glasses. Sylvia and Adela suffered most because Emmeline regarded their socialist opinions as inconsistent with her campaign for the women's vote. In January 1914 Sylvia was expelled from the Women's Social and Political Union (WSPU). 'You are unreasonable, always have been and, I fear, always will be,' Emmeline told her, 'I suppose you were made so!' Shortly afterwards she gave Adela a one-way ticket and banished her to Australia.

After this things could only get worse. In December 1927 Sylvia became an unmarried mother, which might have been the occasion for a reunion. But when the pregnant Sylvia visited her, Emmeline disappeared, refusing to see 'that Scarlet Woman'. 'I shall never be able to speak in public again,' she complained.

Some propagandist historians still credit Mrs Panhkurst with winning the vote for women. But the ruthlessness that blighted the Pankhurst family also damaged the suffragette movement. Women who refused to give unquestioning obedience to Emmeline and Christabel were simply driven out of the WSPU. Many felt there was something fraudulent about a movement for democratic rights run as an autocracy. Cicely Hamilton described it as a precursor of interwar dictatorships. When war broke out in 1914 many suffragettes were horrified to see Emmeline effectively abandoning the women's cause to become an agent of the Government. To cap it all, after 1914 they believed that she had misappropriated suffragette funds for her own maintenance.

MARTIN PUGH

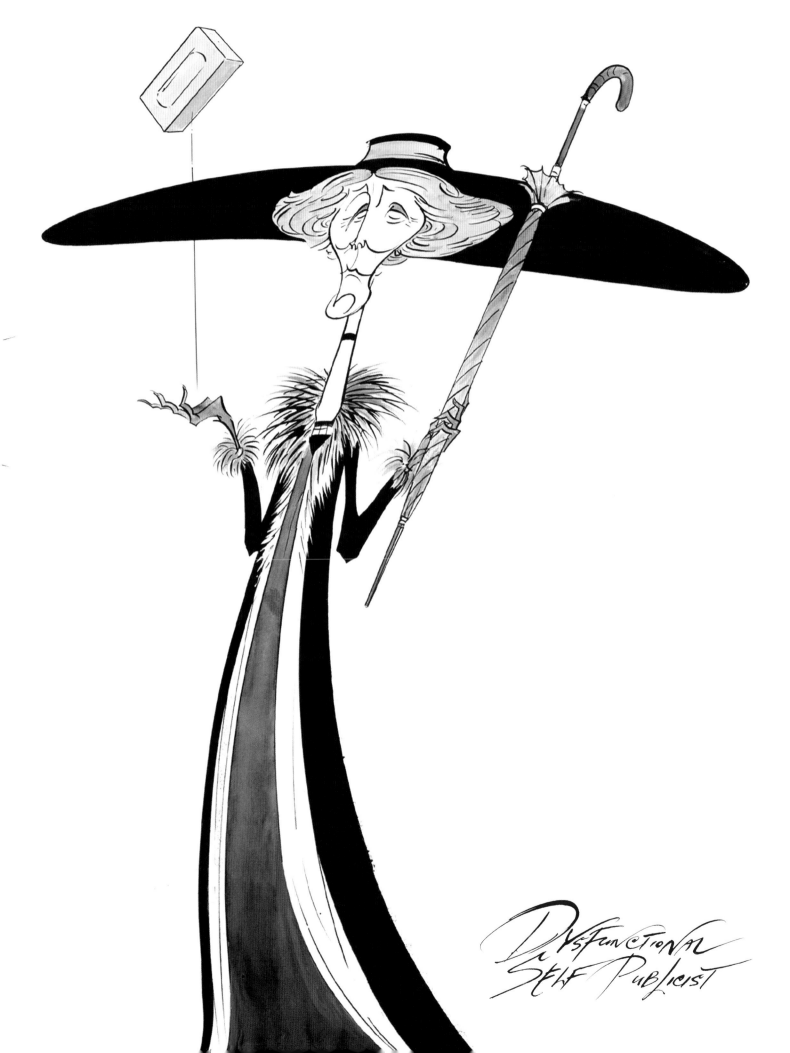

Dysfunctional Self Publicist

# Prince Charles

OF COURSE PRINCE CHARLES IS DERIDED – being nasty to royals is a national sport and it sells newspapers. If he were conventional, he'd be portrayed as an upper-class twit. As he is controversial and concerned, he's portrayed as barking. Yet the causes he was mocked for espousing thirty years ago are now mainstream issues.

Take the environment for example: Prince Charles supported Friends of the Earth when business thought Jonathan Porritt a dangerous revolutionary. Now businesses fall over themselves proclaiming (or at least claiming) green credentials.

And architecture: when developers were sweeping away our inner cities to make way for high-rise concrete, Prince Charles advocated a less aggressive, less alienating and softer approach. It's true that his influence sometimes led to banal pastiche and phoney clock towers on supermarkets, but it also meant the brutalist's love affair with exposed concrete died and it is now OK to care about detailing, local materials and human-friendly spaces.

And what about deprivation? The Prince's Trust is a model of cost-effectiveness and excellence, funding young people's enterprises when no one else will, and helps to rehabilitate, train and motivate some of the most disadvantaged of our youth.

And who else would dare tackle the touchy-feely question of spirituality and the human need for something besides getting and spending? Years before it became part of management development, Prince Charles knew the value of time spent with nature, or in meditation, or alone.

Above all, Prince Charles has worked out what influence without power can achieve. He has used his spotlight generously but carefully.

PRUE LEITH

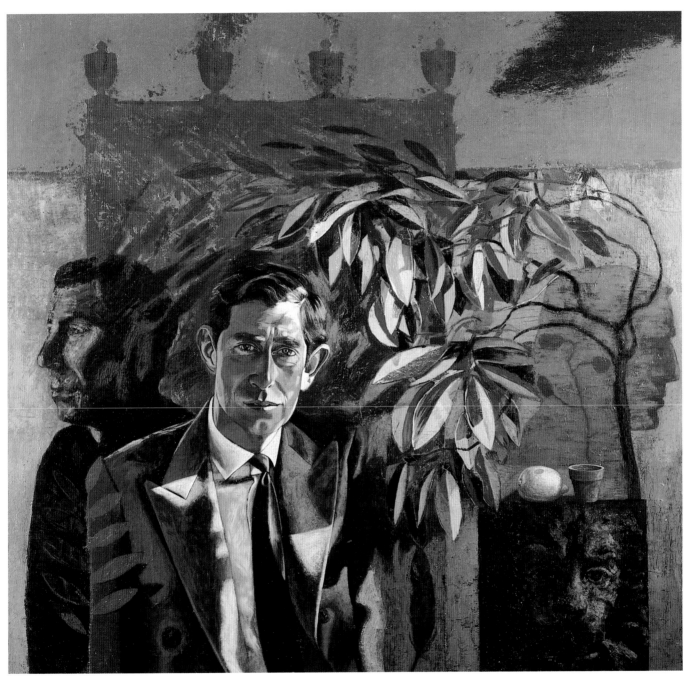

**PRINCE CHARLES**
TOM WOOD, 1989

# Prince Charles

A HYPOCRITE, WHO TALKS OFTEN about duty but apparently found it impossible even to perform the elementary duty of looking after his wife.

A philistine, who knows little about modern art or architecture but knows he's agin it.

A pampered pudding, who allegedly needs a valet to put the toothpaste on his toothbrush.

An intellectual waverer, who can believe twenty different things before breakfast.

A self-pitying whinger, who in his forties had to tell the world that mummy and daddy didn't love him.

An advocate of the simple life, who takes his own towels and lavatory paper when staying with friends.

A ditherer, who still, at his engagement, wondered 'Whatever love means'.

A man of little distinction, who will one day be king.

LYNN BARBER

GENETICALLY MODIFIED 'WEED

# Richard III

**A**FTER A GRUESOME DEFEAT at the hands and feet of the Scots, St Anne's hockey team dutifully crocodiled its way to the National Portrait Gallery. Aged fifteen, the pursuit of culture in all its forms was not high on my agenda. However, there was something I wanted to find: the Chandos Shakespeare. On my way I chanced upon Richard III. One glance and I was fascinated. But where was the crookback? Where was the beady eye? In short, where was Laurence Olivier?

Chandos was forgotten. I stayed, stared and carefully dissected him with my mind's eye. I saw that his was an aesthetic mouth, his eyes had known pain, but the gaze was stalwart and the brow noble. I became aware of his beautiful, slender fingers, and in the hands I detected somehow a sense of humour.

This anonymous portrait inspired me to track down the Richard III Society, an organisation that vindicates his reputation, so badly bruised by Shakespeare. I discovered that Richard was, in fact, an able and good king who brought stability to a fragile society. He instigated the process of judiciary, and indeed travelled the length and breadth of the country to ensure the law courts were properly run and consistent in their execution of the law. Without this chance encounter, I doubt I would ever have learned more about this King than I already knew: that he was responsible for killing the young Princes in the Tower.

The experience taught me that in order to see you have to look, that in order to observe you have to be able to dispose of the preconceived or inherited baggage you are carrying with you. The portrait reinforced my teenage suspicion that I should question received information. I also realised, of course, that however excited and stimulated I might be by the spoken and written word, I was diminishing the quality of my life if I did not learn to appreciate the visual experience. The effect upon me was very dramatic, and it has only subsequently happened in such a heartfelt way on one other occasion, when I saw for the first time Picasso's *Guernica*.

THELMA HOLT

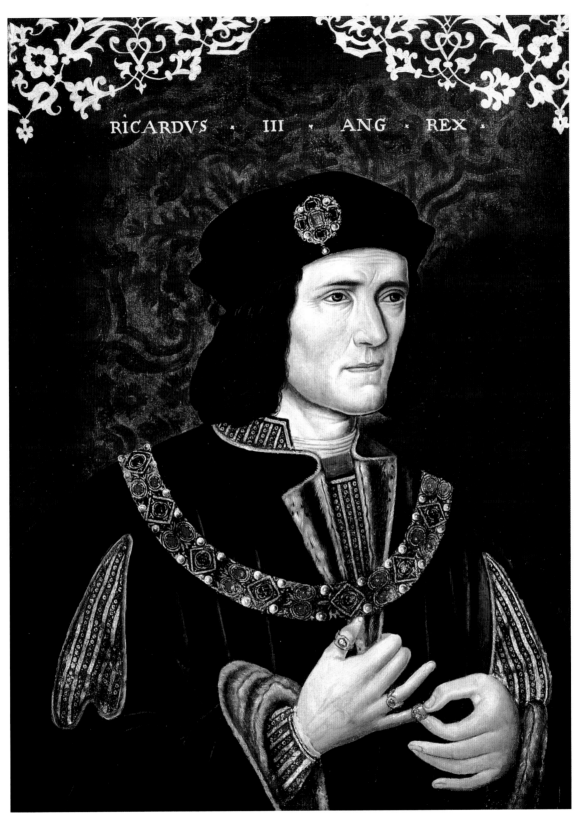

RICARDVS · III · ANG · REX ·

**RICHARD III**
UNKNOWN ARTIST, POSSIBLY LATE SIXTEENTH CENTURY

# Richard III

**R**ICHARD III'S DEFENDERS often describe their man as a 'much maligned monarch'. This is hard to argue against. Oceans of ink have been spilt in accusing Richard of crimes, while proven adepts of mass-arrest, torture, show-trial and political execution (including several Tudors) have been indulged and tacitly forgiven. Nonetheless, a historian can legitimately take a moderate view of Richard III, absolve him of murdering his brother, his wife, Henry VI and the Lancastrian Edward Prince of Wales, discount the psychosis of Shakespeare's caricature (along with the hunchback, withered arm, unequal legs), and still find him guilty on several counts.

The events leading up to Richard's coronation in 1483 entailed deaths and disappearances. Most dramatic of these was the death of William Lord Hastings, usually seen as a friend and ally of Richard. Hastings was arrested during a Council meeting in the Tower of London (together with several others) and died inside the fortress, either cut down by Richard's men-at-arms, or as a victim of summary execution. Likewise, the issue for which Richard is most notorious, the mysterious disappearance of his nephews, 'the Princes in the Tower', is hard to explain without casting Richard in a decidedly bad light. It is an unavoidable fact that the princes took up residence in the Tower in May 1483, were never reliably seen again at liberty, and by the autumn were no longer considered as a factor in politics. The idea that Richard's bad press was only Tudor rewriting is no longer a tenable line for historians to take. Several contemporary writers believed that the princes had died, almost certainly violently. Most of them further cast the blame on Richard himself.

JEREMY ASHBEE

*I am not the villain you think I am*

*My kingdom for a correct portrayal*

*The Theatrical Villain*

# John Ruskin

'THERE IS NO WEALTH but life,' wrote John Ruskin. It was a perfect summation of his aesthetic and political philosophy: a belief in the purpose of existence beyond monetary gain.

Ruskin was a man of contradictions: a violent Tory of the old school, his writings inspired the creation of the modern Labour movement; a fervent admirer of medieval architecture, his legacy was the fabric of the modern city. Yet he sustained a constant vision. Ruskin battled against the dehumanising constraints of industrial society, championed the dignity of work and warned of the perils facing a society wedded to the 'Goddess of Getting-on'.

I admire him as a thinker and a critic, but above all as an author. *The Stones of Venice* (1851–3) stands as one of the great works of English literature. A monumental account of morality and aesthetics, it charts the rise and fall of a city whose history was a 'warning which seems to me to be uttered by every one of the fast-gaining waves, that beat like passing bells, against the Stones of Venice'. Through the mirror of Venetian art and architecture, Ruskin cautioned Victorian Britain of the dangers of retreating from Christianity and community to 'the forgetfulness of all things but self'.

Seldom has a single book made such an impact on the built environment. Today, in the Gothic spires of Manchester Town Hall, the loggia of Glasgow's municipal buildings, the campanile of the Foreign and Commonwealth Office and the frieze of Northampton Town Hall can be read the lessons of Ruskin's Venice. His vision of society and architecture produced the iconic landmarks of the Victorian city.

Amidst the fierce materialism and social inequality of industrial Britain, Ruskin voiced an ethic of society and design that resonates across the centuries. It was a belief in morality free from the market. Mahatma Gandhi described how Ruskin's writings 'captured me and made me transform my life'. They also captured me and have made Ruskin my hero.

TRISTRAM HUNT

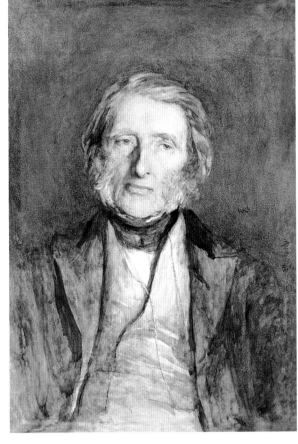

**JOHN RUSKIN**
SIR HUBERT VON HERKOMER, 1879

THE FALLING ROCKET

I HAVE SEEN AND HEARD MUCH OF COCKNEY IMPUDENCE BEFORE NOW BUT NEVER EXPECTED TO HEAR A COXCOMBE ASK TWO HUNDRED GUINEAS FOR FLINGING A POT OF PAINT IN THE PUBLICS FACE

# John Ruskin

**T**HE LIBRARY EDITION OF JOHN RUSKIN'S complete works has more than three thousand index references to the Scriptures. Ruskin, the magnificently paradoxical conservative moralist of Victorian art and letters, was the last Hebrew prophet. Or some would say the first Jeremy Clarkson. Whatever, his dotty opinions boom and echo around the twilit ruins of the British Imperium.

The privileged – and somewhat overwrought – son of a wealthy wine merchant, Ruskin had a childhood of strict religious discipline: paintings were turned to face the walls on Sundays. This may have enhanced his appetite for art. A complex and contradictory figure, Ruskin was the tireless champion of Turner, the equally tireless antagonist of Whistler: it never much bothered him that the two painters had much in common. Still, the Biblical cadences of his prose style are one of the great monuments of nineteenth-century English prose. At the same time, Ruskin's influence had a perniciously retarding influence on British taste that is still felt today.

CRITICISM

I ASK IT FOR THE KNOWLEDGE OF A LIFETIME

THE ART CRITIC —
OR
WHISTLER DOWN WIND

Ruskin's opinions were never opposed, even when manifestly daft. An indefatigable supporter of Gothic architecture (which in his opinion was good) and a tireless opponent of the classical (which was bad), when Ruskin described the Duomo at Siena as 'over-cut, over-striped, over-crocketed, over-gabled, a piece of costly confectionary and faithless vanity' few were prepared to disagree. Painting and architecture were not sufficiently large subjects to contain all of Ruskin's moralising and reforming energy. His opinion that art has a moral character inevitably led to the 1857 publication of his *Political Economy*. And his tenure as Slade Professor of the Fine Arts at Oxford gave him many opportunities to develop his taste for righteous work; he once made a group of undergraduates go road-mending. It is thought that Ruskin became impotent when he discovered that women had pubic hair. He subsequently went mad.

In his awful authority, maniacal industry, his delirium, his priggishness, his sexual repression and his hypocrisy, John Ruskin was the typical, if imperfect, Victorian gentleman.

STEPHEN BAYLEY

# Robert Falcon Scott

CAPTAIN SCOTT was a national hero for fifty years after his tragic death in 1912. Then came the 1960s when cynicism prevailed, and the moral virtues of yesteryear were systematically dismantled, the Establishment attacked and its heroes subjected to hostile biographies. Like Lawrence of Arabia, Winston Churchill, Lenin and Laurens Van der Post, Captain Scott was torn off his pedestal and vilified. The fabrications and distortions of historic facts used to achieve the volte-face of Scott's international reputation would have been worthy of the KGB's top disinformation experts.

Robert Falcon Scott was a junior Royal Navy officer when Sir Clements Markham, President of the Royal Geographical Society, picked him to lead Britain's efforts to reach the South Pole. Scott, with no previous polar experience, pioneered exploration in Antarctica in 1902 and in 1910 led a British expedition to the South Pole. On the day he set out, no man had ever been there. Scott succeeded in reaching the Pole; and but for uniquely bad weather conditions, he would have returned alive.

Just like other polar travellers of his time, such as Shackleton and Amundsen, Scott made many errors but the scientific results of his pioneering journeys were far greater than his rivals'.

Scott's detractors' main accusation remains that he used men instead of dogs as his chief means of travel. In 1993, with a colleague, I used Scott's man-haul system to complete the first unsupported crossing of the Antarctic continent. No dog team could have achieved this. I know of no historic figure so falsely denigrated after his death than Robert Falcon Scott.

RANULPH FIENNES

**ROBERT FALCON SCOTT**
C. PERCIVAL SMALL, BASED ON
PHOTOGRAPHS TAKEN IN 1910

# Robert Falcon Scott

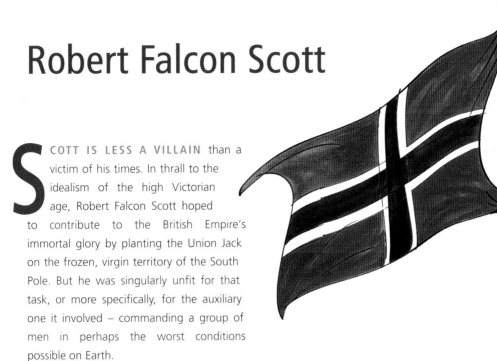

**S**COTT IS LESS A VILLAIN than a victim of his times. In thrall to the idealism of the high Victorian age, Robert Falcon Scott hoped to contribute to the British Empire's immortal glory by planting the Union Jack on the frozen, virgin territory of the South Pole. But he was singularly unfit for that task, or more specifically, for the auxiliary one it involved – commanding a group of men in perhaps the worst conditions possible on Earth.

Weak, rigid, secretive and irritable, Captain Scott was not a natural leader. He was ill-organised, squeamish and a bad judge of character and situation. As one of his men later put it, he saw leadership as a martyrdom. But it was a role he was willing to take on because he was hungry to be associated with Britain's greatness in the fields of exploration and scientific endeavour, and hungry for the adulation that would accompany those achievements.

He was not, of course, all bad: Scott's quiet lyricism has preserved his posthumous reputation, ensuring that future generations would accept his vision of himself as a brave man battling insurmountable odds. His final diary entry is a masterpiece of restraint, dignity and despair. He was a loving husband and loyal friend. But his heroism was misguided, at the terrible cost of his men's lives as well as his own. Captain Scott bought into the Victorian myth; he would have to have transcended it truly to have been the hero he longed to be.

LUCY MOORE

**WILLIAM SHAKESPEARE**
JOHN TAYLOR, c.1610

# William Shakespeare

**S**HAKESPEARE AND HIS FRIENDS were largely, though not entirely, responsible for creating a new kind of theatre. This has helped transform how we see ourselves as individuals in society – a contribution as great as that made by any psychologist, sociologist or philosopher you care to mention. Shakespeare's plays show people in social action, acted upon by circumstances then acting to create new circumstances – Hamlet's discovery that his father has been assassinated and his subsequent stuggles to try to figure out what to do are a prime example of this. What's more, as they respond, they tell us what they are thinking and why. The soliloquies of Macbeth, Hamlet and Lear are remarkable moments where individuals struggle with what's happened to them and with what they've done. More than that, we hear what people think of each other – think of the soldiers at the beginning of *Antony and Cleopatra* describing Antony as the 'triple pillar of the world transform'd into a strumpet's fool'.

But to say all this is to sound dry and dull and academic. It doesn't capture the life and power of what we see on stage: the sequence of incredible moments when our emotions of sympathy, anger, pity and amusement come and go in waves; the contradictory feelings we have when we find ourselves sympathising with villains and despising heroes; the moments of knowledge, when we know more of what's going on than the character in the scene – classically in the moment when Juliet's father is ordering Juliet to marry Paris, only moments after we have seen the lovers separating after their first night of love-making.

And then there is the question of language. In what is still something of a mystery, Shakespeare was able to find a way of speaking that expressed the wonder of what it is to be human. His characters reflect on who they are, why they are that way, what they think is right and wrong, and what they might do next. To do this, Shakespeare has them reaching for imagery more based in the real world of his time than on the borrowed imagery of ancient Roman and Greek literature.

MICHAEL ROSEN

# William Shakespeare

**N**OT, OF COURSE, A SMILING, damnèd villain. He knew tragedy too well to be a smiler by profession like his own king-villain in *Hamlet*. Nor could I conceivably wish him damned. He gave the world so much beauty, so much pleasure, so much humanity; surely these are reasons enough to pray for his salvation. Yet his crime, like that of his creation Claudius, is to assassinate a king, in character if not in person. That king was Macbeth.

He traduced Richard III too, of course, but, writing under the rule of Elizabeth I, granddaughter of Richard's conqueror, he could have done no better. His source, Holinshed, simply said that Macbeth killed Duncan, who was his junior and knew him to be an enemy. The story of the murderous host and the sleeping king is from an entirely different part of Holinshed, about obviously different people.

Shakespeare deliberately turned the ambitious, trouble-seeking young Duncan into a sweet old man beloved by all, who entrusted himself to the care of a hitherto loyal general. Holinshed's account of Macbeth's seventeen-year-long reign, largely happy and contented for Scotland, becomes a horrible, brief bloodbath. The real Macbeth, a generous, pious pilgrim to Pope Leo IX, benefactor of the shrine of St Andrew, becomes Shakespeare's hag-ridden thug, however beautifully further equipped (according to Shaw) 'with the humane and reflective temperament' of a 'nervous literary gentleman'. Is this why *Macbeth* is so unlucky in performance that actors avoid the name, calling it 'the Scottish play'? And that it certainly is not.

**OWEN DUDLEY EDWARDS**

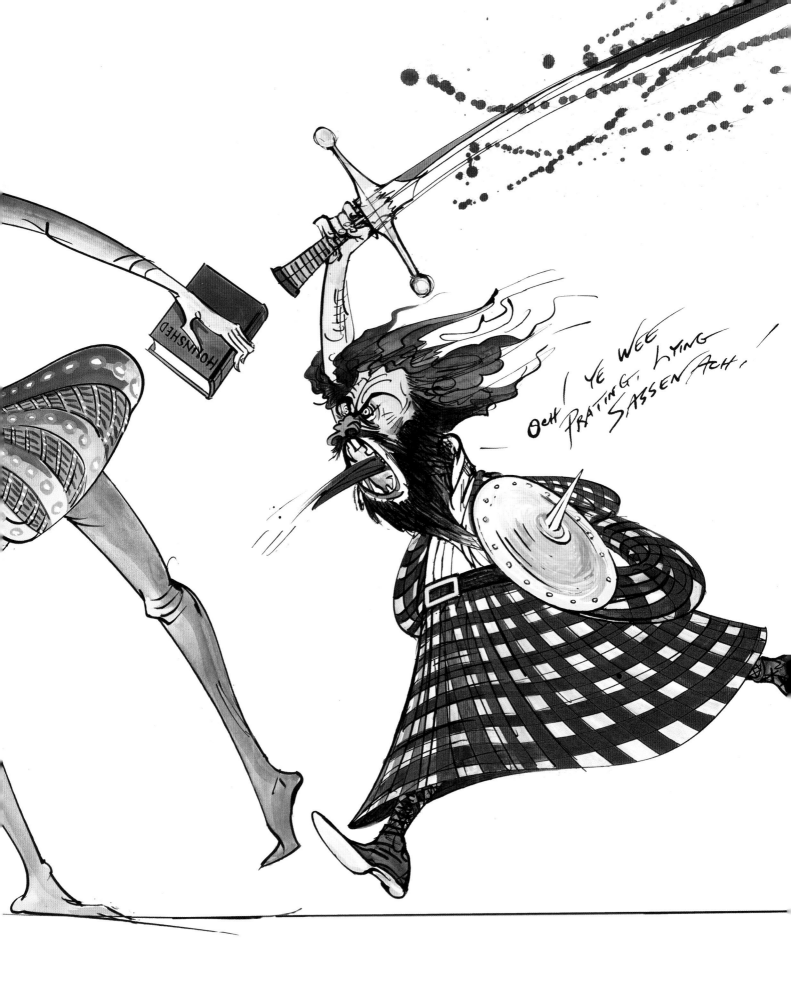

# Adam Smith

ADAM SMITH IS JUSTLY REVERED as the founder of modern economics. His great work *The Wealth of Nations* was published in 1776, as Britain transformed itself into the world's first industrial society and America began its revolution. Smith, an erudite Scotsman, described and explained what he called 'the natural progress of opulence'.

Smith's long discourse contained many new ideas, but the most important was probably the division of labour. He marvelled at the organisation of a pin factory: 'One man draws out the wire, another straightens it, a third cuts it, a fourth points it, a fifth guides it at the top for receiving the head.' Specialised manufacture came to replace the production for own use which had been the normal means of economic organisation for most of history – and still is in many parts of the world today. This is how economic growth transformed agricultural communities into today's global marketplace.

In the twentieth century, Smith became a right-wing icon, and is best known for his metaphor of the 'invisible hand' which leads a businessman to achieve 'an end which was no part of his intention'. Smith was, indeed, an advocate of limited Government, who believed that trade was better undertaken by business people than managed by Governments. And in a world where Government was represented by George III and Louis XVI we can see what he meant.

But read in context, the invisible hand is not the eulogy for unrestricted free markets it appears to be. Indeed, Smith wrote in his other great work, *The Theory of Moral Sentiments*, of the central role of sympathy in human emotion, and of another 'invisible hand' which leads the rich 'to make the same distribution of the necessities of life, which would have been made, had the earth been divided into equal portions amongst all its inhabitants'.

It is fruitless to speculate on what Adam Smith would think today about economic systems unimaginably different from those of two centuries ago. But his values of careful scholarship, meticulous observation and sceptical analysis are as relevant now as they were in the eighteenth century.

JOHN KAY

**ADAM SMITH**
JAMES TASSIE, 1787

# Adam Smith

**T**HE 'INVISIBLE HAND' – ADAM SMITH'S GREAT IDEA – has caused as much damage to humanity as Karl Marx's 'dictatorship of the proletariat'. Smith's theory, expressed in *The Wealth of Nations* (1776), was that if people are allowed to pursue individual gain without hindrance, then, 'led by an invisible hand', they will achieve the betterment of society as a whole. This view – interpreted to mean that Governments should do the bare minimum and that selfishness and greed benefit us all – is the basis of the 'market fundamentalism' that now inspires the rulers of the United States, the most powerful nation on Earth.

The idea of the invisible hand is both damaging and wrong. Damaging because it legitimises the exploitation of labour, the plundering of poor countries and the rape of the environment. Wrong because economists who came after Smith explained the laws of 'unintended consequences'. A decision that is perfectly rational for every single individual who takes it – to make a journey by motor car, for example – may lead to results that nobody would think desirable – traffic jams, global warming, and so on.

Smith himself may not be the true villain; rather, we should blame his modern-day followers who simplify his theory and apply it to a world that Smith himself could not have foreseen. The Europe that Smith knew was one of small traders and producers struggling against monarchical governments that protected hereditary privilege and monopoly. The crimes of twenty-first-century corporations cannot be laid at his door, any more than Stalin's mass murders can be laid at Marx's or the assault on the Twin Towers at the Prophet Mohammed's.

But when you see sweat shops in the Philippines, environmental disaster in South America, starvation in Africa – and when you are told that nothing can be done about such things – be in no doubt. The villain is Adam Smith's 'invisible hand'.

PETER WILBY

*The Invisible Hand That Rocks The Cradle*

# Delia Smith

**DELIA SMITH**
JOHN SWANNELL, 1995

THERE CAN BE FEW PEOPLE IN Britain who have never seen one of Delia Smith's television programmes or referred to one of her cookery books for advice on how to roast a chicken, or make a lemon meringue pie. She has famously taught the nation how to boil an egg. Not as easy as you may think if you want to get it just right. After much practice I've just about got it.

In an age of celebrity chefs and ever more fancy food in ever more fancy locations being prepared on our television screens, Delia has continued to reign supreme. And why is that? She doesn't have the theatricality of Keith Floyd, the funny hair of Gary Rhodes or the good looks of Gordon Ramsey. Indeed, she could be described as dull and mumsy. She doesn't cook ostrich steaks on an African plain, prawns on a beach in Thailand or noodles in downtown Kowloon. She cooks for us in her own kitchen in Norfolk. A very pleasant kitchen certainly but hardly an exotic location. And this is the point about Delia, she is down-to-earth and sensible.

It is all very well getting excited by food, but the bottom line is that if we've a family to feed, we've got to know how to cook. And this is what Delia provides – good recipes carefully explained. She can give you fancy recipes but she also explains the basics. She tells you how much of each ingredient to use, and she explains what will happen during the cooking process.

I imagine that most of us, if we were only allowed to keep one cookery book, would plump for Delia. We know her recipes will work because they are thoroughly researched, tested again and again to ensure that as long as we follow the instructions, it will turn out all right. Delia is the heroine of our kitchens.

MO MOWLAM

# Delia Smith

**W**HEN I LOOKED UP DELIA Smith in *Debrett's People of Today* I found she wasn't listed. I might have guessed. I am sure they asked her. I am sure she declined. On top of everything else, Delia – cook, Christian, football enthusiast – is self-effacing: unshowy, discreet, bereft of vanity and wholly lacking in vulgar social ambition. Delia is perfect in every way. That's what makes her so desperately annoying. With her top-rated television shows and her best-selling books, she has taught the nation to cook and done so in such a pleasant and unassuming way it is positively galling. There is a completely maddening honesty, integrity and simplicity about her. She has a straightforward English name, a wholesome motherly manner, her skin is peachy, her hands well-scrubbed, her recipes tested to destruction. Her recipes never fail. She could teach even me how to boil an egg – and she has. She is in the limelight, but doesn't crave it, she has oodles of dosh and gives most of it away.

It is not her fault that she is faultless. Her heart is pure. Why then is this paragon a villain? Because her perfection makes the rest of us sense our own inadequacy. She is a danger to national morale.

GYLES BRANDRETH

# Margaret Thatcher

**S**HE IS REALLY 'MARGARET THATCHER – HEROINE', not hero, because the single most important fact about Mrs Thatcher is her sex. She was able to do what she did because she was the first woman Prime Minister and it is her sex that has made her a legend.

This does not mean that she was concerned to 'improve the lot of women'. I suspect that this subject hardly interested her at all. Rather, she assumed the superiority of women, and applied this assumption enthusiastically to her dealings with men. She was never very interested in working with women because this represented no sort of challenge. In everything she did, she wanted to overcome a difficulty; she was lower middle class and female and none of her family had ever been to university, so she set out to go to Oxford and marry well and become a lawyer and then a Conservative MP (I don't think she set out to be prime minister – that came much later).

One reason that she was so successful is that she was also genuinely conservative. She was therefore able to win the support of people who might have distrusted her ambition, her radicalism and her sex. She did not question the obstacles that a fairly traditional order of society threw in her way – she simply overcame them.

This portrait shows Margaret Thatcher just after the height of her power. By the mid Eighties, with her consummate professionalism, she had accepted the need to change her voice, her hair, her clothes, her teeth. This is the picture of the first woman to have determinedly and successfully fitted herself for the highest political office. It is therefore a portrait of power and dedication – and of courage.

CHARLES MOORE

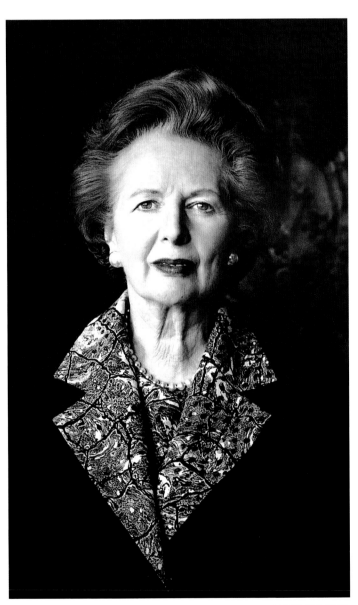

**MARGARET THATCHER**
HELMUT NEWTON, 1991

# Margaret Thatcher

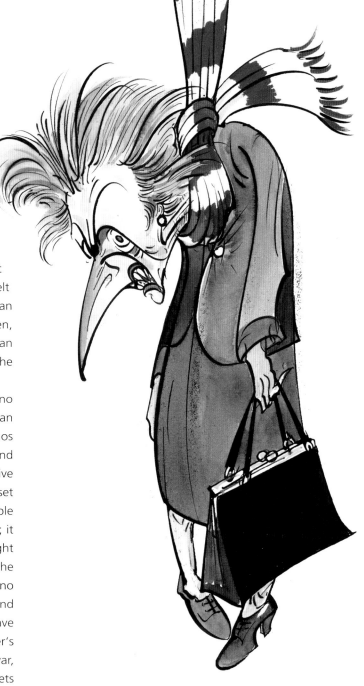

THATCHER IS MY VILLAIN not because she was a Tory prime minister; not because of her privatisations and attacks on the unions; nor because she fought and won the Falklands war (a justified war which would have been unnecessary had her government signalled to Argentina's Galtieri that he was not free to take over whenever he felt inclined); nor because she pushed the Single European Act through parliament under a guillotine and then, having wedded Britain inextricably to the European Union, suddenly and belatedly found out what she had done.

No; she is my villain because she said: 'There is no such thing as society.' Her government inculcated an 'everyone for himself' mentality which bred an ethos of selfishness in a Britain which, during the Second World War, had grown used to having a collective conscience. This ethos did not simply make millions set out greedily to get as much for themselves as possible without paying attention to the wants of the needy; it bred a pattern of anti-social behaviour that brought about such excrescences as proliferation of litter in the streets, putting feet on seats in public transport, no longer bothering to queue for public transport, and other tokens of a society in which courtesies gave place to pushing and shoving. It was during Thatcher's premiership that beggars, not seen since the war, made their appearance in cardboard boxes on streets and in doorways.

The curious aspect of all this is that Thatcher, an orderly person herself, must have hated every one of these manifestations. She would probably denounce them with contumely and deny that they had anything whatever to do with her. But it was she who sowed the dragon's teeth with 'There is no such thing as society'.

GERALD KAUFMAN

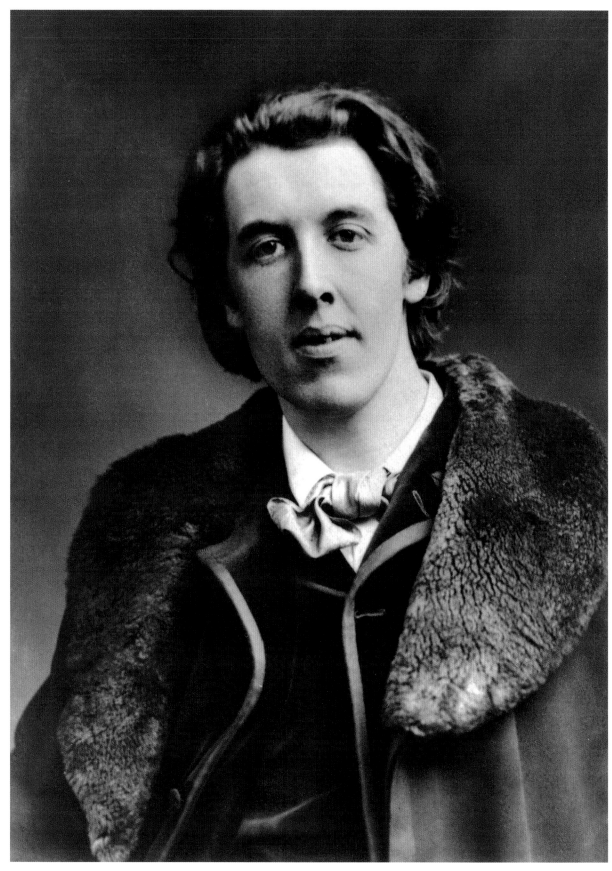

**OSCAR WILDE**
ELLIOTT & FRY, 1881

# Oscar Wilde

**W**ILDE'S *PLAYS OF MODERN LIFE* began in 1892 with *Lady Windemere's Fan* and heralded a few years of amazing success. But by December 1900 Wilde was dead. Reading Gaol, solitary confinement and eight hours a day on the treadmill had done for him. After three months his health was completely broken. This was thought the appropriate punishment for a convicted homosexual just over a hundred years ago.

Wilde was a man of great compassion, who, by his life and his work, demonstrated that love and understanding should breed tolerance, and that tolerance was the very milk of human kindness. He was modest, though he went to great lengths to hide his modesty in outrageous conceit. He was progressive without being dogmatic, tender without being sentimental. He was a pattern of contradictions and he had an Anglo-Irish love of the stiff upper lip as a means of hiding extravagant emotion. He hid behind paradox and took refuge in wit if there was any danger of feeling overcoming him. He believed in God, but only sceptically. He knew that man remains, whatever his disciplines or his education, an animal. But, like the Ancient Greeks, he knew that it was only by knowing the animal that we have any hope of being human. 'Know thyself' was his watchword.

But the English could neither understand nor forgive his brilliance and his contradictions. He clearly loved his wife and his children. But he also loved his fellow males. Even the genius of his work could not permit that. Society broke him because he was different.

PETER HALL

# Oscar Wilde

OSCAR WILDE IS THE HALLMARK CARD of British literature. Open him and you will find a pithy one-liner to mark any occasion.

Like the motto inside a greeting card, Wilde's epigrams are witty, poignant and apparently profound, until you think about them. Then they collapse. It's no surprise that Wilde is the hero of everyone who works in advertising: he writes in jingles, and his cute tunes skim the surface, tickling us with their brilliance, disguising the emptiness that lies beneath.

None of this would matter if people didn't take him seriously – and no one would take him seriously if Wilde hadn't made himself serious by the tragic events of his life. When Wilde chose to sue the Marquess of Queensbury for libel, he ensured that his life would always be more important (and better-remembered) than his art. But he also ensured that his writings would be treated with more reverence and seriousness than they deserve.

We live in an age of soundbites and celebrities. Oscar Wilde can't be blamed for that. However, he is the forerunner of modern celebrity artists, whose lives are more important and more interesting then their art. We can't blame him for *Hello!*, but he must bear some responsibility for the fact that many modern artists would regard an appearance in its shiny pages as the pinnacle of their careers.

If Wilde hadn't been jailed, he would be remembered today as a writer of several brilliant stories for children and some frivolous plays. The tragic end of his life shouldn't be allowed to disguise the silliness of his art. In the words of Dorian Gray 'You would sacrifice anybody . . . for the sake of an epigram.' Wilde squandered his genius on epigrams. To pretend that his writing is anything more profound is like comparing a cheap birthday card to the *Mona Lisa*.

JOSH LACEY

I HAVE NOTHING TO DECLARE BUT MY FLIPPANCY—

# Virginia Woolf

VIRGINIA WOOLF WAS A GREAT WRITER. Her voice is distinctive; her style is her own; her work is an active influence on other writers and a subtle influence on what we have come to expect from modern literature.

She was an experimenter who managed to combine the pleasure of narrative with those forceful interruptions that the mind needs to wake itself. Familiar things lull us. We do not notice what we already know. In art, newness and boldness is vital, not as a rebuke to the past but as a way of keeping the past alive. Virginia Woolf was keenly aware of what she had inherited but she knew that her inheritance must be put to work. Every generation needs its own living art, connected to what has gone before it, but not a copy of what has gone before it.

Virginia Woolf was not an imitator. She was an innovator who re-defined the novel and pointed the way towards its future possibilities.

The twentieth century will be remembered as the century in which the traditional categories of fiction and non-fiction, poetry and prose, reality and invention, even biography and myth, began to topple into each other. Out of this rubble new forms have emerged. Woolf was one of the first to see the possibilities of this chaos: Her *Orlando* (1928) – which called itself a biography, and is a highly fictionalised account of a real person (her friend Vita Sackville West) – is an early experiment with a different kind of writing. Many of the things we take for granted in fiction nowadays – time travel, invented pasts, history seamed through with imagination, begin with Woolf. *Orlando* was a model for the future of fiction, and for the re-interpretation of what biography might mean.

JEANETTE WINTERSON

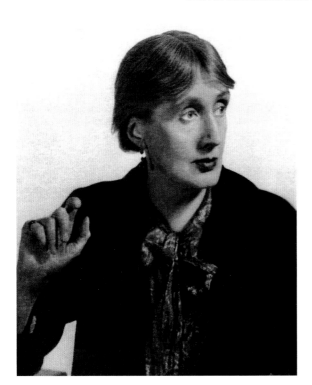

**VIRGINIA WOOLF**
MAN RAY, 1934

# Virginia Woolf

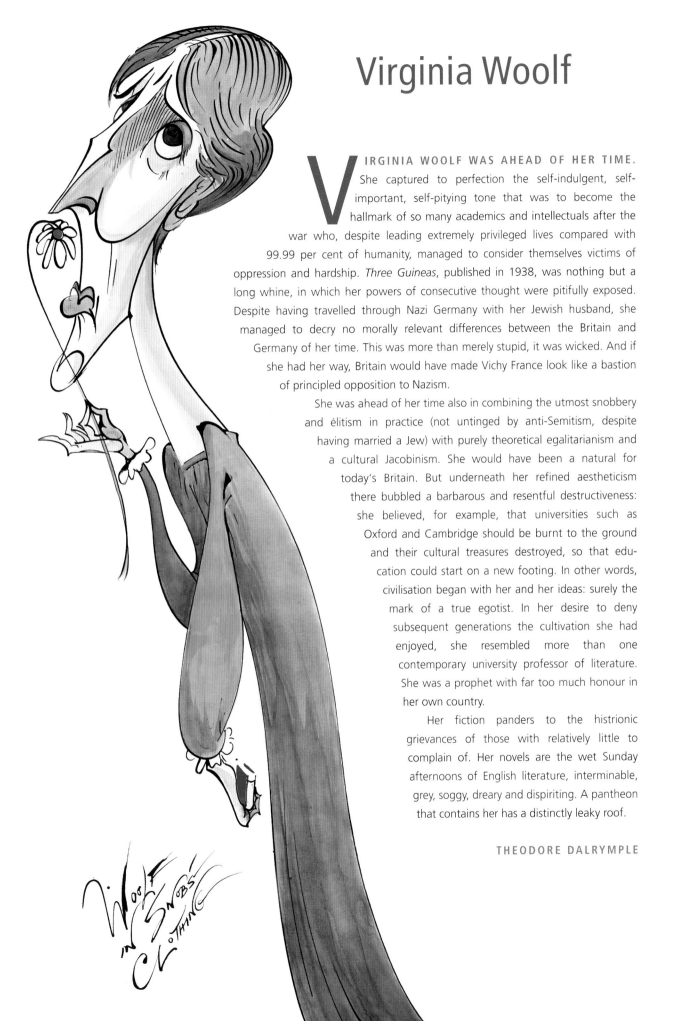

**V**IRGINIA WOOLF WAS AHEAD OF HER TIME. She captured to perfection the self-indulgent, self-important, self-pitying tone that was to become the hallmark of so many academics and intellectuals after the war who, despite leading extremely privileged lives compared with 99.99 per cent of humanity, managed to consider themselves victims of oppression and hardship. *Three Guineas*, published in 1938, was nothing but a long whine, in which her powers of consecutive thought were pitifully exposed. Despite having travelled through Nazi Germany with her Jewish husband, she managed to decry no morally relevant differences between the Britain and Germany of her time. This was more than merely stupid, it was wicked. And if she had her way, Britain would have made Vichy France look like a bastion of principled opposition to Nazism.

She was ahead of her time also in combining the utmost snobbery and élitism in practice (not untinged by anti-Semitism, despite having married a Jew) with purely theoretical egalitarianism and a cultural Jacobinism. She would have been a natural for today's Britain. But underneath her refined aestheticism there bubbled a barbarous and resentful destructiveness: she believed, for example, that universities such as Oxford and Cambridge should be burnt to the ground and their cultural treasures destroyed, so that education could start on a new footing. In other words, civilisation began with her and her ideas: surely the mark of a true egotist. In her desire to deny subsequent generations the cultivation she had enjoyed, she resembled more than one contemporary university professor of literature. She was a prophet with far too much honour in her own country.

Her fiction panders to the histrionic grievances of those with relatively little to complain of. Her novels are the wet Sunday afternoons of English literature, interminable, grey, soggy, dreary and dispiriting. A pantheon that contains her has a distinctly leaky roof.

THEODORE DALRYMPLE

# Biographies &

# & Appendices

# Biographies of Subjects

**Sir Richard Arkwright** (1732–92) inventor and entrepreneur. A leading light of the Industrial Revolution, Richard Arkwright was largely self-taught and started out as a barber and wig-maker. In response to the textile industry's demand for more advanced machinery, he collaborated with John Kay to invent a spinning machine that would mechanise the production of cotton thread. In 1768 he set up a business in Nottingham (then the centre for cotton hosiery manufacture) and built a spinning mill run by horsepower. Three years later, he constructed a water-powered mill at Cromford, which was more revolutionary, both in its use of new technologies and in its organisation of labour. It was this that established him as a founding father of the modern factory system.

**John Logie Baird** (1888–1946) television inventor. After studying electrical engineering at Glasgow University, Baird embarked on a series of ill-fated projects, including schemes to manufacture artificial diamonds and to invent a cure for haemorrhoids. In 1922, however, he succeeded in creating a machine that transmitted moving pictures over short distances. These distances soon increased substantially, and by 1928 – two years after his first public demonstration of 'television' – Baird made the first transatlantic broadcast. The BBC used Baird's mechanically scanned thirty-line television system from 1929 until 1937, before adopting Marconi-EMI's electronically scanned 405-line system. Baird worked with television technology for the rest of his life, developing infra-red TV and experimenting with coloured and three-dimensional images.

**The Beatles** (1960–70) [George Harrison, John Lennon, Paul McCartney and Ringo Starr] pop band. John Lennon and Paul McCartney first played together in 1957 in the skiffle group The Quarrymen; George Harrison joined the following year, and the band was eventually rechristened 'The Beatles', with drummer Ringo Starr completing the line-up. In 1962 their second single, 'Please Please Me', became the first of twenty-eight British number-one hits; others included 'Yesterday', 'Hello Goodbye', 'Hey Jude' and 'Let It Be'. The Beatles were the first major pop group to write, play and sing their own material, and led a British invasion of the American charts, creating a wave of 'Beatlemania'. Despite breaking up in 1970, the Beatles remain the most successful and influential band in music history.

**David and Victoria Beckham** (b.1975 and b.1975) footballer and pop singer respectively. When 'Posh and Becks' were married in 1999, they established themselves as Britain's most glamorous couple. David rose to fame with Manchester United and in 1997 earned his first England cap; he has since captained the national side, and has earned an awesome reputation as a master of the dead ball. In summer 2003 he was signed up as a player for Real Madrid. He is regarded as a style icon and is among the most famous sportsmen in the world. Victoria was a member of the hugely successful all-female pop group, The Spice Girls. She launched a solo career in 2000 with the garage-inspired hit 'Out of Your Mind', and has since worked as a fashion model and television presenter.

**George Best** (b.1946) footballer. Born in Belfast, George Best made his league début with Manchester United in 1963 and remained with the club for ten years. He quickly established a reputation as the most skilful footballer of his generation, and a prodigious striker, scoring well over a hundred goals for the club. Capped thirty-seven times by Northern Ireland, he won both the

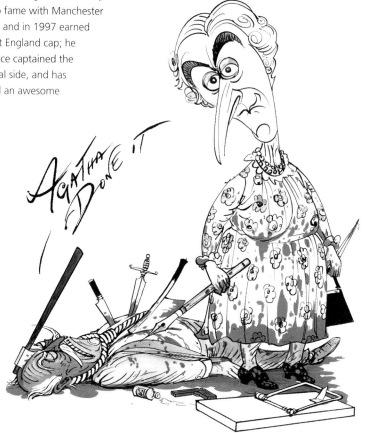

English and European Footballer of the Year awards in 1968, and helped United to victory in the European Cup the same year. Sometimes called 'the fifth Beatle', he was the first footballer to rival pop stars for glamour, but gained notoriety as a drinker and womaniser, and suffered a premature end to his career as a result of his excesses.

**William Blake** (1757–1827) artist, poet and visionary. The son of a wealthy London hosier, Blake was apprenticed at sixteen to an engraver, and by 1784 had opened a print shop, where he published his own poems in illustrated form. Though his early poetry such as *Songs of Innocence* (1789) and *Songs of Experience* (1794) uses simple verse forms, his later works are highly symbolic and complex, reflecting his interest in unorthodox religion. Besides being the first of Britain's great Romantic poets, Blake was a strong influence on artists such as Samuel Palmer. His reputation grew after his death as his warnings against the inhuman world of the Industrial Revolution – the 'dark satanic mills' of 'Jerusalem' – found their equivalent in reality.

**Sir Richard Branson** (b.1950) entrepreneur. Aged only nine, Richard Branson started his first businesses: selling budgerigars and Christmas trees. While still at public school, Branson achieved commercial success with the publication of *Student* magazine. Soon afterwards he established his Virgin mail-order record business; in 1971 he moved into record shops, and two years later started the Virgin record label. In the 1980s he began to shift his focus towards the transport industry, introducing Virgin Atlantic Airlines in

1984 and Virgin Trains in 1996. He sold the Virgin music interests to Thorn EMI in 1992, partly to finance the expansion of his airline. An insatiable adventurer, Branson – with fellow pilot Per Lindstrand – made the first crossing of the Atlantic and Pacific oceans by hot air balloon in 1987 and 1991 respectively.

**Dame Agatha Christie** (1890–1976) novelist and playwright. Born of a wealthy American father, Christie studied singing in Paris. While working as a nurse in the First World War she began writing, and her first work of detective fiction, *The Mysterious Affair of Styles*, was published in 1920. The creator of such characters as Hercule Poirot and Miss Marple, her best book is considered to be *The Murder of Roger Ackroyd* (1926). Other popular novels include *Murder on the Orient Express* (1934) and *Death on the Nile* (1937). In addition to more than

seventy novels, which have been translated into 103 languages, Christie wrote *The Mousetrap* (1952), a play which has run in the West End for more than fifty years.

**Sir Winston Churchill** (1874–1965) politician and writer (Prime Minister 1940–5, 1951–5). Churchill first entered Parliament in 1900, and held important posts in both Conservative and Liberal governments. An early opponent of appeasement, he was shut out of top-level politics for much of the 1930s (his 'wilderness years'), but in 1940 became Prime Minister, a post which he held for the remainder of the Second World War. Despite securing Britain's alliance with the USA and leading the nation to victory, he lost the 1945 election. He made another comeback and was re-elected Prime Minister in 1951; he resigned four years later, at the age of

eighty-one. His literary works, for which he was awarded the Nobel Prize in 1953, include *The Second World War*.

**Oliver Cromwell** (1599–1658)
politician (Lord Protector 1653–8) and soldier. As MP for Huntingdon and then Cambridge, Oliver Cromwell was an outspoken critic of Charles I. He helped lead the parliamentary forces to victory in the Civil War, and played a key role in the execution of the King in 1649; he also led ruthless campaigns against the Irish and Scots. Cromwell emerged as head of state in the form of Lord Protector when he and the army dissolved Parliament in 1653; though the second Protectorate Parliament offered him the crown in 1657, he refused it. He died the following year. After the restoration of the monarchy in 1660, his body was exhumed, hanged and beheaded.

**Charles Darwin** (1809–82)
naturalist. Upon graduating from Cambridge in 1831, Charles Darwin spent five years in the southern hemisphere as the ship's naturalist aboard HMS *Beagle*. From the observations he made in the Galapagos Islands, he concluded in 1837 that, rather than having remained fixed since creation, species continually evolved. Darwin was reluctant to share this conclusion, knowing his theory would be seen as irreligious, but after receiving a paper from Alfred Russel Wallace in 1858 that presented an evolutionary theory similar to his own, he rushed to finish *The Origin of Species*. It was published the following year, and its challenge to the biblical view of history created an immediate furore. Its sequel, *The Descent of Man*, appeared in 1871.

**Diana, Princess of Wales** (1961–97)
As the daughter of the 8th Earl of Spencer, Diana was seen as an excellent choice of bride for Prince Charles.

Following their wedding in 1981, she emerged unexpectedly as a fashion-conscious beauty with a mind of her own. This, together with her warmth as a mother and her devotion to charitable causes, transformed her into an international icon. Always a subject of media fascination, Diana's love life gave rise to even more speculation after her separation from Charles, and her relationship with Dodi Al-Fayed was under intense scrutiny when the two were killed in a car crash in Paris on 31 August 1997. The following week saw an unprecedented outbreak of public mourning for the 'People's Princess'.

**Elizabeth I** (1533–1603)
Queen of England (1558–1603). The daughter of Henry VIII and Anne Boleyn, Elizabeth succeeded her Catholic sister Mary, much to the relief of England's persecuted Protestants. Despite tensions among the Catholic populace, especially after the execution of Mary Queen of Scots, Elizabeth's reign saw the firm establishment of the Church of England. Known as 'the Virgin Queen', she remained unmarried, but used her

availability to play a shrewd diplomatic game with the great powers of France and Spain, and inspired her subjects' loyalty in the face of grave foreign threats – notably that of the Armada. She encouraged explorers such as Sir Francis Drake and Sir Walter Ralegh, and her reign was characterised by a flourishing of literature and music.

**Tracey Emin** (b.1963)
artist. One of Britain's best-known contemporary artists, Tracey Emin grew up in Margate and studied at KAID, previously Maidstone College of Art, (1983–6) and the Royal College of Art (1987–9). She uses a wide range of media from appliqué to neon to express different aspects of her life experience – including confronting the traumas of rape and abortion. She is particularly known for her installations *Everyone I Have Ever Slept With 1963–1995* (1995) – a tent embroidered with names – and for *My Bed* (1998), the latter giving rise to huge controversy when Emin was shortlisted for the Turner Prize in 1999. This work is currently on display at the Saatchi Gallery at County Hall, London.

**Rosalind Franklin** (1920–58)
scientist. After completing her doctorate at Cambridge in 1945, Rosalind Franklin moved to Paris, where she learned X-ray diffraction techniques at the Laboratoire Central des Services Chimiques de L'Etat. In 1951 she began work as a research assistant for John Randall's laboratory at King's College, London, and led a group in the study of DNA. She produced high-quality X-ray diffraction photos, which her hostile colleague Maurice Wilkins showed to fellow DNA researchers James Watson and Francis Crick at Cambridge. These enabled Watson and Crick to discern DNA's helical structure and its existence in two crystalline forms. Wilkins, Watson and Crick won the Nobel Prize for this work in 1962, four years after Franklin had died of ovarian cancer.

**Kenneth Grahame** (1859–1932)
children's writer. Born into a Scottish literary family, the young Grahame composed non-fiction pieces for publications such as *The Yellow Book* while working as a gentleman-clerk at the Bank of England. He married Elspeth Thomson in 1899 and they had one son, Alistair. He created the basis for *The Wind in the Willows* in letters sent to Alistair while away from his parents on holiday in 1907. The complete book was published in 1908. It was not an immediate success, but eventually became a children's classic with the help of E.H. Shepherd's illustrations and A.A. Milne's stage adaptation, *Toad of Toad Hall*. After his son's death during the First World War, Grahame stopped writing and became a recluse.

**Graham Greene** (1904–91)
novelist, poet and screenwriter. Greene was still a student at Oxford when he published his first book of verse. Upon graduation he became a newspaper sub-editor, until the success of his first novel, *The Man Within* (1929), allowed him to become a full-time writer. With the encouragement of his future wife he converted to Catholicism – a key influence on his work – in 1926. Although sued by 20th Century Fox for criticising Shirley Temple in a film review, he was responsible for screenplays such as *The Third Man*. Greene travelled extensively in search of new material, and the persecution of the Catholic Church in Mexico inspired him to write arguably his best work, *The Power and the Glory*.

**Henry VIII** (1491–1547)
King of England and Ireland. After succeeding his father Henry VII, in 1509, he embarked on expensive wars against France and Scotland. In 1531 the Pope awarded him the title of Defender of the Faith for writing (or taking credit for) an anti-Lutheran tract. After his marriage to Catherine of Aragon failed to produce a male heir, Henry sought to have it annulled, and was furious when the Pope refused to co-operate. In 1535 he established himself as head of the Church of England, which left him free to marry a further five times. Although he eventually fathered the heir he needed – Edward VI – the boy reigned for only six years before dying at the age of sixteen.

**William Hogarth** (1697–1764)
artist. Although he was an innovative portrait painter, leading the new fashion for the conversational piece, it was as a satirical engraver that Hogarth won an international reputation, with series such as the *Harlot's Progress* (1732), the *Rake's Progress* (1733–5) and *Marriage*

*Hogarth as his Dog Pug*

à-la-mode (1743–5). Since his engravings were often copied illegally, he championed a copyright act (often called Hogarth's Act), which became law in 1735. In the same year he wrote a statement of his aesthetic principles, *The Analysis of Beauty*, which was well-received on the Continent but scorned by British critics since it held that the artist's convictions carried more weight than theirs. He played an important part in professionalising the arts, which culminated in the founding of the Royal Academy in 1768. However, he would have objected to the hierarchical structure of the institution.

**Ken Livingstone** (b.1945)
politician (Mayor of London 2000–). Known to his adversaries as 'Red Ken', Livingstone entered London politics as a Labour councillor for Lambeth in 1971, and was leader of the Greater London Council (GLC) from 1981 until 1986. His progressive views and his support for controversial fringe groups put him at odds not only with the Conservative government of Margaret Thatcher – which abolished the GLC – but with many members of his own party too. Later, as MP for Brent East (1987–98), Livingstone became one of the parliamentary Left's most outspoken

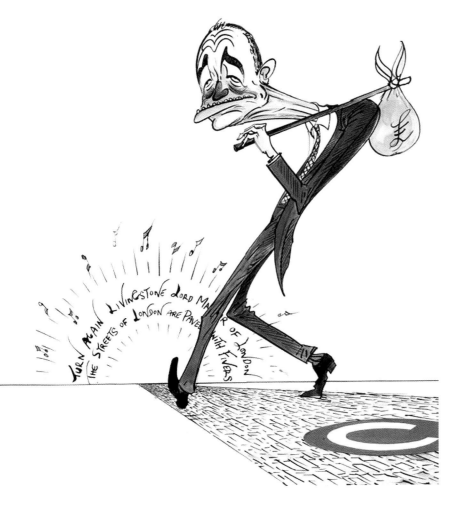

voices. Rejected by the Labour leadership as its candidate for London's mayoral elections, he stood successfully as an independent. In 2003 he launched London's congestion-charge system.

**Earl Lloyd-George** (1863–1945)
politician (Prime Minister 1916–22). A Welshman known for his charisma and eloquence, David Lloyd George proved himself an architect of groundbreaking liberal reform as Chancellor of the Exchequer (1908–15) by introducing the Old Age Pensions Act (1908) and the National Insurance Act (1910). He was the one leading Liberal to meet the challenges of the First World War, and in 1916 became Prime Minister of the Coalition Government. Although he proved a successful war leader, and went on to win the 1918 election, he alienated many Conservatives by agreeing to the partition of Ireland in 1921. He was also accused of selling Honours, and in 1922 was voted out of office. He remained an MP for the rest of his life.

**Sir Oswald Mosley** (1896–1980)
politician. A graduate of Sandhurst, Oswald Mosley began his political career as Conservative MP for Harrow (1918–22). Dissatisfied with the party, he then sat as an independent (1922–4) before joining the newly formed Labour Party. He became Chancellor of the Duchy of Lancaster in 1929, and proposed a national programme of public works and Government spending to solve Britain's severe economic problems – a plan which proved too radical for the Labour Cabinet. He resigned from the Government in 1930 and founded first the New Party and then the British Union of Fascists. His party's anti-Semitic stance led to the Battle of Cable Street in 1936, and he and his wife Diana were imprisoned as Nazi sympathisers from 1940–3.

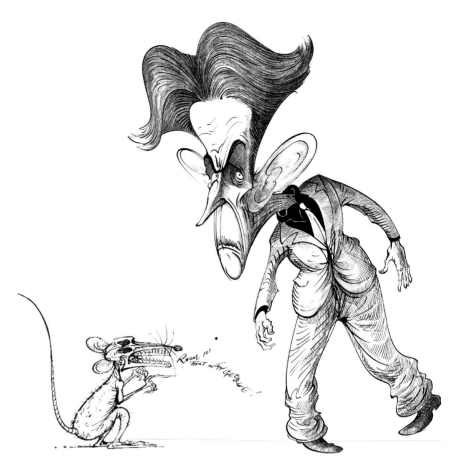

**Sir Isaac Newton** (1642–1727)
mathematician and scientist. Driven from his studies at Cambridge by the plague, he returned to his home at Woolsthorpe Manor in Lincolnshire, and in 1665–6 achieved some of the most spectacular results in the history of physics and mathematics. He solved several major problems that had flummoxed mathematicians for several decades, and developed a series of important theories concerning light, colour and calculus, as well as the 'Universal Law of Gravitation'. Interested in the work of Galileo, Newton constructed what is believed to be the world's first reflecting telescope, to observe the moons of Jupiter. He reformed Britain's coinage as Master of the Mint, and was President of the Royal Society from 1703 until his death.

**George Orwell** (1903–50)
writer. The son of a civil servant, George Orwell was born Eric Blair in Bengal, India. After Eton he joined the Imperial Indian Police, but came to hate the system he served, and in 1927 left to become a writer. He detailed his time in the police force in his first novel *Burmese Days* (1934). After working for the BBC and *The Observer*, he travelled to Spain to cover the Civil War, but ended up joining the Republican forces; he recorded his experiences in *Homage to Catalonia* (1938). Horrified by the excesses of Stalinism, he wrote *Animal Farm* in 1945, followed by the prophetic *Nineteen Eighty Four*. His career was cut short when he died at forty-seven of tuberculosis.

**Emmeline Pankhurst** (1858–1928)
suffragette. After serving with her husband on the Manchester Women's Suffrage Committee, Emmeline Pankhurst founded the Women's Social and Political Union (WSPU) in 1903 with her daughter Christabel. The two moved to London as the WSPU became more

militant and nationally focused. Emmeline was imprisoned on charges of vandalism and took part in multiple hunger strikes between 1911 to 1914. In observance of the militants' truce, the WSPU ceased its activities on the outbreak of the First World War, whereupon Pankhurst channelled her energies into the war effort, making public speeches to urge enlistment. As a result of the truce, she took little part in the campaigns leading to the first phase of women's suffrage in 1918.

**HRH The Prince of Wales** (b.1948)
heir to the British throne. Though quiet and artistic by nature, Prince Charles served successfully in the Navy after graduating from Trinity College, Cambridge. He has subsequently devoted himself to public service, taking particular interest in the environment, architecture and young people. The Prince raises tens of millions of pounds for charities each year, and has founded such charities as the Prince's Trust, which helps disadvantaged young people. In 1981, Charles married Lady Diana

Spencer, with whom he had two sons, Princes William (b.1982) and Harry (b.1984). Prince Charles's obvious affection for his sons – who share his enthusiasm for polo – and his determination to bring them up well has enhanced his reputation. He is also a leader in the organic food industry, with much of the profit from his Duchy Originals line going to the Prince of Wales's Charitable Foundation.

**Richard III** (1452–85)
King of England (1483–5). Richard became Duke of Gloucester soon after his eldest brother, Edward IV, won the throne for the House of York in the Wars of the Roses. After Edward's death in 1483, Richard was appointed protector to the young Edward V, but two months later proclaimed himself King. When Edward V and his brother the Duke of York – the 'Princes in the Tower' – disappeared shortly afterwards, Richard did nothing to dispel reports that they had been murdered, and many of Edward IV's followers joined the Duke of Buckingham in revolt. In 1485 Richard

fought Henry, Earl of Richmond (afterwards Henry VII) at the Battle of Bosworth Field, and was killed, possibly by his own troops.

**John Ruskin** (1819–1900)
art critic and social theorist. Through his extensive travels, John Ruskin acquired a love for European landscape and architecture, forming a lasting influence on his personal aesthetic, with its emphasis on truth to nature. His art criticism and social theory went hand-in-hand; the superiority of Venetian and Gothic architecture to that of his own age was, he believed, due to the superiority of the medieval work ethic. Ruskin's best-known works include *Modern Painters* (1843–60), *The Seven Lamps of Architecture* (1849) and *The Stones of Venice* (1851–3). He championed Turner and the Pre-Raphaelites, and his writings were a vital inspiration to the Arts and Crafts movement, helping to give craftsmen a new status in society.

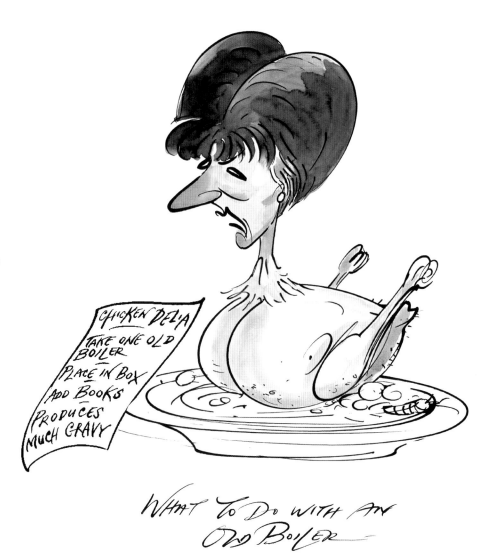

WHAT To Do WITH AN OLD BOILER

**Captain Scott** (1868–1912)
explorer of Antarctica. Robert Falcon Scott joined the Navy as a cadet at thirteen, and went on to become Commander of HMS *Discovery* on the National Antarctic Expedition of 1901–04. After reaching Antarctica, the expedition travelled further south than any previous party, and Scott returned to Britain a national hero. He led another Antarctic expedition in 1910, this time hoping to win the race to the South Pole. Blizzards and severe temperatures forced seven members of his team to turn back; Scott and his four remaining companions finally reached the South Pole on 18 January 1912, only to find that Norwegian explorer Roald Amundsen had arrived there a month earlier. Scott and his men died on the return journey in March. Their bodies were found eight months later.

**William Shakespeare** (1564–1616)
poet and playwright. Born in Stratford-upon-Avon, Shakespeare moved to London to earn his living as a playwright and performer – possibly for either the Leicester or Queen's Players. During this time he attracted the patronage of Henry Wriothesley, Earl of Southampton, who many believe was the subject of Shakespeare's sonnets, which he began writing in 1593. He also attracted Elizabeth I's favour. Later in life he returned to Stratford. Shakespeare's plays can be divided into four categories: tragedies (including *Hamlet* and *Macbeth*); histories (*Henry V*, *Richard III*); comedies (*Twelfth Night*, *A Midsummer Night's Dream*); and the mysterious last plays (*A Winter's Tale*, *The Tempest*). He is the most celebrated English playwright and poet, and his influence on European culture is surpassed only by the Bible.

**Adam Smith** (1723–90)
political economist. The son of a Scottish comptroller of customs, Adam Smith studied first at Glasgow Unversity, and then Oxford University for seven years before becoming Professor of Moral Philosophy at Glasgow, where he wrote *The Theory of Moral Sentiments* (1759). In 1776 he settled in London, publishing his most influential text, *Inquiry into the Nature and Causes of the Wealth of Nations*, the same year. In it he argued for individual freedom and enterprise tempered by moral obligations such as kindness, sympathy and justice. He also used this work to voice his belief in free trade, as opposed to the exclusive rights of the mother country (on which the British Empire was then based). He returned to Scotland and was appointed Commissioner of Customs in Edinburgh in 1778.

**Delia Smith** (b.1941)

cookery writer. Delia Smith began cooking seriously to quiet a boyfriend who constantly praised a former girlfriend's expertise. After studying cookery books in the British Museum, she tried out recipes on friends, and by 1969 was providing recipes for the *Daily Mirror*. She was writing for the *Evening Standard* (1972–85) when she published her first book, *How to Cheat at Cooking* (1973). Her influence is such that she can clear supermarket shelves of an ingredient simply by mentioning it, as with the 'Great Cranberry Crisis' in 1998. *How to Cook I and II* (1998/9) – published to accompany her eponymous television series – are her most successful books to date. A passionate football supporter, she serves on the board of Norwich City.

**Baroness Thatcher** (b.1925)

politician (Prime Minister 1979–90). The daughter of a grocer, Margaret Thatcher studied chemistry at Oxford before training as a barrister. As Conservative MP for Finchley, she rose to become Leader of the Opposition in 1975. She was elected Britain's first woman Prime Minister in 1979, and secured her position by successfully sending troops to recapture the Falkland Islands from Argentina. Her second administration was marked by a policy of privatisation, and – buoyed up by the economic boom of the mid 1980s – she narrowly secured a third term in office. But her radically right-wing politics gave rise to violent opposition – from the miners' strikes of 1984–5 to the anti-poll-tax riots of 1990 – and she resigned after losing the confidence of her party.

**Oscar Wilde** (1854–1900)

writer. The son of an eminent Irish surgeon, Wilde's reputation for verbal brilliance and flamboyant behaviour was founded during his student days at Oxford. He began to publish essays and stories such as *The Happy Prince*, but it was not until publication of his only novel, *The Picture of Dorian Gray* (1891), that he achieved real prominence. A leader of the Aesthetic movement, he scored a huge success with plays such as *Lady Windermere's Fan* and *The Importance of Being Earnest*. But his relationship with the young Lord Alfred Douglas brought about his downfall, and led to a prison sentence for homosexual practices. His health broken, Wilde died three years after leaving prison, at the age of forty-six.

**Virginia Woolf** (1882–1941)

novelist. A leading member of the Bloomsbury Group – along with her sister, the painter Vanessa Bell – Virginia Woolf was a pioneer of the 'stream of consciousness' technique in literature. Her reputation was established with *Mrs Dalloway* (1925); later novels included *To the Lighthouse* (1927) and *The Waves* (1931). Her essay *A Room of One's Own* (1929) is regarded as a feminist classic. She married writer Leonard Woolf in 1912 and together they founded the Hogarth Press, which published the works of such authors as Katherine Mansfield and T.S. Eliot, as well as those of Woolf herself. After suffering from manic depression for much of her life, she committed suicide by walking into the River Ouse near her house in Rodmell, Sussex.

# Biographies of Contributors

**Wallace Arnold**

Wallace Arnold is a veteran writer and broadcaster. His books include *A Man for All Seasons: A Biography of Prince Philip*; *Doctor, There's a Fly in My Engine – The Punch Book of Motoring* and *Those Marvellous Mitfords*.

**Jeremy Ashbee**

Jeremy Ashbee has been an Assistant Curator at the Tower of London since 1996. He has a particular interest in the Tower of London in the Middle Ages, and he is currently completing his doctorate on 'The Tower of London as a Royal Residence, 1066–1400' at the Courtauld Institute of Art, London.

**Lynn Barber**

Lynn Barber is a journalist who has won five British Press Awards and currently works for the *Observer*. She has published two books of interviews, *Mostly Men* and *Demon Barber*.

**Stephen Bayley**

Stephen Bayley is one of the world's best-known authorities on design. Creator of the Victoria and Albert Museum's influential Boilerhouse Project and London's unique Design Museum, he is the author of countless articles and many books including *The Albert Memorial* and *Sex*.

**Peter Bowler**

Peter J. Bowler is Professor of the History of Science at Queen's University, Belfast, and is a member of the Royal Irish Academy. He has published widely on Darwin and on the history of evolution. His most recent book is on the interaction between science and religion in early twentieth-century Britain.

**Melvyn Bragg**

The Rt Hon. Lord Melvyn Bragg is Controller of Arts and Features at London Weekend Television and Editor and Presenter of *The South Bank Show*. He serves as President of the National Campaign for the Arts, a Governor of the London School of Economics, President of Mind and Chancellor of Leeds University. He writes and presents 'In Our Time' on Radio 4. His latest novel is *A Son of War*.

**Gyles Brandreth**

Gyles Brandreth is a writer, broadcaster, performer and former MP. His career has ranged from serving as a Lord Commissioner of the Treasury in John Major's government to appearing in his own award-winning musical *Zipp!* in the West End. He has published diaries, novels, biographies and children's books.

**Craig Brown**

Craig Brown writes the thrice-weekly 'Way of the World' column for the *Daily Telegraph*. He also writes a weekly book review for the *Mail on Sunday* and the parodic diary for *Private Eye*. He has published a selection of his writing, *This is Craig Brown*.

**Beatrix Campbell**

Beatrix Campbell is a journalist, writer, and broadcaster. Her articles appear in *The Guardian*, *The Independent* and *The Scotsman*. She is also Visiting Professor of Women's Studies at Newcastle University. Her books include *Diana, Princess of Wales: How Sexual Politics Shook the Royal Family* and *Goliath: Britain's Dangerous Places*. With Judith Jones she co-authored the acclaimed play *And All the Children Cried*.

**John Carvel**

John Carvel is Social Affairs Editor of *The Guardian*. He has been with the paper since 1973 and his specialities have included industry, local government, politics, home affairs, European affairs and education. He won a Freedom of Information Award for action in the European Court of Justice against official secrecy in the European Union.

**Theodore Dalrymple**

Theodore Dalrymple is a doctor who writes a column for *The Spectator* and is Contributing Editor of the *City Journey of New York*. His books include *Mass Listeria: The Meaning of Health Scares*, *So Little Done: The Testament of a Serial Killer* and *Life at the Bottom*.

**Hunter Davies**

Hunter Davies is the author of over forty books, including the only authorised biography of the Beatles. He has also written biographies of William Wordsworth, Beatrix Potter, R.L. Stevenson, George Stephenson, Alfred Wainwright and Eddie Stobart. As a journalist, he writes about football in the *New Statesman* and about money in the *Sunday Times*.

**Richard Dawkins**

Professor Richard Dawkins has been Lecturer in Zoology at Oxford and a Fellow of New College since 1970. In 1976 he published his first book on evolution, *The Selfish Gene*. He is the author of numerous award-winning books, including *The Blind Watchmaker*.

**Bill Deedes**

The Rt Hon. Lord Deedes began his journalism career with the *Morning Post* in 1931, and was a war correspondent in 1935. After serving in the Second World War, he was elected as a Conservative MP for Ashford (1950–74). From 1974 to 1986 he served as Editor of the *Daily Telegraph*. He has written an autobiography, *Dear Bill: W.F. Deedes Reports*.

**Julia Eccleshare**

Julia Eccleshare is a writer, broadcaster and lecturer, as well as Children's Book Editor for *The Guardian*, Chairman of the

Smarties Book Prize and winner of the Eleanor Farjeon Award 2000 in recognition of her contribution to children's literature. Her books include *A Guide to the Harry Potter Novels* and *Beatrix Potter to Harry Potter*.

**Owen Dudley Edwards**
Owen Dudley Edwards is Reader in History at the University of Edinburgh and has taught at a number of universities in the United States. The author and editor of many books, his subjects include John Adams, Burke and Hare, Thomas Carlyle, Anthony Trollope, Oscar Wilde, Conan Doyle and P.G. Wodehouse.

**Robert Elms**
Robert Elms presents a weekday afternoon radio show on BBC London. An accomplished journalist, he was named Travel Writer of the Year in 1997 and is the author of *Spain: A Portrait After the General*. He has also written a novel, *In Search of the Crack*.

**Harold Evans**
Harold Evans was Editor of the *Sunday Times* from 1967–81 and Editor of *The Times* from 1981–2. In the US, he was President of Random House and also served as Editorial Director and Vice Chairman of *US News and World Report*, the *New York Daily News* and the *Atlantic Monthly*. His history book *The American Century* was an acclaimed best seller. He is currently writing a book and television series on innovation.

**Ranulph Fiennes**
Sir Ranulph Fiennes served in the Royal Scots Greys, the SAS and the Sultan of Oman's Forces. He received the Sultan's Bravery Medal in 1970. With Charles Burton, he was the first to reach both Poles and to circumnavigate Earth on a polar axis. With Dr Mike Stroud, he was the first to cross the Antarctic continent unsupported. He discovered the long-lost city of Ubar in Saudi Arabia in 1991.

**A.A. Gill**
Adrian Anthony Gill is a features writer and critic for the *Sunday Times* and *GQ*. He has won numerous awards for his writing, including two Glenfiddich awards for his travel writing, the *Sunday Times Magazine* Writer of the Year and the 'What the Papers Say' Critic of the Year. He has written two novels, *Star Crossed* and *Sap Rising*, as well as *The Ivy Cookbook*.

**Peter Hall**
Sir Peter Hall is a director of plays, operas and films. He founded the Royal Shakespeare Company in 1960 and was Director of the Royal National Theatre from 1973 to 1988. He has won many awards, including two Tony Awards and an Olivier Award for Lifetime Achievement. He founded his own company, the Peter Hall Company, in 1988, for which he has directed more than forty productions.

**Adam Hart-Davis**
Adam Hart-Davis is a writer, broadcaster, and presenter of the *Local Heroes* television programmes. The recipient of a Medal from the Royal Academy of Engineering for the Public Promotion of Engineering, he has also worked as a television producer and science photographer.

**Thelma Holt**
Thelma Holt founded the Open Space Theatre in 1969 and was then Director of the Round House. Subsequently she was Head of Touring and Commercial Exploitation at the National Theatre. She is now an independent theatre producer in the London's West End, United Kingdom and overseas, mainly in Japan. In 1998 she was Cameron Mackintosh Professor of Contemporary Theatre at Oxford.

**Tristram Hunt**
Dr Tristram Hunt teaches history at Queen Mary College, University of London. His book on Victorian civic pride, *Manufacturing Cities*, will be published by Weidenfeld & Nicolson in early 2004. He writes regularly for *The Guardian* and *The Observer* and recently made the case for Isaac Newton in the BBC series *Great Britons*.

**Shirley Hughes**
Shirley Hughes is an author and illustrator of children's books. Starting as an illustrator, she began to write and illustrate her own books when her children were young. Best known for her series *Lucy and Tom* and *Alfie and Annie Rose*, she has more recently written and illustrated visually adventurous books for slightly older children, such as *Ella's Big Chance*.

**P.D. James**
Baroness James of Holland Park is the author of fifteen crime novels and two non-fiction books, and is President of the Society of Authors. She worked in the National Health Service and the Home Office, retiring in 1979. She has seven honorary doctorates from various British universities.

**Rachel Johnson**
Rachel Johnson writes a heavyweight weekly column for the *Daily Telegraph* called the 'Mummy Diaries' and also contributes to *The Spectator* with 'tiresome regularity'. She has worked for the BBC, the Foreign Office and the *Financial Times*, and has reported from Washington DC and Brussels.

**Gerald Kaufman**
The Rt Hon. Gerald Kaufman is a Labour backbench MP, representing Manchester Gorton. Kaufman entered politics in 1983 after working as a political writer for the *Daily Mirror* and the *New*

*Statesman*. Since 1997 he has chaired the Culture, Media and Sport Select Committee, and served on the Liaison Committee.

### John Kay

Professor John Kay is one of Britain's leading economists. He is a fellow of St John's College, Oxford and is a Visiting Professor at the London School of Economics. A frequent writer, lecturer and broadcaster, he contributes a weekly column to the *Financial Times*. His most recent book is *The Truth About Markets*.

### Josh Lacey

Josh Lacey is a freelance writer, who was born and still lives in London. He writes plays, screenplays, journalism and criticism. He is currently working on his first book for children, which will be published in 2004.

### Prue Leith

Prue Leith is founder of the Leith's group of restaurant, catering and cookery-school companies, is chair of Forum for the Future, Ashridge Management College and the education company 3E's. She is a non-executive director of Woolworths and Whitbread, and writes novels.

### Joanna Lumley

Joanna Lumley is an actress. She gained recognition in the 1970s and 1980s and is now best-known for her role as Patsy Stone in the television comedy series *Absolutely Fabulous*. In 1993 she earned both the Bafta Award for Best Light Entertainment Performance and the British Comedy Award for Best Actress.

### Joanna MacGregor

Pianist and composer Joanna MacGregor divides her time between playing classical, jazz and contemporary music. She has performed in over forty countries and owns her own record label, SoundCircus. Her recordings include *Play*, nominated in 2002 for a Mercury Music Award.

### Sean Matthews

Sean Matthews teaches in the School of English and American Studies at the University of East Anglia. He is currently writing on projects involving Raymond Williams and the New Left, and the British novel of the 1980s. He reviews contemporary fiction for a number of publications.

### Charles Moore

Charles Moore is Editor of the *Daily Telegraph*. He is writing the authorised biography of Lady Thatcher.

### Lucy Moore

Lucy Moore is the author of the critically acclaimed *The Thieves' Opera: The Remarkable Lives and Deaths of Jonathan Wild, Thief-Taker, and Jack Sheppard, House-Breaker* and *Amphibious Thing: The Life of a Georgian Rake*. *Maharanis: The Lives and Times of Three Generations of Indian Queens* will be published in 2004.

### Diana Mosley (d. August 2003)

Diana, the Hon. Lady Mosley was a writer, who lived in Paris for over fifty years. One of the Mitford sisters, she counted both her cousin Winston Churchill and Adolf Hitler as close friends. She married Sir Oswald Mosley in 1936. She was imprisoned for three and a half years for 'spousal association' in 1940. Her memoirs, *A Life of Contrasts*, have recently been republished.

### Mo Mowlam

The Rt Hon. Dr Marjorie (Mo) Mowlam was a member of the UK Government and Tony Blair's Cabinet until the general election of 2001. She has been Secretary of State for Northern Ireland and later Minister for the Cabinet Office and Chancellor of the Duchy of Lancaster. She is the author of a political memoir, *Momentum*.

### Julia Neuberger

Rabbi Julia Neuberger is Chief Executive of the King's Fund. She became a rabbi in 1977, serving the South London Liberal Synagogue for twelve years. The author of books on a number of subjects; her latest book is *Dying Well, A Guide to Enabling a Good Death*. She broadcasts and writes articles frequently.

### Anthony O'Hear

Anthony O'Hear is Weston Professor of Philosophy at the University of Buckingham and Director of the Royal Institute of Philosophy. His most recent books are *Beyond Evolution*, *After Progress* and *Philosophy in the New Century*. He is currently working on a book on appearance and reality in contemporary life.

### Martin Pugh

Martin Pugh was Professor of Modern British History at Newcastle University until 1999 and Research Professor in History at Liverpool John Moores University from 1999 to 2002. He writes on political, social and women's history in the nineteenth and twentieth centuries. His acclaimed biography, *The Pankhursts* (2001), will appear as a television drama series in 2004.

### Ian Rankin

Ian Rankin is the author of the 'Inspector Rebus' novels, the latest of which is the recently published *A Question of Blood*. He also writes radio plays and short stories, and appears on BBC2's *Newsnight Review*. In 2003 he produced a three-part series on the nature of evil, shown on Channel 4.

**Fiona Reynolds**

Fiona Reynolds is Director-General of the National Trust. Before taking up the post she was Director of the Women's Unit in the Cabinet Office and was previously Director of the Council for the Protection of Rural England and Secretary to the Council for National Parks.

**Michael Rosen**

Michael Rosen writes books and poetry collections for children. He published his first poetry collection, *Mind Your Own Business*, in 1974. His many other works include *Centrally Heated Knickers*, *Lunch Boxes Don't Fly*, *Michael Rosen's Book of Very Silly Poems* and *Carrying the Elephant*. He presents *Word of Mouth* on Radio 4.

**Simon Schama**

Simon Schama is University Professor of Art History and History at Columbia University. An internationally acclaimed author, among his best-selling books is *Citizens*, winner of the 1989 *Yorkshire Post* Book of the Year Award and the 1990 NCR Book Award for Non-fiction. Publications he has written for include the *New York Times* and *The Guardian*.

**Alexandra Shulman**

Alexandra Shulman is the Editor of British *Vogue*. In 1982 she joined Condé Nast with *Tatler* and became Editor of *Vogue* in January 1992.

**David Solkin**

David Solkin is Professor of the Social History of Art at the Courtauld Institute of Art, and a leading authority on British art of the 'long' eighteenth century. In 2001 he organised the award-winning exhibition *Art on The Line: The Royal Academy Exhibitions at Somerset House 1780–1836* at the Courtauld Institute Gallery. He is actually quite fond of William Hogarth.

**Norman Tebbit**

Commissioned as an RAF pilot, The Rt Hon. Lord Tebbit flew as a civil pilot until entering Parliament in 1970. He served in the Cabinet as Secretary for Employment and for Trade and Industry and as Chancellor of the Duchy. Severely injured by the IRA in 1984, he left government in 1987 to care for his wife who was disabled in the same attack.

**Jenny Uglow**

Jenny Uglow is a publisher and author, and Honorary Visiting Professor at the University of Warwick. Working on the eighteenth and nineteenth centuries, she has written biographies of George Eliot, Elizabeth Gaskell and William Hogarth, and a colourful account of inventors, scientists and industrialists, *The Lunar Men: 1760–1820*.

**Alison Weir**

Alison Weir writes history books and has been researching the monarchy and the Tudor period since 1965, and to date has published nine books, two of them about Henry VIII: *The Six Wives of Henry VIII* and *Henry VIII: King and Court*. She lives in Scotland.

**Peter Wilby**

Peter Wilby has been Editor of the *New Statesman* since 1998. He read history at the University of Sussex and joined *The Observer* in 1968. He was later Education Correspondent for the *New Statesman* and the *Sunday Times* and *The Independent*. In 1995, he became Editor of the *Independent on Sunday*.

**Jeanette Winterson**

Jeanette Winterson is a novelist and writer whose works include *Oranges Are Not The Only Fruit*, *The Passion*, *Sexing The Cherry*, *Written On The Body*, *Art And Lies*, *Gut Symmetries*, *The World And Other Places*, *The Powerbook*, and *Art Objects*, a collection of essays. She is published in thirty-two countries and writes for film, television and the theatre.

**Lewis Wolpert**

Lewis Wolpert is Professor of Biology as Applied to Medicine at University College, London. His books include *Principles of Development*, *The Unnatural Nature of Science* and *Malignant Sadness*. He presented *The Dark Lady of DNA* on Radio 3.

# List of Plates

p.100 **George Orwell**
Felix H. Man, *c.*1947
Bromide print, 283 x 184mm
(11$^1$/$_2$ x 7$^1$/$_2$")
National Portrait Gallery
(NPG P865)

p.104 **Emmeline Pankhurst**
Georgina Agnes Brackenbury,
1927
Oil on canvas, 787 x 616mm
(31 x 24$^1$/$_4$")
National Portrait Gallery
(NPG 2360)

p.109 **Prince Charles**
Tom Wood, 1989
Oil on panel, 1524 x 1575mm
(60 x 62")
National Portrait Gallery
(NPG L198)

p.113 **Richard III**
Unknown artist, possibly late
sixteenth century
Oil on panel, 638 x 470mm
(25$^1$/$_8$ x 18$^1$/$_2$")
National Portrait Gallery
(NPG 148)

p.115 **John Ruskin**
Sir Hubert von Herkomer, 1879
Watercolour, 737 x 483mm
(29 x 19")
National Portrait Gallery
(NPG 1336)

p.118 **Robert Falcon Scott**
C. Percival Small, based on
photographs taken in 1910
Oil on canvas, 533 x 419mm
(21 x 16$^1$/$_2$")
National Portrait Gallery
(NPG 1726)

p.120 **William Shakespeare**
Attributed to John Taylor, *c.*1610
Oil on canvas, 552 x 438mm
(21$^3$/$_4$ x 17$^1$/$_4$")
National Portrait Gallery
(NPG 1)

p.124 **Adam Smith**
James Tassie, 1787
Glass paste medallion,
89 x 64mm (3$^1$/$_2$ x 2$^1$/$_2$")
National Portrait Gallery
(NPG 3237)

p.126 **Delia Smith**
John Swannell, 1995
Iris print, 499 x 394mm
(19$^5$/$_8$ x 15$^1$/$_2$")
National Portrait Gallery
(NPG P717(13))

p.128 **Margaret Thatcher**
Helmut Newton, 1991
Bromide print, 1990 x 1140mm
(78$^1$/$_2$ x 45")
National Portrait Gallery
(NPG P507)

p.132 **Oscar Wilde**
Elliott & Fry, 1881
Modern print from original
negative
National Portrait Gallery
(NPG x82203)

p.136 **Virginia Woolf**
Man Ray, 1934
Silver print, 246 x 195mm
(9$^5$/$_8$ x 7$^5$/$_8$")
National Portrait Gallery
(NPG P170)

# Selected Reading

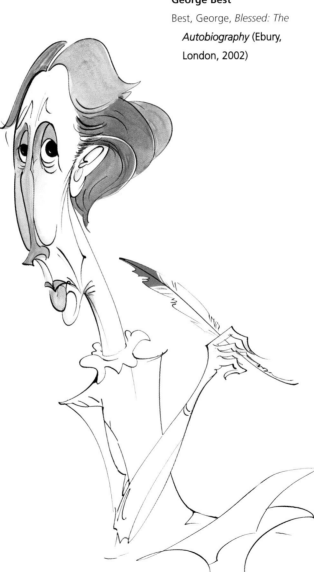

### General reference

Cooper, John, *Great Britons* (National Portrait Gallery, London, 2002)

Hart-Davis, Adam, *Chain Reactions: Pioneers of British Science and Technology and the Stories that Link them* (National Portrait Gallery, London, 2000)

Williamson, David, *The Kings and Queens of England* (National Portrait Gallery, London 1998, revised ed. 2002)

### Richard Arkwright

Egerton, Judy, *Wright of Derby* (Tate Gallery catalogue, London, 1990)

Fitton, R.S., *The Arkwrights, Spinners of Fortune* (Manchester University Press, 1989)

Uglow, Jenny, *The Lunar Men* (Faber & Faber, London, 2002)

### John Logie Baird

Kamm, Antony and Baird, Malcolm, *John Logie Baird: A Life* (National Museums of Scotland, Edinburgh, 2002)

McArthur, Tom and Waddell, Peter, *Vision Warrior: The Hidden Achievement of John Logie Baird* (The Orkney Press, Orkney, 1990)

### The Beatles

Davies, Hunter, *The Beatles* (Heinemann, London, 1968,

revised ed. Cassell, London, 2003)

Turner, Steve, *A Hard Day's Write* (Carlton, London, 1994)

### David and Victoria Beckham

Beckham, David and Freeman, Dean, *David Beckham: My World* (Hodder & Stoughton, London, 2000)

Beckham, Victoria, *Learning to Fly* (Penguin Books, London, 2001)

Morton, Andrew, *Posh & Becks* (Michael O'Mara, London, 2001)

### George Best

Best, George, *Blessed: The Autobiography* (Ebury, London, 2002)

### William Blake

Bentley, G.E. Jr., *The Stranger from Paradise: A Biography of William Blake* (Yale University Press, New Haven and London, 2001)

Bindman, David, *Blake: His Art and Times* (Thames & Hudson, London, 1982)

Hamlyn, Robin and Phillips, Michael, *William Blake* (Tate Publishing, London, 2000)

### Richard Branson

Branson, Richard, *Losing My Virginity* (Virgin, London, 2002)

Brown, Mick, *Richard Branson: The Authorised Biography* (Headline, London, 1989)

de Vries, Manfred F.R. Kets and Florent-Treacy, Elisabeth, *The New Global Leaders: Richard Branson, Percy Barnevik, David Simon and the Remaking of International Business* (Jossey-Bass/Wiley, London,1999)

### Agatha Christie

Cade, Jared, *Agatha Christie and the Eleven Missing Days* (Peter Owen, London, 1998)

Christie, Agatha, *An Autobiography* (Harper-Collins, London, 2000)

### Winston Churchill

Blake, Robert and Louis, W.R. (eds), *Churchill* (Oxford University Press, Oxford, 1993)

Gilbert, Martin, *Churchill: A Life* (Pimlico, London, 2000)

Jenkins, Roy, *Churchill* (Pan, London, 2002)

Roberts, Andrew, *Eminent Churchillian* (Weidenfeld & Nicolson, London, 1994)

## Oliver Cromwell

Coward, Barry, *Oliver Cromwell* (Longman, London, 1994)

Fraser, Antonia, *Cromwell, Our Chief of Men* (Weidenfeld & Nicolson, London, 1973)

Hill, Christopher, *God's Englishman: Oliver Cromwell and the English Revolution* (Longman, London, 2000)

## Charles Darwin

Bowler, Peter J., *Charles Darwin: The Man and His Influence* (Blackwell, Oxford, 2000)

Bowler, Peter J., *Evolution: The History of an Idea* (Revised ed. University of California Press, Berkeley, 1989)

Browne, Janet, *Charles Darwin: Voyaging* (Jonathan Cape, London, 1995)

Browne, Janet, *Charles Darwin: The Power of Place* (Jonathan Cape, London, 2002)

Dawkins, Richard, *River Out of Eden: A Darwinian View of Life* (Phoenix, London, 1996)

Desmond, Adrian, and Moore R., *Darwin* (Michael Joseph, London, 1991)

## Diana, Princess of Wales

Burchill, Julie, *Diana* (Weidenfeld & Nicolson, London,1998)

Campbell, Beatrix, *Diana, Princess of Wales: How Sexual Politics Shook the Monarchy* (The Women's Press, London, 1998)

Morton, Andrew, *Diana: Her True Story* (Michael O'Mara, London, 1992)

## Elizabeth I

Hibbert, Christopher, *The Virgin Queen: The Personal History of Queen Elizabeth I* (Penguin, London, 1992)

Starkey, David, *Elizabeth* (Vintage, London, 2001)

## Tracey Emin

Merck, Mandy and Townsend, Chris, *The Art of Tracey Emin* (Thames & Hudson, London, 2002)

## Rosalind Franklin

Maddox, Brenda, *Rosalind Franklin: The Dark Lady of DNA* (HarperCollins, London, 2002)

Watson, James, *The Double Helix* (Penguin, London, 1968, revised ed. 2001)

## Kenneth Grahame

Eccleshare, Julia, *Beatrix Potter to Harry Potter: Portraits of Children's Writers* (National Portrait Gallery, London, 2002)

Prince, Alison, *Kenneth Grahame: An Innocent in the Wild Wood* (Allison & Busby, London, 1994)

## Graham Greene

Greene, Graham, *A Sort of Life* (Vintage, London, 1999)

Sherry, Norman, *Graham Greene* (Jonathan Cape, London, 2003)

## Henry VIII

Erickson, Carolly, *Great Harry, The Extravagant Life of Henry VIII* (Robson Books, London, 1998)

Fraser, Antonia, *The Six Wives of Henry VIII* (Weidenfeld & Nicolson, London, 1998, revised ed. 1999)

Smith, Lacey Baldwin, *Henry VIII: The Mask of Royalty* (Houghton Mifflin, London, 1971)

## William Hogarth

Bindman, David, *Hogarth and His Times* (British Museum Press, London, 1981)

Craske, Matthew, *William Hogarth* (Princeton University Press, Princeton, 2000)

Einberg, Elizabeth, *Hogarth the Painter* (Tate Gallery catalogue, London, 1997)

Uglow, Jenny, *William Hogarth: A Life and a World* (Faber & Faber, London, 1997)

## Ken Livingstone

Carvel, John, *Turn Again Livingstone* (Profile, London, 1999)

## David Lloyd George

Marquand, David, *The Progressive Dilemma: From Lloyd George to Blair* (Phoenix, London, 1999)

Wrigley, Chris, *David Lloyd George and the British Labour Movement: Peace and War* (Harvester, London, 1976)

## Oswald Mosley

Mosley, Nicholas, *Rules of the Game/Beyond the Pale: Memoirs of Sir Oswald Mosley and Family* (Pimlico, London, 1998)

Mosley, Oswald, *My Life* (Soho, London, 1990)

Skidelsky, Robert, *Oswald Mosley* (Papermac, London, 1990)

## Isaac Newton

Fara, Patricia, *Newton: The Making of a Genius* (Macmillan, London, 2002)

Fauvel, John (*et al.*), *Let Newton Be! A New Perspective on His Life and Works* (Oxford University Press, Oxford, 1988)

## George Orwell

Bowker, Gordon, *George Orwell* (Little, Brown, London, 2003)

Crick, Bernard, *George Orwell: A Life* (Penguin, London,

1982, 1992)

Shelden, Michael, *George Orwell: The Authorised Biography* (Heinemann, London, 1991)

Taylor, D.J., *Orwell* (Chatto & Windus, London, 2003)

**Emmeline Pankhurst**

Pankhurst, E. Sylvia, *The Suffragette Movement* (Longmans, London, 1931)

Pugh, Martin, *The Pankhursts* (Penguin, London, 2001)

Pugh, Martin, *The March of the Women: A Revisionist Analysis of the Campaign for Women's Suffrage, 1866–1914* (Oxford University Press, Oxford, 2001)

Purvis, Jane, *Emmeline Pankhurst: A Biography* (Routledge, London, 2002)

**Prince Charles**

Dimbleby, Jonathan, *The Prince of Wales* (Warner, London, 1998)

Holden, Anthony, *Prince Charles: A Biography* (Bantam, London, 1998)

Junor, Penny, *Charles: Victim or Villain?* (HarperCollins, London, 1998)

**Richard III**

Dockray, Keith, *Richard III: A Source Book* (Alan Sutton, Stroud, 1997)

Horrox, Rosemary, *Richard III: A Study in Service* (Cambridge University Press, Cambridge, 1989)

Pollard, A.J., *Richard III and the Princes in the Tower* (Alan Sutton, Stroud, 1991)

**John Ruskin**

Batchelor, John, *John Ruskin: No Wreath but Life* (Pimlico, London, 2001)

Kemp, Wolfgang, *The Desire of My Eyes: The Life and Works of John Ruskin* (Farrar Straus and Giroux, London, 1990)

**Robert Falcon Scott**

Fiennes, Ranulph, *Captain Scott* (Hodder & Stoughton, London, 2003)

Huntford, Roland, *Scott and Amundsen* (Weidenfeld & Nicolson, London, 1993)

King, Robert (ed.) and Scott, Robert Falcon, *Scott's Last Journey* (HarperCollins, London, 2000)

Soloman, Susan, *The Coldest March: Scott's Fatal Antarctic Expedition* (Yale University Press, London 2001)

**William Shakespeare**

Schoenbaum, S., *Shakespeare's Lives* (Oxford University Press, Oxford, 1979)

Taylor, Gary, *Reinventing Shakespeare* (Hogarth Press, London, 1990)

**Adam Smith**

Ross, Ian Simpson, *The Life of Adam Smith* (Clarendon Press, Oxford, 1995)

**Delia Smith**

Smith, Delia, *Delia Smith's Complete Cookery Course: A New Edition for the 1990s* (BBC Consumer Publishing, London, 1992)

Smith, Delia, *How to Cook Book I, II and III* (BBC Consumer Publishing, London, 1998,1999, 2001)

**Margaret Thatcher**

Campbell, John, *Margaret Thatcher, Vol. 1: The Grocer's Daughter* (Jonathan Cape, London, 2000)

Reitan, Earl A., *The Thatcher Revolution: Margaret Thatcher, John Major, Tony Blair and the Transformation of Modern Britain, 1979–2001* (Rowman & Littlefield, London, 2003)

Thatcher, Margaret, *The Downing Street Years* (HarperCollins, London, 1995)

Thatcher, Margaret, *The Path to Power* (HarperCollins, London, 1995)

**Oscar Wilde**

Ellmann, Richard, *Oscar Wilde* (Penguin, London, 1988)

Holland, Merlin and Holland, Vyvyan B., *Son of Oscar Wilde* (Oxford Paperbacks, Oxford, 1988)

Holland, Merlin, *The Wilde Album* (Fourth Estate, London, 1997)

Pierce, Joseph, *The Unmasking of Oscar Wilde* (HarperCollins, London, 2001)

**Virginia Woolf**

Bell, Quentin, *Virginia Woolf: A Biography* (Pimlico, London, 1996)

Lee, Hermione, *Virginia Woolf* (Vintage, London, 1997)

Nicolson, Nigel, *Virginia Woolf* (Phoenix, London, 2001)

# Index

Illustrations are in *italics*.

*SIGN OF A GOOD PORTRAIT — THE EYES FOLLOW YOU AROUND THE ROOM!*

# Acknowledgements

The publishers would like to thank all the people who contributed and made this book possible – there are too many to mention all by name but special thanks to Christopher Charlton and Martin Gilles of the Arkwright Society, Mark Amory, Julie Davies, Anthony Gardner, Rupert Grey, Charles Jencks, Prof. Ludmilla Jordanova, Lucy Lethbridge, Jeremy Lewis, Alexander Mosley, Alison Morrison Low, Steven Norris, Jeremy O'Sullivan, Harry Ram, Mark Rylance, Jane Scarfe, Richard Seymour and Jim Thomas for their advice and suggestions; Robin Gibson for interviewing Gerald Scarfe; Lidia Polubiec for proof-reading and Vicky Robinson for the index.

We would also like to thank the staff and curators at the National Portrait Gallery, London, particularly Kate Martin and Erin Petty for invaluable editorial research, Emma Cavalier, Seraphina Coffman, Tarnya Cooper, Alexandra Finch, Sarah Howgate, Jacob Simon, Catharine Macleod, Lucy Peltz, Terence Pepper, Hazel Sutherland and Pallavi Vadhia.

**Picture Credits**

Every effort has been made to contact copyright holders; any omissions are inadvertent, and will be corrected in future editions if notification is given to the publisher in writing. We are grateful to the owners and the following copyright holders who have kindly agreed to make their images available in this book.

p.10: © Jane Scarfe; p.34: © Estate of Linda McCartney; pp.40–1: © Neil Libbert; p.51: © The Harvard Theatre Collection, The Houghton Library; p.71: © Johnnie Shand Kydd; p.76: Courtesy of Bodleian Library, University of Oxford; p.79: © Anthony Palliser; p.89: © Tom Miller; p.95: © Estate of Glynn Warren Philpot; on loan to the National Portrait Gallery, London; p.100: © Estate of Felix H. Man/National Portrait Gallery, London; p.109: © Tom Wood; p.126: © John Swannell; p.128: © Helmut Newton/ Machonochie Photography; p.136: © Man Ray Trust/ADAGP, Paris and DACS, London 2003.

**Caricatures in biographies and appendices:** p.140 Agatha Christie; p.141 Winston Churchill; p.142 Charles Darwin; p.143 William Hogarth as Pug; p.144 Ken Livingstone; p.145 George Orwell; p.146 Delia Smith; p.151 James McNeill Whistler; p.152 Charles I; p.155 Virginia Woolf; p.159 Gerald Scarfe; p.160 Queen Victoria.